ART AND FREEDOM

Art and Freedom

E. E. SLEINIS

UNIVERSITY OF

ILLINOIS PRESS

URBANA AND

CHICAGO

© 2003 by the Board of Trustees
of the University of Illinois
All rights reserved
Manufactured in the United States of America
c 5 4 3 2 1

♾ This book is printed on acid-free paper.

Library of Congress Cataloging-in-Publication Data
Sleinis, E. E. (Edgar Evalt), 1943–
Art and freedom / E. E. Sleinis.
p. cm.
Includes bibliographical references and index.
ISBN 0-252-02777-9 (cloth : alk. paper)
1. Aesthetics. 2. Arts—Philosophy. 3. Liberty. I. Title.
BH39.S5528 2003
701'.17—dc21 2002005250

CONTENTS

ACKNOWLEDGMENTS

Many people have helped in this enterprise by discussing ideas, reading and correcting drafts, offering advice, or otherwise assisting in the production of this work. Among those that I am indebted to are George Dickie, Bill Harwood, Sandra Kellett, Jeff Malpas, Richard Martin, Moira Nicholls, Carol Anne Peschke, Theresa L. Sears, Sally Sleinis, Hannah Speden, Frank White, and Bruce Wilson.

The Art Enterprise

Unless art delivers values that life without art cannot, it is pointless. The value issues here transcend the specific aesthetic values that attach to individual artworks. Certainly a natural view is that the value of art as a whole reduces to the sum of the values of its individual artworks. But this natural view embodies problematic assumptions about the atomistic nature of value in art that overlook questions about the value of art as a whole. To my mind, exclusive focus on value pertaining specifically to individual artworks misses important value issues.[1] Whether art as a whole promotes values that cannot be reduced to the sum of the values of individual artworks certainly merits further consideration. My claim is that art definitely generates values that cannot be reduced to the sum of the values of individual artworks and that these values are intrinsic to the art enterprise and are not mere byproducts. Doubtless the two kinds of value are closely linked, but

the value issues are not identical. Let me proceed directly to the argument.

The art enterprise inherently promotes freedom.[2] The role of freedom also emerges in theorizing about art and even casts light on the rise and fall of theories of art. To begin my case, let me review some fundamentals. Art produces objects primarily for conscious awareness.[3] But why art creates objects primarily for conscious awareness when the world is already full of potential objects of conscious awareness is not immediately evident. What, more specifically, is the role of objects created by art, and why cannot that role be met adequately by objects the world already contains? In short, what can art furnish that reality cannot?

The broad solution is that art furnishes recast presentations of the outer world to conscious awareness, it furnishes recast presentations of the inner world to conscious awareness, and it also furnishes novel, world-independent presentations to conscious awareness. The challenge is to explain more fully the point of such presentations. The simple answer is that art creates objects that command, sustain, and reward contemplation. For this, artworks need inherent drawing power, but how such drawing power is possible is neither simple nor obvious. I argue that freedom is crucial here and that the cultivation of inwardness is inseparable from it.

The point of art is perplexing in ways that the point of science or morality is not. Eliminate science or morality, and negative consequences ensue beyond the sheer absence of science and the sheer absence of morality. With one, we lose the technological fruits of science; with the other, we face the loss of a livable civil society. Eliminate art, and it is unclear that any negative consequences ensue beyond the sheer ab-

sence of art itself. The puzzle is increased by the fact that the first and long dominant theory of art – the representation or imitation theory in its original form – makes art appear largely pointless. Even those who accept the importance of art struggle to articulate what that importance consists in.

Art proliferates conflicting theories, and this partly drives postmodern skepticism about the viability of comprehensive theories of art. As one noteworthy conflict, according to Kant, art requires detached and disinterested contemplation; according to Nietzsche, art requires a rapturous personal engagement. For Kant, art stands apart from life; for Nietzsche, art is the great stimulus to life. It is hardly surprising that such apparent irreconcilability should induce pessimism about prospects for an adequate comprehensive theory. To my mind, both Kant and Nietzsche have points that merit respect. Theory is culpable in prematurely abandoning the quest for a single account that accommodates both points. My aim is to articulate a theory that incorporates such seemingly distinct viewpoints.

Art's unique relationship to freedom compared with science and morality is worth noting. Morality is normative in relation to action. Morality cannot permit unconstrained killing, hurting, depriving, and deceiving. Furthermore, morality must also partly restrict feelings. Feelings that lead to unconstrained killing, hurting, depriving, and deceiving must be curbed, as must feelings of enjoyment in such occurrences. Morality exists to limit freedom of action and feeling. Morality insists on specific routines of action and interaction. Morality presupposes the freedom to conform to moral rules, but it is not the function of morality to promote freedom. The aim is to propound a single set of rules to which all must conform. It is not the function of morality to create new objects for conscious

awareness with power to command, sustain, and reward contemplation. Nor is it the function of morality to foster and enlarge individuals' inner lives. Indeed, if we accept Aristotle's view, moral behavior should become habitual and automatic, and this would contract rather than expand inner life.[4] To be sure, philosophers such as Kant insist on an inner element, the appropriate intention, as vital to moral action, but beyond this minimum there is no pressure to enlarge inner life.[5]

Science is normative in relation to belief. It deems many beliefs as categorically unacceptable and others as merely undeserving of credence. Science cannot permit totally unconstrained belief, nor can it be totally flexible about methods of attaining beliefs. To be sure, science may advocate freedom instrumentally to reach better theories, but each improvement in theory further limits belief by abandoning more beliefs as no longer scientifically tenable. The rejection of certain beliefs is essential to science. It exists to limit freedom of belief. The aim is to generate a single set of beliefs that all must embrace. Nor is it the function of science to create new objects for conscious awareness with power to command, sustain, and reward contemplation. Although science may produce these as side effects, they are not its principal aims, and the best scientific theories could exist without them. Nor is it the function of science to cultivate the inner lives of its devotees. Morality strives for a single set of mandatory rules;[6] science strives for a single set of mandatory beliefs; neither strives to promote values beyond this.

The Fundamental Features of Art

The three core features of the art enterprise are that it fosters freedom, it creates objects that command, sustain, and reward

contemplation, and it fosters and enlarges the inner life of individuals. My thesis is that these three features are mutually interdependent and that the art enterprise is impossible without any one of them. These features ground the capacity of art to deliver values unobtainable from a world without art. Some connection between art and freedom is a recurring theme in thinking about art, but the connection typically is made at an excessively culturally sophisticated level. Views that see art as a tool to promote specific political freedoms fall into this category. Though not excluding such aims, the sheer ubiquity of art across different social and political systems argues against their being essential to art, for art flourishes even where political freedom is not an issue. If a significant connection exists between art and freedom, it must be at a more basic level than the political.

At the most basic level, art frees us from the commonplace and the merely instrumental. It frees us from habitual and routine modes of perceiving, thinking, feeling, and acting that arise from activities needed to sustain life.[7] To survive, we need food, water, shelter, and companionship; the acquisition of appropriate cognitive and behavioral repertoires to secure these needs is paramount. Habitual and routine ways of perceiving, thinking, feeling, and acting all arise in this process. But human beings typically seek more from life.

Here we must distinguish a trivial thesis from a nontrivial thesis. In a loose sense, any uncommon or noninstrumental action frees us from the commonplace or instrumental. If I have never thrown pebbles into water and I then throw pebbles into a lake for idle amusement, this frees me from behaviors that are either commonplace for me or necessary to sustain my life. But this sense of freeing is trivial and means no

more than that the action is not instrumental or one I usually do. In the nontrivial sense of freeing, freeing entails overcoming resistance or inertia or loosening fixed patterns. The claim here is precisely that an underlying function of art is to overcome such resistance. Art is not simply an alternative activity; it is an activity that, at least partly, goes against the grain of previous patterns of activity. Art frees, and in doing so, it changes us. Art is essentially formative; it develops inwardness and independence. Art is not significant for a self fully preformed independently of art; art is significant for a self that art itself continuously creates.

My underlying claim is that the habitual and routine modes of perceiving, thinking, feeling, and acting that are necessary to sustain life or have simply become common contain an inertia that can be modified only with effort.[8] Art is the modifier. Art itself induces a separation from the commonplace and practical. The immediate objection is that to engage in art we certainly must be freed from the routine and practical, but we have art after we are freed from the routine and practical, and it is not the function of art to do the freeing. In short, art is a nonpractical activity that already presupposes freeing from the routine and practical. I argue that art has a double aspect: Art must free us from the mundane and simultaneously furnish fulfilling activities beyond the routine and practical. Art both liberates and supplies significant new objects of focus. These two aspects are inseparable. The process of freeing partly creates the possibility of significant new objects of focus with new intensities, and the attracting power of the created objects at least partly drives the freeing.[9] Insofar as there is such a thing as an aesthetic attitude, the contemplation of art creates it, and it is not a prerequisite for such contemplation.

Before defending these claims directly, let me comment on what a good theory of art must accomplish. First, an adequate theory ought to explain why there are the arts that there are. Focusing on central cases, why is there visual art, music, literature, and dance? Here neither traditional theories such as the representation theory nor contemporary theories such as the institutional or historical theory offer any plausible explanation.[10] The diversity of the arts is a puzzle begging explanation. Second, an adequate theory ought to explain why the now-rejected traditional theories of art had the strong appeal that they had. Again, neither the traditional theories themselves nor contemporary theories offer any plausible explanation. My proposal has definite explanatory advantages in these areas. The principal defense of my claims occurs in my reassessment of both the major traditional and contemporary theories of art, but I proceed immediately to outline the implications of my thesis for the major arts.

VISUAL ART Visual artworks are material objects to which the thoughts, feelings, and actions possible and appropriate to actual nonart objects or real people are either impossible or inappropriate.[11] We cannot ride purely visual representations of horses; we can sit on sculptures of horses, but ride them we cannot. It is as unrewarding to eat visual representations of fruit as it is to fish in visual representations of lakes. Visual artworks, when apprehended as visual representations, sever the awareness from cognitive, emotional, and behavioral possibilities latent in the awareness of the represented objects themselves when perceived directly. Where visual artworks are purely abstract, the divorce from normal thoughts, feelings, and actions is even more evident. Furthermore, even in the

most expressive visual artwork, whatever emotions we experience are not properly directed at the artwork itself.[12] In general, the internal impulses generated by visual presentations are barred from discharge by the special status of such presentations, and this grounds the potential for a heightened intensity absent in normal perception. The very freeing from routine action grounds the possibility for an intensity of experience beyond the ordinary. Visual art creates impulses that cannot find expression in action and metamorphose to be experienced as charged aspects of the visual presentation itself. Visual artworks exist apart from the chaotic flux of daily life, and this very separation grounds their potential to free, to intensify experience, and to enlarge inner life.

MUSIC Musical artworks are sound complexes,[13] often generating emotion-like states, to which the behavior possible and appropriate to nonart sounds and emotions is either impossible or inappropriate.[14] Take the funeral march from Beethoven's *Third Symphony.* Listening to it does not require donning somber clothes and heading for a cemetery. Take the chorus of the Hebrew slaves, *Va, pensiero,* from Verdi's *Nabucco.* It may generate feelings of sympathy for the oppressed there, but the artistic presentation lacks actual oppressed people to aid or rescue as appropriate expressions of such emotions. Musical presentations, when apprehended as expressive musical presentations, sever the awareness from behavioral possibilities latent in the awareness of emotions when experienced in life. In actual life, emotions are there to spur action; in music, emotions are there with nowhere to go. This severing of connection between musical presentation and action at least partly grounds the special intensity of music. It also furnishes a com-

plementary explanation for some of Schopenhauer's remarks about the connection between music and the will.[15] There is a much stronger connection between emotion and action than there is between perception and action or between thought and action. Consequently, when the connection between presentation and action is severed, the internal state has greater felt intensity where the connection is strongest.

Furthermore, real-life emotions often occur in complex and pressing situations where exclusive focus on the emotion itself is either impossible or imprudent. The fear generated by an approaching wild tiger is unsuitable for exclusive introspective attention; the circumstances demand attention to urgent tasks such as accurate assessment of danger and execution of appropriate courses of action. Musical artworks free us from such actions and distractions and offer themselves as sole and all-absorbing centers of attention. Here liberation from the chaotic flux of daily life is crucial to both the special intensity and the special inwardness of music.

LITERATURE Literary presentations typically generate lifelike situations to which the behavior appropriate and possible when generated by the actual life situations is either impossible or inappropriate.[16] Typically actual life situations engender direct actions and responses; in literature, the actions and responses have nowhere to go. This severing of connection between literary presentations and direct actions and responses grounds the possibility of intense experiences that differ from those derived from life. When the connection between literary presentations and direct actions and responses is severed, the internal states attain an intensity that they lack where the aroused states discharge themselves in direct ac-

tion and response. When emotive content increases, as it of-
ten does in poetry, felt intensity also increases. The content of
literature is mediated cognitively through language, and al-
though this liberates literary works from the limitations of the
senses and opens extensive new possibilities, this occurs at the
expense of the immediacy and the vibrancy that the senses
furnish.

Drama combines literature with visual art and, in opera,
with music. My central thesis conflicts with Aristotle, who
maintains that the contemplation of tragedies purges specta-
tors of fear and pity.[17] Surely this is improbable, for although
fear and pity may well be aroused, no means exist for their
discharge in such circumstances. Here Nietzsche, who main-
tains that such contemplation is likely to make spectators more
fearful and pitying, is arguably closer to the mark.[18] Goethe's
The Sorrows of Young Werther, in which the central character
commits suicide out of unrequited love, reputedly stimulated
a spate of similar suicides. Rather than purging its contempla-
tors of morbid feelings, the literary representation intensified
them and led to some suicides that would not have occurred
without the literary exposure.[19]

DANCE The classical narrative ballets such as *Swan Lake*
contain literary and musical elements that have already been
considered, but if we disregard such borrowings and focus on
what is unique to dance, then clearly bodily movement and
sequences of bodily movement are central. However, not just
any bodily movement suffices; for that we need only enter a
crowded street for observation or participation. The bodily
movements of dance are not ordinary, everyday movements.
Dance frees the body from its normal patterns of movement.

Freedom from the normal and everyday is perhaps more striking in dance than in any other art form, and this doubtless moved Nietzsche at times to regard dance as the highest art form. Dance increases bodily awareness in both dancer and spectator. Feeling or seeing what bodies can do enlarges our conception of bodies, even when our own bodies cannot match what we see.

In summary, visual art severs the normal connection between seeing and action, music severs the normal connection between hearing and action, literature severs the normal connection between thinking and action, and dance undermines common and habitual patterns of physical movement. The arts free us from routine and habitual modes of perceiving, thinking, feeling, and acting in multiple ways. Human freedom is as complex as humans themselves are, and multifarious resources are needed for its proper cultivation. The different arts are there at least partly because of their differential contribution to human freedom and to the rewards that are associated with it. Each art form frees us from different routine and habitual responses. Each art form furnishes its own intensified experiences. Clearly this implies that they are not mutually reducible. Visual art cannot be reduced to music, music cannot be reduced to visual art, and neither can be reduced to literature. Nor can any of them be reduced to dance. They simply have different and complementary potentials to liberate and reward. Possibly more sensual types are attracted by visual art, more emotional types by music, more intellectual types by literature, and more physical types by dance. If so, they may be attracted to their favorite art partly because they are freed from the domination of the sensual, the emotional,

the intellectual, and the physical, and that such attraction is no mere reflection of their enslavement.

An important corollary of the basic thesis is that the very possibility of art depends on the prior existence of a world and life of nonart. Art is art at least partly because it differs from an antecedent world and life of nonart. Beings for whom art is not a liberation from and an addition to an art-independent world could not experience in art the intensity or novelty that we do. One factor that makes art valuable is the existence of a contrasting nonart world from which we are partly freed by art. Paintings could not conceivably have the value that they have if there were no world outside paintings. Music could not conceivably have the value that it has if there were no sounds other than music or if there were no emotions experienced outside music. Literature could not conceivably have the value that it has if there were no life outside literature. Dance could not conceivably have the value that it has if there were no other human movements beside it. If these points are sound, then clearly all value in the arts cannot be reduced to the intrinsic aesthetic values of individual artworks; their value must at least partly depend on the broader context in which they are embedded.

To be sure, artworks must command, sustain, and reward contemplation. If artworks lack intrinsic drawing power, then they lack power to dislodge us from routine and habitual ways of perceiving, thinking, feeling, and acting. Unless the presence of an artwork in conscious awareness furnishes rewards to contemplators, its destiny is oblivion. Some artworks attract immediately; others attract only after extended exposure to other artworks. But artworks are pointless if they lack the capacity to command, sustain, and reward contemplation in

ways unavailable from the nonart world. Art must deliver what the world outside art cannot.

Art partly creates the self that derives value from art.[20] There is a common supposition that human nature is fixed independently of the encounter with art and that this nature explains how value arises in the encounter with art. However, art contemplators must be freed from their routine and habitual modes of perceiving, thinking, feeling, and acting. The interaction here is two-way: the attraction of the artwork tends to free, and successful freeing tends to enhance the attraction of the artwork. Because the freeing is from what one is oneself, because the loosened chains are internal, the freeing creates a new self. Naturally this new self is an extension of a self forged by the world independently of art.

Awareness of oneself as a self depends on awareness of other things and other selves. Our subjective self only fully emerges in relation to the subjectivity of others. Art discloses the subjectivity of others and thereby promotes expanded self-consciousness. The interactions of daily life largely generate our public identities, whereas the interactions with art largely generate our subjective identities. Expansion of self-consciousness entails movement beyond the routine and habitual in which consciousness is both minimal and peripheral. Transcending the routine and habitual is essential to growing inner awareness, and it is precisely this transcendence that art supplies.

Where one is aware of the self only as distinct from other things, one has only a primitive conception of the self that hardly extends beyond being a body among other bodies. Where one becomes aware of the self as distinct from other selves, one has an enlarged sense of the self as a center of awareness among other centers of awareness. Perception of the self as one among

other selves is essential to the development of self-conscious-ness. By revealing the subjectivity of others, art both shapes and heightens awareness of our own inner nature. Whereas science grounds our shaping of the natural word and morality aspires to shape our social world, art is the great shaper of our inner world. What follows is a defense of my basic claims.

Representation

Representation has played a major role in thought about the arts and has furnished one of its most influential theories. But the representation theory of art is no longer viable as a comprehensive theory of art.[1] Nor is there much point in exhuming a corpse merely for flaying and reburial. Yet to my mind, the representation theory grounds important insights that still warrant attention. Indeed, I argue that whatever else art does, it will always contain ample room for representation. According to the representation theory, the essential function of an artwork, whether it is a painting, a sculpture, a poem, a play, and so on, is to represent, imitate, copy, describe, reveal, or reflect some aspect of the world. In its basic form, the theory embodies an apparently straightforward criterion of aesthetic merit. The more closely artworks resemble what they depict, the better they are as artworks.

The theory has great natural appeal. There is almost instinc-

tive admiration for artists who can render realistically whatever they choose, and the more realistic the rendition is, the greater admiration tends to be. The representation theory was the first major theory of art, doubtless because of its natural appeal. It has been the longest-lasting and most widely embraced of all art theories. In some form, it has attracted numerous philosophers from Plato on. Many artists, including Leonardo da Vinci and most of the painters and sculptors of the Renaissance, writers, critics, and various influential art theorists, have all espoused it.[2]

The theory continues to influence popular thinking about the arts. One still hears objections to opera that people dying do not sing long arias and that chorus and orchestra do not accompany the planning of foul deeds. In short, opera is artificial, exaggerated, and untrue to life.[3] Such objections have sufficient currency to warrant books being written in response.[4] Indeed, similar sentiments appear to activate productions of classical operas that insist on relating them to contemporary life by placing them in contemporary settings with contemporary clothes and contemporary manners, presumably in the belief that they are thus rendered truer to life. Such attitudes appear to rest on naive versions of the representation theory that require artworks to mirror reality as closely as possible. The theory underpins condemnations that are still heard, although less frequently, of nonrepresentational painting and sculpture, collage, installations, happenings, conceptual art, and the like.[5] Most people know someone with unshakeable convictions that any painting that is not the representation of some person, animal, tree, flower, fruit, or other natural scene is manifest rubbish and that the charlatans who produce such things should be, if not whipped, then at least made to do a decent day's work.[6]

The representation theory of art, as a label, deceptively masks complexity. To unravel some of this complexity, let me begin with a broad view of the theory and some of its leading thinkers. The three key conceptions in the representation theory are the artwork, the world, and the relation of representation. The specific implications of the representation theory depend on detailed elaboration of these key features. Vary the account of any of them, and the representation theory assumes quite different guises. This is particularly so concerning the value of art, as is evident in the case of Plato.

In *The Republic*, Plato presents a fundamentally two-tiered view of reality. First, there are forms. These are abstract, ideal objects that are not in space or time; they are eternal and unchanging. They are apprehended directly by the mind. Forms are perfect exemplars: The form of the circle is perfectly circular, the form of the straight line is absolutely straight, and so on. Second, there are ordinary things. These are concrete, specific objects in space and time such as beds and trees; they are neither eternal nor unchanging. They are apprehended directly by sense perception.[7] Ordinary things are never perfect; they are mere imperfect resemblances or imperfect copies of perfect forms. For Plato, forms constitute ultimate reality; ordinary things in space and time are mere fleeting appearances. Only the unchanging forms yield genuine knowledge. The changing appearances in space and time yield only beliefs.

Within this framework, Plato considers what artists actually do (specifically, painters).[8] Suppose an artist produces a painting of a bed. What is the artist really doing? According to Plato, the artist produces a copy of a copy. The ordinary bed that the artist sees is a copy of the form of the bed. The ordinary bed is already, as a mere copy of the form of the bed,

inferior to the form of the bed. The artist makes a copy of this inferior copy. But the artist's copy of the bed in a painting is inferior to the bed. So the painting is an inferior copy of an inferior copy. To contemplate the form of the bed is best; to contemplate a bed is next best; to contemplate a painting of a bed is worst. Naturally, with this analysis Plato took a dim view of the value of visual art.[9] Arguably Plato loads the case against art by selecting an extremely common item without much visual interest. Typically what matters most about beds is how good they are to sleep in, not how they reward visual contemplation. In any event, whatever those rewards are, they must all but vanish with the frequency of our exposure to beds. Had Plato selected something less common and less mundane, something rare with inherent visual interest such as an orchid or a peacock, perhaps, his case may not have seemed as powerful.

A natural response to Plato's low valuation of visual art is that it depends entirely on his metaphysics, and those who reject his metaphysics can safely ignore his valuation of art. Before yielding to this point, it is worth uncovering one of Plato's main assumptions. Plato's key premise is that contemplating the original is better than contemplating a copy. It is better to contemplate the form of the bed than a bed. It is better to contemplate a bed than an imitation of a bed in a picture. Why is it better? For Plato, it is essentially a matter of knowledge. Contemplating the form yields the highest-quality and most complete knowledge. Contemplating a copy of the form yields less in quality and completeness of knowledge. Contemplating a copy of a copy of the form yields even less in quality and completeness of knowledge. Plato assumes that the point of contemplating artworks is the knowledge that such contem-

plation yields. This assumption virtually excludes the possibility of serious independent value in art. It is worth considering how other proponents of the representation theory handle this issue.

Aristotle has a more commonsense conception of reality than Plato. For Aristotle, reality is not multitiered; there is only one world, and the world that you see and touch is the world as it is.[10] In his *Poetics*, Aristotle regards poetry or drama as more valuable than history because, whereas history only recounts particular events, poetry or drama conveys universal truths about human nature. Again the value of art resides in knowledge; here art is valuable for furnishing knowledge that history does not. However, troublesome questions recur: Why bother with artworks? Why not approach reality directly? Why not conduct thorough scientific investigations? Why not let psychologists and sociologists loose on the phenomena along with historians?[11] Doubtless their combined efforts will reveal whatever is discoverable about human nature. In any event, would it not be better to immerse ourselves directly in life and learn about human nature that way rather than to learn about it second-hand from poetry and drama?[12] These are serious questions that proponents of the representation theory need to answer.

Aristotle had other important things to add here. According to Aristotle, human beings naturally take pleasure in imitation.[13] One answer to the question, "Why contemplate paintings rather than directly contemplating reality?" is that seeing a picture as an imitation is pleasurable and yields a pleasure unobtainable from contemplating the corresponding reality because the corresponding reality is not an imitation. The very recognition that artworks transcend real things is crucial to the

pleasure derivable from them. This is an interesting suggestion, but it is hard to see art furnishing important values if this were the whole story. However, Aristotle had further points. In discussing drama, Aristotle argued that certain departures from reality are acceptable if the internal coherence of the drama demands them.[14] This introduces the idea that deviations from reality are permitted on aesthetic grounds and ensures the production of objects that cannot be encountered in reality directly. This furnishes another possibility of deriving experiences from artworks that cannot be derived from the contemplation of reality. I consider this point directly in due course.

Take Schopenhauer as another example. His views on tragedy imply commitment to the representation theory. For him, drama is the best reflection of human existence, and tragedy is its highest form.[15] Tragedy truly reveals the appalling nature of human existence in which suffering predominates, and frustration, defeat, disappointment, and despair are the iron rule. The great merit of tragedy – and this flows from its accurate portrayal of life – is that it turns us away from life and thus spares us some of its suffering. Clearly, in this view it is better to contemplate the artistic representation than participate in the reality it represents. This contrasts neatly with Plato. For Plato, it is better to contemplate reality rather than its artistic representation. For Schopenhauer, it is better to contemplate the artistic representation rather than the reality.

There are further noteworthy contrasts. Schopenhauer also had a two-tiered view of reality, but it is quite different from Plato's.[16] For Schopenhauer, reality consists of the noumenal and the phenomenal. The phenomenal is the aspect of reality accessible to direct awareness; it is what we perceive and con-

ceptualize. The noumenal is the more fundamental aspect of reality and is normally inaccessible to direct awareness; it cannot be perceived or conceptualized. A key difference between Plato and Schopenhauer is that whereas for Plato, both the forms and ordinary things are accessible to us, for Schopenhauer, only ordinary things – the phenomenal world – are readily knowable; the noumenal world, reality as it is in itself, is not readily knowable, although he thinks that we can glean enough about it to call it will. Furthermore, the phenomenal world is an expression or manifestation of the noumenal world.

Surprisingly, Schopenhauer thinks that music can reflect the noumenal world.[17] He is dismissive of "pictorial" music, which seeks to represent or imitate aspects of the phenomenal world.[18] But genuine music is a direct reflection of ultimate reality. This appears to rescue music from the triviality that threatens art in Plato's view. The contemplation of music acquaints us with a reflection of reality, but unlike the situation for Plato, it acquaints us with a reflection of the ultimate and most important component of reality, the will, and not merely with a reflection of some phenomenal manifestation of the will. The positive value of music seems easier to accept in this view than the positive value of painting is in Plato's. In Schopenhauer's view, genuine music is not just a copy of a copy. Nevertheless, awkward questions persist. In this view, is not music just a reflection or representation of the noumenal world? To be acquainted directly with the noumenal world rather than with a reflection or representation of it in music surely would be better. Obviously, if no one can be directly acquainted with the noumenal world, then certainly composers cannot be acquainted with it, and no one can know whether music reflects the ultimate reality. However, if composers are directly acquainted with the

noumenal world, then surely it is better for us also to be acquainted with ultimate reality directly and not through some reflection of it in music.[19]

Schopenhauer's approach initially looks more promising than Plato's, but eventually the value of art again suffers serious challenge. Naturally, defenses are possible. One might argue that composers are special beings who directly apprehend ultimate reality, which ordinary mortals cannot do. So contemplating reality directly is optimal for composers, but the best we can do is listen to their music. I will not explore whether this defense is sustainable in Schopenhauer's philosophy, but note that the representation theory repeatedly battles to justify the value of art.

For Plato, the point of contemplating artworks appears to be the knowledge derivable from such contemplation, and evidently other important thinkers share this assumption. This assumption is questionable. If we contemplate paintings of horses, is this to gain knowledge of horses? If we contemplate drawings of flowers, is this to gain knowledge of flowers? The suggestion seems odd, and Plato's assumption warrants challenge. What then is the value of contemplating a copy or imitation or representation rather than the original? The issue need not be construed in terms of knowledge. The problem is that whatever the value is in contemplating something, seemingly more of that value flows from contemplating the original rather than from contemplating copies, imitations, or representations. Even if we focus on the intensity, richness, and completeness of experience, rather than knowledge, seemingly reality furnishes these more fully than any mere representation or copy or imitation.

Let me call this the fundamental justification problem for the

representation theory. The representation theory must explain why we should contemplate artworks rather than directly contemplating what they depict. Why contemplate paintings of beautiful bodies when you can contemplate beautiful bodies? Why contemplate sculptures of horses when you can contemplate horses? Why witness plays about domestic life when you can live it and directly observe others living it? I focus on this issue henceforth. To begin, the term *representation theory* embraces a cluster of theories in which the implications vary from case to case. A systematic ordering of representation theories is necessary for progress here, and I will present just such an ordering in which I distinguish four versions of the representation theory. Let me start with the simplest and clearest version of the representation theory.

The Pure Representation Theory

The function of art is to represent, copy, imitate, reveal, or describe some segment of reality as accurately and completely as possible. The theory embodies a strong criterion of aesthetic merit. The more an artwork resembles the real thing – indeed, the more it can be mistaken for the real thing – the better it is as an artwork. Anything added, anything deleted, anything altered is a defect.[20] The theory is primarily applicable to visual art and is readily applicable to literature and drama. Its application to music is problematic but not impossible. I initially focus on its application to visual art, but with due caution the observations can be generalized.

The theory has had distinguished adherents. Giorgio Vasari in *Lives of the Artists* tells a story about Giotto.[21] During the absence of Giotto's master, Cimabue, Giotto painted a fly on the nose of a figure in one of Cimabue's paintings. On return-

ing, Cimabue tried several times to brush the fly off the nose of the figure in his painting before realizing that the fly was not real. The story is told partly to show that Giotto had a sense of humor but also partly to show that Giotto must have been a great artist to trick the expert eye of his master. The implicit ideal is to make a painting indistinguishable from the reality it represents. Vasari tells the story of another artist who painted a picture of a horse so realistically that not only were humans deceived but even horses were deceived.[22] One is among the artistic elite if one can deceive humans about horses, but one is truly exceptional if one can deceive horses about horses. In describing a painting by Titian, Aretino relates, "And the lamb he bears in his arms is so lifelike that it actually drew a bleat from a passing ewe."[23] These stories neatly illustrate the ideals of the pure representation theory. During the reign of the theory, the formulation is regularly repeated that paintings should reveal no more and no less than a mirror reveals. Even Leonardo uses this formulation.[24]

The theory generates questions that are otherwise barely intelligible. For example, which is the highest art form? Again Vasari tells a relevant story. The painter Giorgione had a dispute with some sculptors.[25] The sculptors argued that sculpture is the superior art form because it permits more accurate and realistic representations than painting. In particular, painting shows only how things look from a single point of view, whereas sculpture shows how things look from any point of view. In response, Giorgione painted a picture of a man with his back to the viewer but facing a stream with the reflection of his front in the water. To one side, there is shining armor, which reflects one of his profiles, and on the other side there is a mirror, which reflects the other profile. In

short, the picture shows the front, back and both sides of the person. According to Giorgione, we cannot simultaneously see the four sides of a person in a sculpture; to see them we must walk around the sculpture. The painting shows more of the reality without moving and therefore is the superior art form. I will leave this dispute unresolved but note that certain issues become meaningful only within a theory and are vacuous without one.

The pure representation theory carries strong implications about the role of the artist. Here artists are mere artisans. The artist's skill may be as high as we please, but apart from the skill to represent, artists not only need not but must not contribute anything. No thought, no feeling, no reaction, no creation, no act of imagination from the artist must intrude into the representation. Reality must wholly dictate the contents of representations, and artists have no legitimate freedom to deviate from it. The closer artists are to what we conventionally conceive cameras to be, the better.[26] Artists are free to select their subjects, but that is all.

Let me pose the fundamental justification problem here. In the pure representation theory, how can art enrich human experience? What value can art add to life? The problem is formidable and can be sharpened as follows. Surely whatever art offers we could obtain more fully directly from reality and bypass art entirely. For the sake of argument, grant that the conception of representation or imitation involved here is coherent and unproblematic.[27]

The capacity of this version of the theory to resolve the fundamental justification problem is limited but not entirely ineffectual. Let me cite the benefits that accrue from art even in this unpromising version of the theory.

ACCESSIBILITY Some things are less accessible than others. Some things are more beautiful or more rewarding to contemplate than others. With exact representation, we have enhanced access to such beauties or rewards.[28] To see the real thing may necessitate excessive travel, there may be physical or human barriers, it may be too dangerous or too expensive, and so on. Pure representations furnish access to sights that are difficult or normally impossible to access. Thus, in the pure representation theory, although art fails to introduce any new beauty or new experience not otherwise obtainable, it greatly increases access to beauties and experiences that are already obtainable.

PORTABILITY Mountains are not portable, but representations of mountains are. If visual contemplation of a mountain is rewarding, then an exact representation can deliver that rewarding experience wherever we go. The point applies equally to anything we might want to see. Greater portability and greater accessibility often go together, but they are independent features. A large statue or huge portrait may be more accessible than the person of whom it is a statue or portrait, yet both the statue and the portrait may be even less portable than the person. Although the greater portability of many representations compared with the corresponding realities cannot furnish new rewarding experiences, it can increase the proportion of rewarding experiences to nonrewarding experiences.

PERMANENCE The beauty of youth inevitably fades. Exact representations of people in their youthful beauty furnish continued access to that beauty even when it is no longer directly observable in the world.[29] Here is another answer to the

question "Why contemplate representations rather than real things?" With the passage of time the real thing might no longer be directly observable. Representations preserve beauties or sources of rewarding experiences when the originals have left this world. Again the greater permanence of representations cannot furnish new rewarding experiences, but it can preserve the sources of rewarding experiences and thereby increase the proportion of rewarding experiences to nonrewarding experiences.

SELECTIVITY If only the most interesting, most rewarding, or most beautiful aspects of reality are reproduced in representations, then we can increase our exposure to what is valuable. Certainly no new values emerge, but art can furnish a digest of the best that reality offers.

PLEASURE IN REPRESENTATIONS If Aristotle is right, we take pleasure in representations just because they are representations. Typically, the better the representation is the more it furnishes this particular pleasure. This pleasure genuinely adds to human experience; we cannot have this pleasure without representations. But as I noted earlier, this is hardly an addition of decisive significance. If this were the only genuinely new value or new experience flowing from art, it would not amount to much.

SEVERANCE FROM ACTION Representations sever the ordinary or routine nexus between perception and action that obtains in life. Representational artworks free us from practical involvement and release us for unrestricted and concentrated contemplation of the artworks themselves.

 Let me summarize the benefits of art in the pure represen-

tation theory. The greater accessibility, portability, and permanence of representations enable us to increase the ratio of rewarding to unrewarding experiences. Even when original sources of rewarding experiences are absent, those rewarding experiences remain available through representations of their sources. So even in the pure representation theory, art has a significant capacity to increase value, but notably it fails to deliver any essentially new experiences or new values. Apart from representations freeing us from practical action in relation to objects of awareness, representations multiply old values rather than creating new ones. Here the increase in value furnished by art is quantitative rather than qualitative.

Irrespective of its potential benefits, the theory faces formidable difficulties. First, it implies that such uninspired things as wax fruit, plastic flowers, and full-scale models of battle scenes are aesthetically superior to paintings of fruit, flowers, or battles simply by being more accurate representations. It implies that photographs are aesthetically superior to paintings. This conflicts strongly with our settled aesthetic judgments and is a major weakness in the theory.

Second, the theory is inapplicable to major artworks that are generally regarded as representational. Botticelli's *The Birth of Venus*, Leonardo's *The Last Supper*, and Michelangelo's *The Last Judgment* cannot be pure representations. Botticelli was not present at the birth of Venus, Leonardo was not present at the last supper, and Michelangelo was not present at the last judgment.[30] None of these are pure representations of events witnessed by the artist. Far from being pure representations, they are more nearly works of pure imagination.

Third, the theory fails to accommodate the pretheoretically

inchoate sense that art furnishes what we cannot obtain else-where and thus threatens to trivialize art. Surely we expect more from art. However, the pure representation theory is not the only representation theory.

The Augmented Representation Theory

The key difference between the pure representation theory and the augmented representation theory is that the latter permits deliberate deviations from reality on aesthetic grounds. Let me illustrate this with two suggestions that were made during the Renaissance. One suggestion concerns portrait painting: If the subject has warts or other obvious blemishes, it is permissi-ble, perhaps even obligatory, to omit such blemishes. Anoth-er suggestion came from the Renaissance architect and art theorist Leon Battista Alberti.[31] He suggested that in painting human figures, a painter should select the most beautiful body parts from different people and paint a figure more beautiful than any actual person in the world. So representation or im-itation of separate parts that are fully in reality generates a whole that is as such not in reality.

This proposal has obvious difficulties that I will ignore, such as whether sense can be made of the beauty of a specific body part outside the context of the particular body whose part it is, but one point is worth noting. Suppose that Alberti's instruc-tions could be followed to yield a painting of a person more beautiful than any single person in the world; what difference would this make to value in art? The difference is dramatic. Beautiful features that are diffused and scattered throughout the world and can only be experienced there in a diffused and scattered way furnish an intensified experience of beauty when concentrated in a single artwork. Here is a specific idea of re-

wards from art that direct contemplation of the world cannot deliver.

Given the underlying point, other possibilities readily emerge. There are etchings by Picasso on the theme of the artist and his model.[32] They consist of simple lines, and there are no colors, no irrelevant details, no filling in of backgrounds, no hint of differing surface textures, mere hints of three dimensionality, and so on. In other words, most of the complexity in the visual world that naturally confronts us is omitted. These omissions furnish the basis for a purity and intensity of response to the simple forms that is impossible amid the full visual complexity of the world.[33] Here again, art offers what the world cannot while remaining recognizably representational. Take another example: Imagine a sculpture of Nero done exactly to scale. Next consider the size of that statue increased twentyfold; this change of scale induces a quite different response, one surely unobtainable by observing the real person.[34] These examples suggest that it is only by differing from the world in some way, only by furnishing experiences that the world fails to furnish, that art can distinctively enrich human life. The closer art adheres to the world, the lesser its capacity to enrich life distinctively; the more art deviates from the world, the greater its potential to enrich life with new experiences.

There are numerous ways of deliberately deviating from reality to produce representations that furnish rewards unobtainable from a contemplation of real things.

Selection: The things represented can be selected from separate sources.

Composition: The things represented can be ordered in ways that they are not ordered in the world.

Simplification: The things represented can be simplified in varying degrees by leaving things out.

Concentration: The things represented can be concentrated by packing more in than can naturally be found together in the world.

Attenuation: The things represented can be attenuated by such means as diluting color and blurring shape.

Accentuation: The things represented can be accentuated with brighter colors and sharper shapes.

Distortion: The things represented can undergo a change of proportions such as depicting the head as larger than the body.

Change of scale: The things represented can undergo a uniform change of size while retaining their actual proportions.[35]

Each of these means signals intervention in and control of the character of the artwork by the artist. In augmented representations, traces of the artist's mind in the artwork are unavoidably present. Although there is no difficulty in finding examples of these devices in the accepted corpus of artworks, caricatures are a particularly rich source of them all. Among recent artists, Hervé Di Rosa is remarkable for his copious use of these devices.

The fundamental justification problem here is, "How can art enrich human experience in the augmented representation theory?" To begin, all benefits that accrue to art in the pure representation theory transfer to the augmented representation theory. In addition, there is now an expanded range of

devices for furnishing experiences unobtainable directly from the world, so these are devices by which art can genuinely enrich experience. It is worth repeating that these devices inevitably leave traces of the artist's activity in the artwork, which implies that the specific contributions made by artists ground the possibility of genuine enrichment in experience. Art need not merely repeat experiences derivable from the world; art can now yield experiences that the nonrepresentational world cannot furnish. Clearly the fundamental justification problem is less acute for the augmented representation theory.

In this version of the theory, which is the superior art form? Arguably, the superior art form is the one that furnishes most freedom to deviate from reality because a greater potential to deviate from reality indicates a greater potential to furnish rewarding experiences unavailable from reality. In this view, painting probably is superior to sculpture, and painting surely is superior to photography. The role of the artist also changes markedly here. Artists are no longer mere artisans. Artists make positive individual contributions. Creativity from artists is allowed and even necessary if artworks are to generate rewarding experiences that cannot be derived directly from reality. Artists are no longer mere slaves to the scenes before them. Artists can actively reflect on possible effects and produce effects that are entirely new, thereby leaving traces in artworks not only of the world but also of their own creativity.

The augmented representation theory deals better with objections that are serious problems for the pure representation theory. First, the augmented representation theory no longer implies that wax fruit, plastic flowers, and full-scale models of battle scenes are better than paintings of fruit, flowers, or bat-

tles simply by being more accurate representations. It no longer implies that photographs are aesthetically superior to paintings. Deviations from reality may produce more aesthetic value than slavish adherence to it. The augmented representation theory obviously is better in accommodating these points.

Second, the theory remains inapplicable to major artworks that are generally regarded as representational. Botticelli's *The Birth of Venus,* Leonardo's *The Last Supper,* and Michelangelo's *The Last Judgment* cannot be augmented representations. Plainly none of these are augmented representations of actual events witnessed by the artist. Far from being augmented representations, they are more nearly pure inventions.

Third, as opposed to the pure theory, the augmented theory partly accommodates the pretheoretically inchoate sense that we approach art for what we cannot obtain elsewhere, and it no longer threatens to trivialize art to the same degree. Here art is a source of experiences that are unobtainable independently of art, a quality that imbues art with genuine potential to enrich life.

Fourth, the theory lacks a satisfactory criterion for what deviations from reality are permitted and what deviations are not permitted. The augmented representation theory cannot have the same criterion of aesthetic merit that the pure representation theory has, but it is hard to see what replacement criterion could flow naturally from the theory.

Fifth, although the theory grounds the possibility of a positive enrichment of experience, it fails to explain why we should be interested in deviations from reality. To be sure, if there are deviations from reality they will furnish experiences that reality cannot, but this is not an automatic guarantee of positive

value. At this level of articulation, the theory fails to connect positively deviations from reality in representation and human good.

Overall, the augmented representation theory is better than the pure representation theory, for it fits better with our settled pretheoretical judgments about art. But these two versions of the representation theory share one assumption. The common assumption is that the idea of exact representation is coherent and that exact representation is in principle possible. The pure representation theory requires exact representation; the augmented representation theory presupposes its possibility but permits deviations on aesthetic grounds. The third form of the representation theory challenges this fundamental assumption.

The Sophisticated Representation Theory

The key difference between the pure representation theory and the augmented representation theory on one hand and the sophisticated representation theory on the other is that the latter denies the possibility or even intelligibility of the idea of exact representation. The key claim is that exact representation is in principle impossible. Many notable theorists endorse this claim and reject the conception of representation underpinning the two previous versions of the representation theory.[36]

The central contention is that there are indefinitely many methods of representation; within each particular method there are good representations and bad representations, accurate representations and inaccurate representations, but there is no method of representation in principle that captures how things are in their own right. All representations are influenced by the

method of representation used. Representations are not just accidentally different from the realities they depict; they are essentially different. All methods of representation are conventional in some degree, and representations, as the embodiments of these conventional elements, necessarily differ from the realities themselves. Indeed, Arnheim and Gombrich advance the even stronger thesis that the very way in which artists perceive the world is influenced by the methods of representation available to them. Gombrich's more extreme formula is that an artist does not paint what he or she sees; rather an artist sees what he or she paints.[37]

Besides the inescapable element of conventionality necessitated by the choice of a method of representation, social and personal factors inevitably affect artistic representations. An artistic representation typically fuses several viewpoints: a viewpoint reflecting the method of representation, a viewpoint reflecting the artist's own society, and a viewpoint reflecting the artist's own intellectual, emotional, and sensual makeup. Thus representational artworks do not so much reveal the way the world is as they reveal the way the world looks to a particular person, embedded in a particular society, and steeped in particular methods of representation.

Media also contribute distinctively to representations, reinforcing the point that representations are not completely determined by the realities represented. Consider the choice from three visual media: pen-and-ink drawing, oil painting, and watercolor. Suppose that the very same scene is rendered in each medium. Obviously each rendition will differ in some way from the others. Clearly they cannot all be exact resemblances of the original scene, and this follows directly from the logic of exact resemblance. If A exactly resembles B, and B

exactly resembles C, then A exactly resembles C. But a pen-and-ink drawing cannot exactly resemble an oil painting or a watercolor. At most one of them could be an exact resemblance of the actual scene. However, it is entirely arbitrary to select one of these media as furnishing an exact representation and the others not. To be sure, some pen-and-ink drawings are more realistic than others, some oil paintings are more realistic than others, and some watercolors are more realistic than others, but we cannot claim that pen-and-ink drawing is inherently more realistic than oil painting or watercolor. Questions of realism arise after the choice of a medium; the question of realism does not arise in the choice of a medium. The choice of medium always makes some difference; it always introduces some gap between the scene and its representation, yet we cannot escape selecting a medium.

Another choice is whether to use the perspectival representation developed by artists in the Renaissance or to use some flatter method of representation such as that used by ancient Egyptians. Arnheim argues persuasively that the choice between the two methods is not a choice between a realistic method of representation and one that is not realistic.[38] Neither method fully captures how things really are, and both have their individual strengths and weaknesses. Neither method is inherently superior to the other. Furthermore, this choice of representational method is entirely independent of the choice of medium. Here already are several independent factors affecting the nature of representations that undermine the idea that representations render things exactly as they are.

There are further individual and social factors. All artists have their own personal style that is as distinctive as their

handwriting. The emotional makeup of the artist inevitably leaves its trace.[39] Historical, social, and cultural factors influence what appears realistic. Notoriously, what looks realistic to one age need not look realistic to another, and what looks realistic to westerners need not look realistic to easterners, and vice versa. In short, all representation is influenced by the choice of a method of representation and the choice of a medium. All representation is influenced by the personal characteristics of the artist. All representation is influenced by the society and culture in which the artist is embedded. There is no way to represent things as they really are apart from these influences. Here deviations from reality are not merely permitted; there is no way to avoid them.

The strongest challenge to these claims comes from photography. But that challenge can be met. Photographs do not automatically show how things really are.[40] Suppose that someone stretches out a hand in the conventional "halt" gesture; a photograph taken from the front at an appropriate angle and distance will show the hand as larger than the head even though that is clearly not the actual case. Here the photograph is definitely not showing how things really are. The common retreat is that although a photograph does not necessarily register how things actually are, it renders how things really look. But this is also false. For in the kind of photograph just mentioned, the hand looks bigger than the head, but when we see the situation in life this is not the case, and both are perceived as normal-sized. No doubt the difference results partly from our binocular perception, whereas the camera is a monocular device, and partly from our having extensive contextual spatial data in actual perception that are severely curtailed in

a photograph. In any event, the camera renders it neither exactly as it is nor exactly as it looks. Nor does the matter end there. The choice of film (black-and-white or color), the choice of specific film chemistry, the choice of exposure times, and the choice of paper on which to print the photograph all influence the nature of the final representation. The influence of the medium remains unavoidably present. Photography is no exception to the claim that representations cannot with absolute exactness render what they represent.

The fundamental justification problem here is, "How can art enrich human experience in the sophisticated representation theory?" Why seek representations rather than real things? The reply is both more emphatic and more persuasive: We simply cannot obtain from real things what we obtain from representations. From representations, we grasp how things look to others, but this is not what we obtain from directly observing real things. Representations are more than mere reflections of real things. Representations are always interpretations, and although individual and collective factors vary in importance from representation to representation, they are never entirely absent. Representations cannot avoid carrying traces of the artist's activity.

One of the great liberating potentials of art emerges here. If we eschew art and only experience the world directly, the world is experienced through our own and our culture's habitual and commonplace modes of perception. Only exposure to representations can reveal ways of seeing other than our own or our culture's. To learn about the world, we must consult the world. But to learn how people see the world, we must consult their representations of the world. Art is the great lib-

erator from individual and collective blinders. But this also indirectly enriches our conception of the world. That the world can be seen in many ways is noteworthy independently of its liberating potential.

The benefits derivable in the pure representation theory such as accessibility, portability, and permanence also apply, but these benefits must be understood in a modified way, for representations can no longer be seen as repeating experiences gained from real things. Similarly, the benefits derivable in the augmented representation theory, such as those furnished by simplification, concentration, attenuation, accentuation, and distortion, are also available here but also must be understood in a modified way. The departures produced by such devices are not departures from reality as such but rather departures from reality in relation to specific methods of representation. Given these qualifications, clearly in the sophisticated representation theory, artworks have greatly expanded potential to furnish experiences unobtainable directly from the world.

In the sophisticated representation theory, the art form that offers the widest choice of methods of representation seems the best, at least in the sense of being potentially the most rewarding source of experiences unobtainable directly from the world. Here painting is superior to photography and sculpture. The role of the artist also changes, and the creative involvement of artists increases dramatically. Reality no longer dictates the contents of artworks. Art is no longer a mere mirror image of reality. Artists must select a method of representation and a medium, even if these choices are heavily influenced by the prevailing culture's preferred methods of representation.

Furthermore, the artist's personal vision and style cannot be excluded from the final product, nor can the formative social and cultural influences that shape the character and personality of the artist. Here the inevitable traces of artists' activity in the production of their artworks become even more marked.

The sophisticated representation theory deals better with objections that are serious problems for previous versions of the theory. First, the sophisticated representation theory, like the augmented representation theory, no longer implies that wax fruit, plastic flowers, and full-scale models of battle scenes are inherently better than paintings of fruit, flowers, or battles simply by being more accurate representations. Nor does it imply that photographs are inherently superior to paintings. Representations must differ from the realities they represent, and that they do so cannot by itself be an objection to them.

Second, the theory remains inapplicable to major artworks that are generally regarded as representational. Botticelli's *The Birth of Venus*, Leonardo's *The Last Supper*, and Michelangelo's *The Last Judgment* cannot be representations according to the sophisticated theory. None of these are representations of actual events witnessed by the artist. Far from being representations according to the sophisticated theory, they remain more nearly pure inventions.

Third, the sophisticated representation theory does have some implications concerning criteria of merit. Initially a method of representation must be chosen; within each specific method there are better and worse representations. Here is at least one dimension along which aesthetic merit might be determined, and this criterion emerges naturally from the theory. Also, the theory claims that the artist's personality and

culture inevitably leave their traces in the representation, and it is natural to assume that these traces warrant some consideration in assessing aesthetic merit. Thus there is scope here for a more developed account of aesthetic merit arising from the theory itself.

Fourth, I argued that the augmented representation theory fails to explain why we should be interested in deviations from reality and how such deviations could be positively enriching. How does the sophisticated representation theory answer the question, "Why contemplate art rather than contemplating reality directly?" Partly the answer is the same as for the augmented representation theory; there are rewards obtainable from artworks that are unobtainable from contemplating reality directly. Also, artworks reveal how reality looks to others, and we cannot obtain that by contemplating the world directly. Artworks convey human viewpoints. If we want access to how others see the world, art is the main source. Here artworks must be representational; they must be about the world. Nonrepresentational art cannot reveal how the world looks to others. It may contain its own revelations about people, but it cannot reveal how they see the world. We can now connect representational art in the sophisticated representation theory with a genuine human interest, namely discovering how others see the world. In this way, we can partly escape the isolation of our own subjectivity by access to the subjectivity of others. Furthermore, seeing things in many ways furnishes an enriched conception of things. In considering the augmented representation theory, I emphasized that there, art furnishes new experiences not furnished by the world. The sophisticated repre-

sentation theory goes further by showing how such new experiences can advance vital human concerns. However, there is a further version to consider.

The Unrestricted Representation Theory

The key difference between the pure representation theory, the augmented representation theory, the sophisticated representation theory, and the unrestricted representation theory is that the latter permits everything coherently possible under previous versions of the theory, but it further weakens the connection between representation and reality. Here one is no longer constrained to represent the actual world; merely invented worlds and merely possible worlds become legitimate objects of artistic representation. These possible worlds may be as similar or as dissimilar to the actual world as we please. In the unrestricted representation theory, it is no longer an objection that Botticelli was not present to record *The Birth of Venus,* that Leonardo was not present to record *The Last Supper,* or that Michelangelo was not present to record *The Last Judgment* and that none of them encountered their subjects in real life.

Art can distinctively enrich life only by differing from the world, by furnishing experiences that the world fails to furnish. The more art deviates from the world, the greater its potential for such enrichment. In this light, the unrestricted representation theory opens new possibilities for enrichment that are inconceivable in the pure representation theory. Here are extensive further possibilities for furnishing new experiences unobtainable from the world. Whereas the fundamental justification problem is a major difficulty for the pure representation theory, by the time we reach the unrestricted

representation theory, the problem is either resolved entirely or at least largely attenuated.

Here the superior art form is surely the one that furnishes most freedom. In this view, painting is superior to sculpture, and painting is surely superior to photography. The role of the artist also changes here, and creative involvement by artists again increases dramatically. Artists are even less mere artisans. Artists are expected to contribute positively. Creativity from artists is not just permitted; it is required. Artists are no longer mere slaves to the scenes before them or to mere modifications of them. Nor is this just freedom to choose between different methods of representation and different media. Artists are now free to choose or even invent the content of artworks, unconstrained by the world. Artists are now freed almost completely. The major limiting factor is the imagination of artists. The only other serious limiting factor is that artworks must have a subject matter, real or imaginary.

The unrestricted representation theory deals best of all with objections that are problems for previous versions of the theory. First, the unrestricted representation theory clearly no longer implies that wax fruit, plastic flowers, and full-scale models of battle scenes are inherently better than paintings of fruit, flowers, or battles simply by being more accurate representations. The theory definitely no longer implies that photographs are inherently superior to paintings. Deviations from reality may produce more aesthetic value than slavish adherence to it, as may representations of the entirely unreal. The unrestricted representation theory is obviously better in accommodating such points.

Second, the theory is now clearly applicable to major artworks that are generally regarded as representational, such

as Botticelli's *The Birth of Venus,* Leonardo's *The Last Supper,* and Michelangelo's *The Last Judgment,* but that previous versions of the theory have difficulties with. That these are fruits of the imagination and more nearly pure inventions does not impugn their representational status here; it is enough if they depict a way in which the world could be.

Third, the theory no longer threatens to trivialize art. Here even more emphatically than before, art is a source of experiences unobtainable independently of art, a quality that imbues art with the potential to enrich life distinctively. Once again our access to the subjectivity of others is dramatically expanded.

The sophisticated representation theory is better than both the pure representation theory and the augmented representation theory, for it fits better with our settled pretheoretical judgments about art, but the unrestricted representation theory obviously is the best. Furthermore, it suggests even more strongly that what counts is what is in artworks and not in how artworks relate to something else. In other words, what matters most about artworks is what creative minds contribute to them.

The Ascent of Freedom

The development from the pure representation theory to the augmented theory to the sophisticated theory and finally to the unrestricted theory is a development from the less adequate to the more adequate theory. Whatever the ultimate fate of the representation theory as a comprehensive theory of art, the unrestricted representation theory certainly is a far better theory than the pure representation theory. It is better for the more adequate way in which it handles the data, of which our

pretheoretical patterns of evaluation are an important part, but the progression also reveals a significant underlying trend.

The progression from less adequate to more adequate theory coincides with an increase of freedom in art. With the pure theory, representations simply free us from practical or habitual actions appropriate to the objects represented. This freeing persists in subsequent versions of the theory. The augmented theory reinforces this by freeing us from routine and commonplace modes of perception. The sophisticated theory takes this further by freeing us from our own limited viewpoint and discloses the viewpoints of others. The unrestricted theory takes this even further by freeing us from the world entirely. Two distinct factors drive this increasing freedom. At the first stage, the mere fact that something is a representation frees us from dealing with its contents as if they were real things. But beginning with the augmented representation theory, the content of the representation itself increases the gap between the representation and the real world. As we ascend to the unrestricted representation theory, the content of the representation increasingly distances the representation from the real world. Each step in this freeing progression increases the potential for art to furnish attention-absorbing objects in its own right.

There is a further aspect to this progression. As the freedom from action, perception, and the world increases, so does the positive contribution required from artists. More is demanded from artists under the augmented theory than under the pure theory, and yet more is demanded under the sophisticated theory. With the unrestricted theory, the input required from artists is at its peak. In the sequence of representation theories, the greater the creative content of artworks is, the

greater is the freeing potential of artworks, and the greater the freedom of artists is, the greater is the potential for creative content in artworks. As the creative contribution of artists increases, so does the potential to free and to enlarge and enrich the inner life of art contemplators.

There is now an explanation why representation and representation theories of art are so prominent in the early history of art. The real world is the dominant presence in the lives of ordinary human beings, and the primary and most urgent task in fostering freedom is to diminish its dominance. Representational art plays a crucial role here; it actively loosens the dominance of the real world. Representational art comes first because the real world is the primary and major constraint on human freedom. Representational art does not signify a continuing enslavement to the real world; rather, it signifies a progressive freeing from it. The claim is not that freedom is the self-conscious goal of representational art from its inception but rather that freeing is intrinsic to its nature and constitutes a part of the basis for its appeal because it grounds the possibility of experiences unavailable from the nonart world.

The Challenge of Photography

Surprisingly, one still encounters the argument that the advent of photography spells the end of nonphotographic representational visual art, and the issue warrants consideration.[41] The argument succeeds only if two central assumptions are satisfied. The first is that the pure representation theory is the canonical version of the representation theory, and the second is that photography produces exact representations that undeviatingly capture how things really are. Neither assumption is correct. The pure representation theory ultimately is the

least plausible version of the representation theory, and photography does not produce exact representations that undeviatingly capture how things really are. Photography is simply one method of representation among others, and the claim that it renders things as they really are is unsustainable.

Even if we accept for the sake of argument that photography produces exact representations that undeviatingly capture how things really are, it by no means follows that nonphotographic representational visual art automatically becomes redundant. On the contrary, nonphotographic representational visual art would continue as a potential source of values simply not deliverable by photography. To cite previous examples, Botticelli's *The Birth of Venus,* Leonardo's *The Last Supper,* and Michelangelo's *The Last Judgment* could not be produced by photography. Even if Botticelli, Leonardo, and Michelangelo possessed cameras, the equivalents of their works could not have been produced photographically because they were not present at these events. To reject nonphotographic representational visual art in favor of photography is to reject without warrant some of the finest creations of the human imagination. The camera has no imagination, and insofar as nonphotographic representational visual art embodies imagination, it can never be replaced by the camera. The camera may be tolerable in representing how things are, but it cannot in its fundamental mode of operation represent how things might be.

Failure to capture imaginary worlds is a fundamental deficiency in photography compared with nonphotographic methods of representation in visual art, but it is not the only deficiency. Typically nonphotographic representational visual art is not merely about the world; it also reveals the artist's subjective responses to it. Photography severely limits the pos-

sibility for presenting such subjective responses and thereby drastically attenuates one of the chief drawing powers of representational art. A thought experiment is useful here. Suppose that Joseph Turner, Claude Monet, Caspar David Friedrich, Albert Bierstadt, Katsushika Hokusai, and Russell Drysdale possessed cameras and had restricted themselves entirely to photography. Doubtless we would now have some highly noteworthy photographs. But the loss to visual art in general would be enormous.[42] To a significant extent their appeal lies in encapsulating what cameras cannot capture. Had cameras been available and these artists were each contemplating abandoning painting for the camera, the responsible thing would have been to plead with them to continue painting as well. Such a plea is no less cogent today. The notion that representational visual art contributes no more than is contributed by the camera is a damaging misconstruction of the nature of nonphotographic representational art.

Clarity about the force of these points is important. The argument is not that photography is illegitimate as an art form. The argument is that, in the realm of representational art, photography does not have a supplanting preeminence. The legitimacy of photography as an art form is beyond dispute. However, this is largely because photography does not produce exact representations that undeviatingly capture how things really are. It is precisely because photography, as simply one method of representation among many, permits some subjective and creative input from artists that it qualifies as an interesting art form. That the subjective and creative inputs are necessarily more limited in photography disqualifies it from preeminence among the representational visual arts, but that does not disqualify it from being an important art form. Indeed,

the existence side by side of photography and nonphotographic representational visual art enriches both.

The Representation Theory and Literature

The four forms of the representation theory identified can be applied to literature, where they encounter similar but not necessarily identical problems to those they encounter in visual art. The pure representation theory immediately faces serious difficulties here. Fiction necessarily differs from reality in some way, and this automatically disqualifies the pure representation theory as appropriate for it. However, it is useful to consider in general terms what the representation theory implies for literature.[43] In the theory generically considered, the essential aim of literature is in some sense to tell the truth about the world or some aspect of it. Even at this rudimentary level, familiar problems immediately arise. Why consult literature? Why not consult the world directly for the truths we seek? Or why not consult biology, psychology, sociology, or history for such truths?

Indeed, literature raises a Socratic puzzle that does not exist in the same form for painting or sculpture. If we already know the truth, then why consult literature for it? If we do not already know the truth, then surely literature cannot supply it. Because literary works are not self-validating, they present views about which we must remain agnostic. In this argument, literature can only furnish opinions, it cannot furnish truth; or, more cautiously, we can never justifiably accept what literature presents as true. If the function of literature is to convey truth, then apparently literature is either redundant or incapable of achieving its end. It looks as if something has gone wrong here. The argument appears cogent, but this is

balanced by the conviction of most lovers of literature that at times literature conveys truths about the world, that literature is, at least some times, in some way, about life. To my mind, there is a way of reconciling the skeptical argument and the experience of lovers of literature.

First, note that metaphor and simile are characteristic devices in literature, whereas they are not characteristic devices in the writings of mathematics, physics, chemistry, biology, psychology, sociology, and other sciences. To be sure, the sciences are not metaphor free, but a sound rule in these disciplines is that the fewer the metaphors the better. Science without metaphor is a worthy methodological ideal; literature without metaphor is unthinkable.[44] Initially it is tempting to regard metaphor and simile as aspects of style. Metaphor is ornament or embellishment; metaphor pertains only to manner of presentation. In short, metaphor merely gilds content. However, I defend the opposing view that metaphor is integral to literature's substantive content.

What is the function of metaphor in literature? Its essential function is to present new points of view, to cast things in a different light, to propose novel ways of looking at things. Metaphor is such a pervasive feature of literature just because this is what literature characteristically does. A core function of literature is to present fresh and unfamiliar perspectives. Three ways of looking at things anew in literature are looking at old things in new ways or, put otherwise, looking at the familiar in unfamiliar ways; looking at new things in old ways or, put otherwise, looking at the unfamiliar in familiar ways; and presenting new possibilities for living, thinking, perceiving, feeling, and interacting. Literature is the great liberator from the rut of habitual ways of regarding the world. It frees us from

chains that typically pass unnoticed until they are shed. Here metaphor plays a decisive role. Metaphor challenges established ways of seeing things. Metaphor insinuates new viewpoints. Metaphor expands consciousness. Metaphor is not decoration; metaphor is liberation. Here George Orwell's *Animal Farm* is an extreme but instructive case.

Although metaphor is a key literary device, there are an impressive range of other literary devices whose essential function is to convey new points of view rather than literal truths. Take irony, satire, hyperbole, synecdoche, and even allegory. These are principally devices to induce us to look at things in new ways. In addition, these new ways of looking at things are primarily individual. The author's individual way of looking at things is crucial. Multiple authorship for academic and factual books is common, but few novels or poems have multiple authors. A persuasive explanation is that the display of individual points of view is characteristic of literature and grounds its capacity to engage our interest because we all possess an individual point of view. Seeing things from new points of view that we could not invent ourselves enlarges the ways we conceive of things, frees us from our routine modes of interpretation, and enriches our inner life. Beyond even that, literature increases freedom by revealing alternative ways of living of which we were previously unaware. These surely are some of the chief delights of literature.

Kivy proposes that there is a strong link between literature and truth, but one that differs from my own.[45] For him, literature articulates general hypotheses whose truth readers are left to assess and establish for themselves. In my view literary works are essentially complete in themselves and need no independent assessment or confirmation for what they con-

vey. For if literature conveys individual points of view, then the originators of those points of view have privileged authority on what they are, and no confirmation by a third party is necessary or relevant. That one author sees the world as a testing place for the soul and another sees the world as utterly meaningless conveys genuine information about how the world is seen, with no need for further confirmation. My contention is that presentation of such points of view can be valuable in its own right, without resolving whether the world really is a testing place for the soul or whether the world really is utterly meaningless. Furthermore, I contend that my account deals better with what literature has to offer that direct approaches to the world do not, and with the presence of metaphor, irony, satire, hyperbole, synecdoche, and allegory in literature.

In twentieth-century literature, one of the purest and most intricate examples of seeing things from different points of view is Lawrence Durrell's *The Alexandria Quartet*, which consists of the four novels *Justine, Balthazar, Mountolive,* and *Clea.* Each of these novels deals with essentially the same events, places, and characters; what differs is that these same events, places, and characters are seen from the standpoint of four different people, one in each of the four novels. To develop four different believable points of view on the same sequence of occurrences is an extraordinary feat of the imagination. To my mind, it is brilliantly effective and totally absorbing. Similarly one of the features that lends special fascination to Tolkien's *Lord of the Rings* is that the story is told from the standpoint of several of the participants. To be sure, such displays of multiple points of view are by no means the rule, nor do such cases establish my thesis, but they are worthy of note.

In summary, we obtain from literature what we cannot ob-

tain from direct immersion in life. Typically literature furnishes individuals' perspectives on the world, it furnishes individuals' overall reactions to the world, and we discover how worlds both possible and actual present themselves to particular subjectivities other than our own.[46] We cannot gain that by simply experiencing the world directly. No matter how deeply we immerse ourselves in life, we experience it from only one perspective, from one point of view, namely our own. Even if we indulge in extensive daydreams and personal flights of fancy, it is only from our own point of view; literature delivers the viewpoints of others. All this is very much in line with both the sophisticated and unrestricted representation theories. Here is a way in which literature can be about the world, but not in a way in which we could derive what it offers by approaching the world directly ourselves. Literature is looking at life through the window of a consciousness other than our own.

General Assessment of the Representation Theory

Two questions must be clearly distinguished. First, how good is the representation theory as a comprehensive theory of art? Second, does representation have an ongoing vital role in the arts?[47] There is a powerful case that the representation theory, even in its strongest version, is inadequate as a comprehensive theory of art. There is an equally powerful case for an ongoing vital role for representation in the arts.

Let me begin with the obvious limitations of the representation theory. Despite its initial plausibility regarding painting, sculpture, and even literature, in none of its versions is it plausible for music. Certainly some music has been written with intentions to represent. However, even without probing whether it in any sense succeeds in representation, it is simply im-

plausible that the bulk of music is representational. A natural response is that outright rejection of the representation theory is unnecessary; a mere restriction of its scope to visual art and literature would suffice. But this is not the unproblematic solution that it appears to be. For the solution concedes that there can be rewarding nonrepresentational works in some arts, and this then invites the question why there cannot also be rewarding nonrepresentational works in visual art, and this challenge is hard to meet given the original concession.

The point can be sharpened further. The representation theory cannot accommodate nonrepresentational visual art, whether it be painting, sculpture, or some more recent manifestation. There was a time in the dialectical situation when the representation theory could have been used to reject the claim that nonrepresentational visual art was actually art. That situation is now past, and the representation theory lacks sufficient independent warrant to legitimate such excluding fiats. Art lovers have more confidence in the claim that nonrepresentational visual art really is art than they have confidence in a representation theory that excludes nonrepresentational "art" from the realm of art entirely. The willingness of art lovers to regard nonrepresentational art as genuine art is now simply a datum that theory must accommodate, and the representation theory cannot do so. Thus, the representation theory fails as a comprehensive theory not just because it fails in areas for which it was probably never seriously intended, such as music, but more decisively, it fails as a comprehensive theory for the very areas that are central to it, such as painting and sculpture. Without doubt the representation theory is dead as a comprehensive theory of art.

Where does this leave representation? Must representation

be abandoned as inappropriate to art? Is representation in art essentially dated? To my mind, although all art, and perhaps even much art, need not be representational, abandoning representation entirely or marginalizing it severely cripples the potential of art to yield the values of which it is capable. Fundamentally art must derive its capacity to deliver value to human beings largely from the nature of human beings themselves. One basic feature of human beings is their positive interest in the world around them, and there are doubtless good evolutionary grounds for this. One immediate advantage of representational art over nonrepresentational art is that it engages this prior interest and builds on it. Let me develop this point.

Representations sever the normal connection between perception and action. They free us from the normally appropriate actions or concerns. We do not have to escape from or worry about a representation of a raging bull. This separation is crucial; it means that, without extraneous concerns, our attention can focus fully on the representation itself. This separation both liberates and intensifies our perceptual awareness. Merely being a visual representation already guarantees experiences unobtainable from reality. Furthermore, interest in representations depends essentially on our prior interest in the world, but not in such a way that the world alone could satisfy that interest. Representations generate new perspectives on the world that are unattainable directly from the world.

Although the separation from the normal flux of life that results from merely being a representation is a significant ground for the possibility of more intense and focused experiences, representations can be manipulated to heighten that intensity. For example, a simple pen-and-ink drawing that reveals only

the basic forms of objects may furnish an intensity and purity of response to those forms that is unobtainable from contemplation of the objects themselves because of myriad other visual features that envelop them in the world. Many ways of manipulating representations to furnish experiences unobtainable from contemplation of the objects themselves emerged when examining the augmented representation theory.

A natural question arises here. Why be concerned with representation at all? Why not manipulate the characteristics of artworks directly, independently of any attempt at representation? There is no valid objection to following this path, but there are also good reasons to persist with representation. If we return to the previous example of the simplified pen-and-ink drawing and suppose it to be of the human body, then not only can the experience be intensified in the ways suggested earlier, but the experience is enriched by the natural interest we have in the human body. To abandon representation is to abandon this source of enriching experience. Nor does the capacity for enrichment end there. The very fact that the artist, too, finds the human body of absorbing interest, aspects of which the artist feels are worth drawing special attention to, has the potential to reinforce and increase our own interest in the human body and, if the artist is a good one, enriches our conception of it. Here are several ways in which representation can enrich experience that are simply unavailable to non-representational art.

But this still fails to capture fully the contribution that representation can make. If the account of representation embodied in the sophisticated and unrestricted representation theories is correct, as it appears to be, then art yields a wholly new kind of value that is unobtainable directly from the world. The

essential point is that artistic representations never show how things really are in themselves but only how they appear to someone or some group, and this is not something we can gain by multiplying our own direct perceptions of the world. Representational art produces a hybrid entity with one foot in the subjective and the other foot in the objective. Representational art simultaneously shows us something about the world and shows us something about how others perceive the world.

Representational art exploits a double interest: It not only exploits our natural interest in the world but also exploits our natural interest in other people. Representational art enriches our conception of the world, but it also enriches our conception of other people. That the world can be seen in a variety of ways different from our own enlarges our conception of the world. That people can see the world in a variety of ways different from our own enlarges our conception of human beings. Here art furnishes unique access to the subjectivity of others. In this way, representational art, by exploiting a preexisting interest in the world and other people, enhances our conception of both. Naturally, nonrepresentational art forgoes the opportunity to enlarge our conceptions in this integrated way. In his mature views, Nietzsche regarded art as a stimulus to life, as being uniquely placed to enrich our conception of life and increase enthusiasm for it.[48] My account of representational art shows one way to uphold such a view. As long as the world still interests us, and as long as the points of view of others on that world still interest us, there will be a vital place for representational art.

Although these benefits from representational art are important, they are not the totality of representational art. It is vital that representations have a drawing power of their own, that

they capture and hold our attention and reward contemplation in their own right. Without this intrinsic drawing power, representations would have little capacity to elevate us above the ordinary flux of life, and even their capacity to enrich our conception of the world and our conception of human beings would be significantly impaired. But here an analytical impasse confronts us. It is not hard to say when a fine pen-and-ink drawing of the human body has an intrinsic power to attract, but it is impossible to separate how much of what makes it interesting and rewarding to contemplate rests on our prior interest in human bodies and our prior interest in how others see human bodies and how much rests on features intrinsic to the representation itself. Aside from whether such factors are either introspectively or analytically separable, the multiplicity of such factors indicates the possibility of a depth, richness, and complexity in our experience of representational art that simply cannot exist in nonrepresentational art. To voluntarily renounce the opportunities that this presents is impoverishing and pointless self-denial.

Expression

Expression has played an important role in thought about the arts, and it, too, has furnished one of its most influential theories. The expression theory of art attained substantial influence despite emerging much later than the representation theory. Partly the expression theory prospered through accumulating awareness of limitations in the representation theory, particularly in its cruder forms. But like the representation theory, the expression theory is no longer viable as a comprehensive theory of art. Nevertheless, the expression theory also grounds important insights that still warrant attention. Here, too, I will argue that whatever else art may do, it will always contain ample room for expression. According to the expression theory, the essential function of an artwork, whether it is a painting, a poem, a piece of music, a sculpture, or a play, is to express and evoke emotions felt by the artist. In its

basic form, the theory also embodies an apparently straight-forward criterion of aesthetic merit. The more closely artworks express and evoke what artists feel, the better they are as art-works.

Like the representation theory, the expression theory has natural appeal, especially in relation to music. There are other strong parallels. Just as many people spontaneously admire what they regard as realistic representations, many people instinctively admire highly expressive works, and the more expressive the works the more they admire them. The expression theory was the second of the major theories of art to obtain widespread support, and although its natural appeal facilitated its embrace, the limitations of the representation theory and the rise of certain cultural and technological developments also played a significant role in its emergence.

Let me mention two factors. First, there is the modern growth of science and technology. With the advance of science and technology, particularly in the eighteenth and nineteenth centuries, a pervasive conception gradually arose that science has no rival in dealing with the real world. Given that science attains unsurpassably accurate and objective accounts of the world, there is little point in art simply producing further representations that could have nothing to add to what science produces. Another significant aspect of this growth of science is the demystification and deromanticization of nature, which renders nature less appealing as an art subject. But if the role of art is not to deal objectively with the world, then seemingly its proper role is to deal with the subjective element in life. Put otherwise, the more it emerged that science deals effectively with the outer world and is hard to rival in that sphere, the more it seemed that the place for art must be in dealing with

the inner world of feeling. The expression theory assigns this very role to art.

Second, there was the development of photography. In visual art, the invention of the camera dramatically accelerated the trend toward assigning exploration of the inner world to art. With the development of photography from its beginnings in the mid-nineteenth century, the conception of photography to emerge was that photographs are as accurate representations of reality as can be attained. Painters can approximate the accuracy of the camera, in rare cases they might equal it, but on no account could they exceed it. This situation impelled painters to reassess their aims. Increasingly they reassessed their task as concerning the inner element in life as opposed to the supposedly objective aspects captured by the camera.[1] Thus, both general cultural trends and specific technological developments weakened the notion that the only function of art is to represent the world and made it more plausible that the function of art relates essentially to the inner world.[2] Certainly these pressures to reassess were strongest in visual art, but typically reassessment in one area provokes reassessment in others. In any event, the expression theory has been historically the second most influential theory of art.

Let me focus directly on the expression theory. A key underlying assumption is that emotions are valuable and that it is valuable to contemplate their expression in artworks. This assumption generates a parallel question to the one raised for the representation theory: What gain in value accrues from contemplating expressions of emotion in artworks over experiencing emotions directly? Surely it is better to be happy than to read about it in literary works. Surely it is better to fall in love than to observe it on stage. The problem is that whatever

the value is in contemplating expressions of emotion in artworks, surely more of that value is derivable from experiencing those emotions directly. If we consider the intensity, richness, and completeness of experience, then seemingly real emotions furnish them more fully than mere expressions of them in artworks.

I call this the fundamental justification problem for the expression theory. The expression theory must explain why we should seek artworks rather than seeking direct experiences of emotions in life. Why read love poetry when you can feel love? Why listen to an ode to joy when you can seek joy directly? Why contemplate expressions of sorrow in artworks when life inevitably furnishes copious amounts of the real thing? Put dramatically, why seek art at all? Why not simply plunge more deeply into life? Let me proceed immediately to this issue and begin with the simplest and clearest version of the expression theory.

The Pure Expression Theory

Here the function of art is to express and evoke some emotion as accurately and completely as possible. The theory embodies a strong criterion of aesthetic merit. The more an artwork embodies and evokes an emotion, the better it is as an artwork. Anything added, anything deleted, anything altered, any failure to embody or evoke is a defect. The theory is most persuasive when applied to music, but it also applies naturally to visual art, literature, drama, and dance.[3] I will initially assume that its application is intended to be general. The most famous proponent of the theory is the great Russian novelist Leo Tolstoy, but his acceptance of the theory is complicated by his additional contention that art should express specifically the

emotions of ordinary people and that art should carry strong and simple moral messages.[4] Nevertheless, the core conception is that art must transmit exactly emotions felt by the artist.

In the pure expression theory, which is the highest art form? Accepting that emotions are expressible in many embodiments, that music, visual artworks, human gestures, words, and so on can all express emotion, common experience indicates that music has the edge in expressive power. Whereas music appears resistant to representation, it appears receptive to expression.[5] However, not all music is equal in expressive power. Arguably opera greatly exaggerates the emotions of life and therefore is not as good an art form as one not prone to such exaggeration. The theory also carries strong implications about the role of the artist. Here again, although artisanship is important in accurately rendering artists' feelings, artists are no longer mere artisans, as they are on the pure representation theory. Artists and their emotions become central. Artists have to be human beings who genuinely feel things. This implies that the greater the sensitivity, the greater the capacity for feeling in artists, the greater their potential is for producing worthwhile art.

Let me cite the benefits that accrue from art in this simple version of the theory and constitute such resolution of the fundamental justification problem as the theory can offer. Naturally there are strong parallels to the benefits flowing from the pure representation theory, given the strong parallels between the theories themselves.

ACCESSIBILITY We cannot feel directly the emotions of those who were on the *Titanic* when it sunk. It is too expensive or too dangerous to reproduce the actual circumstances

for everyone who wants to feel such emotions. Artworks are the only practical mode of access to such emotions. The point applies equally to what it feels like to be in earthquakes, floods, forest fires, cyclones, wars, and so on. Typically we would rather not experience directly what it feels like to be condemned to death and executed or to have a terminal illness, but it may be valuable to have such experiences mediated by art. In these cases, art does not create new kinds of experiences that are unavailable from immersing oneself directly in life. But here art still has a significant capacity to enrich emotional life by furnishing access to emotional experiences that are difficult to obtain directly from life. Arguably we would also be better off feeling some emotions through artworks rather than directly because feeling some emotions directly could be too damaging psychologically.

PORTABILITY We cannot carry a war around, but we can carry evocative pictures of battles or novels that evoke some of the emotions of war. If such emotions are rewarding, then with exact expressions of them in artworks we can have those rewarding experiences wherever we go. Here again, the often greater portability of artworks expressing emotions cannot furnish new rewarding experiences otherwise unobtainable in the world, but it can increase the proportion of rewarding emotional experiences to nonrewarding ones.

PERMANENCE Events inevitably cease. To have the emotions felt on special occasions such as weddings objectified in art furnishes continued access to those emotions even when the occasion is long past. Here is another answer to the question, "Why contemplate expressions of emotion in artworks rather than feeling emotions directly in life?" Because of the

passage of time, the real emotion may no longer be available. Expressive artworks can preserve emotions even when their originating occasions have ceased. The greater permanence of expressive artworks cannot furnish new rewarding emotional experiences, but it can preserve the sources of rewarding emotional experiences and enrich them with layers of recollection, thereby again increasing the proportion of rewarding emotional experiences to nonrewarding ones.

PLEASURE IN REPRESENTATIONS OF EMOTION Suppose we accept with Aristotle that we take pleasure in representations just because they are representations. Some artworks are expressive of emotions simply by being representations of human beings engaging in natural expressions of emotion such as laughing, smiling, crying, frowning, writhing, and grimacing.[6] Whatever pleasures ensue merely from being representations naturally also ensue from such expressive art. This pleasure certainly adds to human experience; we would lack this pleasure without representations. Indeed, we may take greater pleasure in representations of emotion than in more neutral kinds of representation. But, as previously noted, we could hardly regard this addition as one of major significance. If this were the only genuinely new value or new experience flowing from expressive art, it would not be much.

SEVERANCE FROM ACTION Expressive artworks sever the ordinary or routine nexus between emotion and action that obtains in life. Expressive artworks free us from practical involvement and release us for unrestricted and concentrated contemplation of the artworks themselves. If we encounter dangerous, fear-generating situations in life, to focus our total attention on our emotions is to imperil survival. The

severance of emotion from action in art enhances the prospects of a clarified and intensified awareness of emotion.

Let me summarize the benefits of art in the pure expression theory. The greater practical accessibility, portability, and permanence of artworks expressing emotions compared with the life situations in which they occur increases emotional richness. Even when the original sources of rewarding emotional experiences are absent, those rewarding experiences remain available through artworks, and those experiences can be enriched by layers of remembered repetition. Furthermore, the severance of the nexus between emotion and action in art allows total attention to focus on the emotion expressed. If the contemplation of emotion is valuable, here is broad scope for that value to be enhanced by undisturbed contemplation. Even in the pure expression theory, art has a significant capacity to increase value, but notably it fails to produce any essentially new experiences or new values. Here expression multiplies old values; it does not create new ones. In short, the benefits of pure expression are largely analogous to the benefits of pure representation.

Irrespective of its potential benefits, the theory faces formidable difficulties. First, the pure expression theory implies that direct tear-jerker music, crude horror stories that frighten us witless, and flashy plays that provoke immediate jollity automatically constitute excellent artworks because they effortlessly evoke immediately recognizable emotions. But the very ease with which works evoke emotion often is a sign of their superficiality, triteness, or sentimentality, and such works are routinely condemned as furnishing cheap emotions or cheap thrills. The ease with which common emotions are evoked

does not correlate positively with what is typically regarded as good art.

Second, there are problems in applying the theory to major kinds of complex extended artworks.[7] What and whose emotions does Tolstoy's *War and Peace* express? Surely Tolstoy cannot have felt directly all the emotions expressed by characters in his novel. For one, it is inconceivable that he could have experienced directly all the emotions felt by his female characters. What and whose emotions does Shakespeare's *Othello* express? We can say that *Othello* is about jealousy, we can say that characters in it such as Othello express jealousy, but does the play itself express jealousy? Does it express Shakespeare's jealousy? Surely Shakespeare did not have to experience such jealousy directly. Characters in these works express emotions, but this is quite compatible with a representational account of the artwork and in no way lends sense to the idea that the artwork itself – as opposed to characters in it – expresses emotion. The pure expression theory encounters genuine problems of intelligibility when applied to such complex extended artworks.[8]

Third, analogously to the pure representation theory, the pure expression theory threatens to trivialize art. It implies that whatever we obtain from art we could obtain just as well from direct immersion in life. Surely we want more from art if that is possible. Equally surely, art lovers are largely convinced that they obtain more.

Fourth, superficially the pure expression theory embodies a straightforward criterion of aesthetic merit analogous to the pure representation theory: The more closely artworks express and evoke what artists feel, the better they are as artworks. But the similarity is deceptive, and the criterion is far

more problematic in the pure expression theory. The problem is that it precludes ever determining whether an artwork is good. This arises from our lack of independent access to the artist's emotions. When an artist produces a representation of a tree, we can independently inspect the tree and the representation of the tree and assess how good the representation is. However when an artist expresses an emotion in a painting, we cannot independently inspect the emotion and the expression of the emotion in the painting to assess how accurate the expression of that emotion is.

Here the pure expression theory is less adequate than the pure representation theory, and the underlying point generates an objection to the pure expression theory that cannot analogously be generated against the pure representation theory. The argument proceeds as follows. We can sometimes tell that something is a good artwork. If the pure expression theory were correct, we could, in principle, never tell that something is a good artwork because we could never compare the artist's actual emotion with its expression in the artwork; therefore, the pure expression theory must be wrong. In short, the pure expression theory faces serious problems – surprisingly, some problems more serious than those faced by the pure representation theory. However, the pure expression theory is not the only expression theory, so I advance to the next version.

The Augmented Expression Theory

The key difference between the pure expression theory and the augmented expression theory is that the latter permits deliberate deviations from emotions experienced directly in life on aesthetic grounds. It permits such procedures as the intensifi-

cation, purification, and simplification of emotions felt in life. This is a useful point at which to recall a crucial principle. It is only by differing from emotions felt directly in life; it is only by supplying emotional experiences that life fails to supply that art can significantly enrich life. The closer art adheres to emotions felt in life, the lesser its capacity to enrich life emotionally. If this principle is sound, then the augmented theory is immediately more promising than the pure theory.

There are numerous ways to deliberately deviate from life to produce expressions of emotion in art that furnish rewards unobtainable from direct experience of those emotions.

Selection: Emotions can be selected from complex contexts and focussed on with an exclusivity impossible in life. In Goya's *The Third of May, 1808*, the focus is entirely on the emotions of the insurgents and not on their oppressors. This selective focus intensifies the emotions of the insurgents, an intensity that would indubitably diminish if we were simultaneously compelled to attend to the emotions of the firing squad.

Composition: The juxtaposition of Othello's blind jealousy with Desdemona's innocent trust and Iago's self-conscious malice in Shakespeare's *Othello* creates a dynamic structure that highlights each characteristic in a way that would be significantly diminished if any one of these elements were removed.

Simplification: Human emotions such as love, hate, and jealousy often are exceedingly complex, and their simplification in artworks may be rewarding and may even facilitate the recognition of facets that we often miss or only dimly apprehend.

Concentration: A number of emotions are combinable in art in ways that they are not combined in life. Let me construct an extreme case. You are on a small boat and have your life savings with you. An enraged grizzly bear is approaching from one side; a maniac carrying a syringe with AIDS-contaminated blood is coming from the other direction, intent on jabbing you; the deck is writhing with snakes, and spiders have already crawled over your body; the boat is burning and will shortly plunge over the edge of an immense waterfall unless stopped; someone is circling above in a plane trying to bomb the boat; and some villain on the boat is torturing your beloved. Just as in the Alberti case in representational art, where the most beautiful parts from different people are combined in a single representation, the most acute fears from different situations are combined in a single expressive artwork with prospects of delivering emotional experiences that life cannot offer.

Attenuation: Emotions can be toned down in a variety of ways such as moderating the natural expressions of emotion in visual artworks, dramas, or even literature.

Accentuation: Emotions can be intensified, yielding sadder sorrows and jollier joys than those typically experienced in life. Opera relies extensively on this resource.

Distortion: Emotions can be distorted by changing their proportions such that momentous events produce minute emotions, and minute events produce mountainous emotions.

Change of scale: There can be uniform changes of scale, with all emotions being larger than life or all being smaller than life.

These various devices furnish new emotional experiences unobtainable from the world; therefore, they are devices by which art can genuinely enrich emotional experience. Recourse to these devices inevitably leaves traces of the creative activity of artists in their artworks.

Given the augmented expression theory, which is the highest art form? In considering the pure expression theory, I noted that common experience accords music the edge in expressive power compared with visual art and literature. But whereas opera cannot plausibly rank as the superior musical form in the pure expression theory, the situation changes with the augmented expression theory. Whereas deviating from the emotions of life is a defect in the pure expression theory, it can be a positive feature in the augmented expression theory. If we accept that opera has the greatest capacity to deliver emotional experiences unattainable in life, we have a case that in the augmented expression theory, opera is the highest art form. The theory also has implications about the role of the artist. Here again, artists are no mere artisans. The feelings of artists as human beings matter, and creativity from artists is allowed and expected. Artists make their own special contributions. Furthermore, artists are no longer mere slaves to their emotions, expected simply to transmit them accurately. Artists can actively reflect on real emotions and produce emotional effects that go beyond them, thus leaving in artworks traces not only of actual emotions but also of the operations of creative minds.

The augmented expression theory deals better with objections than the previous version, but it still faces formidable difficulties. First, the augmented expression theory seems not to imply quite as clearly that direct tear-jerker music, crude

horror stories that frighten us witless, and flashy plays that provoke immediate jollity automatically constitute excellent artworks. It is hard to see what would rule them out as constituting excellent artworks, but the augmented theory allows that deviations from emotions felt directly in the world may produce more aesthetic value than the facile transmission of such emotions, so the mere transmission of such emotions cannot be sufficient for excellence in art. The augmented expression theory appears better here than the pure expression theory, at least insofar as the counterexamples are less clear-cut.

Second, problems remain in applying the theory to major kinds of complex extended artworks. What and whose emotions does Melville's *Moby-Dick* express? Did Melville experience all the emotions expressed by his characters? Are Melville's own emotions expressed in the novel separately from the emotions expressed by his characters? What and whose emotions does Shakespeare's *Macbeth* express? We can say that *Macbeth* is about ambition, but does it express ambition? We have already noted that although characters in such works express emotions, attributing the expression of emotion to the artworks themselves is problematic. Nevertheless, suppose that we concede the intelligibility of saying that *Macbeth* expresses ambition; it is no longer an objection that Shakespeare himself may not have experienced just such an ambition. Provided that Shakespeare felt any kind of ambition, the augmented expression theory permits, for aesthetic effect, extensive modification in what he actually felt. By weakening the connection between emotions felt by artists and their expression in artworks, this version of the theory is less prone to this objection, which is devastating for the pure expression theory.

Third, the theory no longer threatens to trivialize art to the

same degree. Here art is a source of emotional experiences unobtainable independently of art and hence imbues art with a significant potential to enrich emotional life.

Fourth, at this level of articulation, the theory fails to answer adequately what the permitted deviations from emotions felt directly in life are. The augmented expression theory cannot have the same criterion of aesthetic merit that the pure expression theory has, but it is hard to see what replacement criterion could flow naturally from the theory.

Fifth, the theory fails to explain why we should be interested in deviations from emotions experienced directly in life and how such deviations could be positively enriching. We cannot simply say that here art furnishes one way of learning about the emotions of others because that is forfeited by permitting deviations from actually felt emotions. Obviously if there are deviations from emotions experienced directly in life, then artworks furnish emotional experiences that reality cannot, but those could just as easily be undesirable emotional experiences. The theory would be better if it could connect positively deviations from emotions experienced directly in life and some intelligible human good.

Overall the augmented expression theory is a better theory than the pure expression theory, for it fits better with our settled pretheoretical judgments about art. The superiority of the augmented expression theory compared with the pure expression theory points firmly in the direction that what matters about art is what is specifically in artworks and not how tightly artworks relate to something external to them such as the real emotions of artists. But the two versions of the expression theory considered so far share a common assumption. The assumption is that the idea of the exact transmission of emotion

is coherent and that the exact transmission of emotion is possible. The pure expression theory requires exact transmission; the augmented expression theory presupposes its possibility but permits deviations on aesthetic grounds. The third form of the expression theory challenges this fundamental assumption.

The Sophisticated Expression Theory

The key difference between the pure expression theory and augmented expression theory on one hand and the sophisticated expression theory on the other is that the latter denies the possibility or even intelligibility of the idea of an exact transmission of emotion. The core claim is that in art emotions are transformed rather than transmitted.[9] At issue is the nature of emotion itself, and the dispute turns on two different conceptions of emotion. First, there is the *definite conception* of emotion, which fits the *transmission model* of the expression of emotion and lies at the basis of both the pure and augmented expression theories. Second, there is the *indefinite conception* of emotion, which fits the *transformation model* of the expression of emotion and lies at the basis of both the sophisticated and unrestricted expression theories.

Let me consider these two conceptions of emotion and what they imply for its expression in art. First, there is the definite conception of emotion. In this view, the emotions are definite, complete, simple, unambiguous, and typically introspectively clear. Here they are likened to simple sensations such as the sweet taste of sugar, the taste of salt, the sensation of cold when you put your hand in cold water, and the awareness of red when you have a red afterimage. A key point about sensations is that successful communication leaves them unchanged. If you communicate a taste sensation, you leave the sensation

unchanged by expressing it, and the ideal is for the other person to experience exactly what you experience. This fits well with the transmission model of emotional expression. If you want others to know what salt tastes like, you give them some salt. If you want others to know what grief feels like, you give them an artwork expressing grief. Just as a recipient of the salt tastes what you tasted, so a contemplator of an artwork expressing grief feels what the artist felt. In one case, we have the same sensation of saltiness; in the other case, we have the same emotion of grief.

The clarity of this conception of emotion is not matched by its fidelity to the phenomena. It misses a key difference between emotion and sensation. Emotions typically refer beyond themselves; sensations typically do not. The grief over the death of a friend contains an essential reference to that friend. The sensation of cold when I plunge my hand into snow does not refer to anything beyond itself. This point bears directly on the possibility of the exact transmission of emotion. When I am grieving over the loss of an intimate friend of thirty years, how do I transfer the intentional object of my grief to the person to whom I am seeking to communicate the grief? There appear to be only two alternatives. Either it is simply impossible for my departed friend to become the intentional object of another person's grief when I am seeking to communicate my grief to him or her, or if my departed friend actually becomes the intentional object of the other person's emotion, it is utterly implausible that they could feel what I feel, particularly if he or she was unacquainted with my departed friend. Departed friends cannot be passed around to generate grief in the same way salt can be passed around to generate sensations of saltiness. The point applies even more forcefully to artworks.

Second, there is the indefinite conception of emotion. In this view, the emotions are indefinite, incomplete, complex, amorphous, and typically introspectively unclear. The emotions are indefinite internal disturbances that neither clearly nor exhaustively reveal themselves to direct awareness. Rather, these internal disturbances are influenced by context and manner of expression. If you are angry at someone, then verbally berating the person partly shapes the anger and lends it a certain tone or form. If you kick the person instead, this also partly shapes the anger but lends it a different tone or form. The emotion is crystallized, clarified, and made more specific through the way in which it is expressed. In other words, expression of emotion is a formative factor in emotion. Different external expressions of the same indefinite internal disturbance generate different overall emotions. Applying this to art, expressions of emotion in artworks shape, form, and define those emotions. The very act of artistic expression affects the emotion. Expression is not transmission; it is transformation; it is making the indeterminate determinate. In short, expression molds emotion.[10]

This conception accommodates the point that emotions typically have intentional objects and has a story to tell about their role in the communication of emotion. Let us accept that when I am seeking to communicate my grief at the loss of an old friend to another person, that old friend does not actually become the intentional object of his or her feeling state. But when I am seeking to communicate my grief to another person, I am not simply seeking to induce a feeling state. I am seeking to communicate what it feels like to lose someone close. Intentional content is essential to what I am seeking to communicate. But if my actual departed friend does not become the intentional object of the other person's feeling state, then what

does? The answer is a *possible friend*. Although my emotion has an actual person as its intentional object, the person to whom I have communicated my emotion has a possible person as its intentional object. This fits well with how we usually conceive the matter. When I am seeking to communicate my grief, I do not literally want others to grieve at the loss of the same person whom I am grieving over. Rather, I want them to feel what it is like to lose a close friend. A possible person is just the right kind of thing to be the intentional object of their feeling state. In short, such communication of emotion creates a new intentional content for the communicated feeling state.

One important implication of the indefinite conception of emotion and its expression is that we cannot feel the exact emotion expressed in an artwork independently of that artwork, for that particular expression is essential to that specific emotion. We simply cannot experience the emotions expressed in Beethoven's *Ninth Symphony* independently of the symphony. The expressive form and the emotional content are essentially and not merely accidentally linked. In this view, artists create new ways of feeling that do not exist independently of their artworks. The sophisticated expression theory needs and embraces the indefinite conception of emotion. It accepts that the simple transmission of emotions is impossible. It accepts that all artistic expressions of emotion are transformations of emotion.

Let me consider how this affects the fundamental justification problem. Why seek art rather than seeking emotion directly? First, art always provides emotional experiences unobtainable from ordinary life. Art is no longer an inferior substitute for direct experiences of emotion. Art always supplies something different from what we experience directly in life; in do-

ing so, art enriches emotional life. Second, if emotions are indefinite, incomplete, complex, amorphous, and unclear internal states, then seeing what shape, tone, or character has been impressed on them in artworks, seeing how these states have been clarified through their expressions in artworks, enables us to shape, clarify, or see our own emotions in a different light. For example, if we are grieving, we are doubtless in a miserable state that we would rather not be in. If we hear grief expressed in a moving choral work – a requiem mass, perhaps – we may be led to confer on our indefinite, amorphous, unclear, and unpleasant internal state a shape, tone, and character that lend it dignity, nobility, and depth. It may change both what we actually feel and how we feel about what we feel. Thus, artworks not only supply additional emotional experiences unobtainable from ordinary life; artworks also change our feelings outside art.

Why seek art rather than going directly to life? The answer now is that whereas life will unfailingly elicit more of our routine and habitual emotional responses, art discloses new ways of feeling. It is useful to consider the two major points together. Art both adds new emotional experiences lacking in life and underpins a more enriching direct emotional experience of life. This parallels the sophisticated representation theory in which art both adds new visual experiences and underpins a more enriching direct visual experience of the world.

In the sophisticated expression theory, arguably the art form that offers the widest choice of means of expression is the best, promising more rewarding experiences unobtainable directly from life. The one art form that combines the means of ex-

pression available to music, painting, literature, dance, and drama is opera. Opera's expressive potential seems preeminent, and this grounds a claim to superior status as an art form. Note that the transition from the pure expression theory to the sophisticated expression theory has such an impact as to shift opera from being one of the lowest art forms to being one of the highest. There are also implications about the role of the artist. Artists are no longer mere artisans. Artists now make further positive contributions. Again the feelings of artists as human beings matter, and even more creativity from artists is allowed and expected in the way artists lend form and character to their emotions. As well as shaping their own emotions, artists also shape the emotions of art audiences and furnish emotional experiences unobtainable elsewhere. Artists now extend the range of human emotional experience. Here the traces of the creative activity of artists in artworks are even more marked.

The sophisticated expression theory deals better with objections that are serious problems for previous versions of the theory. First, the sophisticated expression theory no longer implies that direct tear-jerker music, crude horror stories that frighten us witless, or flashy plays that provoke immediate jollity automatically constitute excellent artworks. Although in the sophisticated theory, the unadulterated transmission of emotion is impossible, the degree to which emotions are transformed varies. Substantial transformations of emotions felt directly in the world may produce more aesthetic value than minimal transformations. Indeed, the further expressions of emotion in artworks are from normal life, the more potential artworks have for emotional enrichment, but concomitantly

more effort may be needed to extract that value. The sophisticated expression theory clearly fits our pretheoretical aesthetic judgments better than previous versions of the theory.

Second, problems remain in applying the theory to major kinds of complex extended artwork. What and whose emotions does Dostoyevsky's *The Brothers Karamazov* express? Characters in such works may well express emotions, but the attribution of the expression of emotion to the artwork itself remains problematic. However, refinement of the concept of expression in this version of the theory partly blunts the force of this objection.

Third, the theory no longer threatens to trivialize art. Here art is a source of emotional experiences unobtainable independently of art; art also reveals how others feel by means for which there are no equivalent substitutes. Furthermore, it allows art to alter our experience of life itself and hence imbues art with the potential genuinely to enrich life both by the contemplation of art and by what it leads to outside art. The theory clearly connects the expression of emotion in art, emotion experienced directly in life, and human good.

The sophisticated expression theory is better than the pure expression theory or the augmented expression theory, for it fits better with our settled pretheoretical judgments about art. But like the augmented expression theory, it points strongly in the direction that what matters about art is what is in artworks, not how tightly artworks relate to something else. However, there is a further version of the expression theory to consider.

The Unrestricted Expression Theory

The key difference between the pure expression theory, the augmented expression theory, the sophisticated expression

theory, and the unrestricted expression theory is that the latter permits everything coherently possible under previous versions of the theory, but it further weakens the connection between the expressive characteristics of artworks and the emotions of life. Artists need not directly experience the emotions displayed in their artworks; indeed, no one need have experienced them. Here artists no longer need to express only the emotions of life; merely imagined emotions and merely possible emotions become legitimate objects of artistic expression. These possible emotions may be as similar or as dissimilar to those experienced in life as we please. Given the unrestricted expression theory, it is no longer an objection that Shakespeare did not experience a jealousy as intense and as blind as Othello's or an ambition as driven as Lady Macbeth's. The theory explicitly permits recourse to emotional imagination; it explicitly permits pure invention in relation to emotion. This looks like the appropriate theory for abstract expressionism and for some ventures in music in the twentieth century.

Expressive art can distinctively enrich life only by furnishing emotional experiences that life lacks. In this light, the unrestricted expression theory opens new possibilities for emotional enrichment that are inconceivable in the pure expression theory and are limited in intermediate versions of the expression theory. These expanded possibilities for new emotional experiences unobtainable from life enlarge the ways by which art can genuinely enrich emotional experience. Whereas the fundamental justification problem is a major difficulty for the pure expression theory, by the time we reach the unrestricted expression theory, the problem is either resolved entirely or at least largely attenuated.

In the unrestricted expression theory, it seems even more

clear that opera is the superior art form. The expressive potential of opera seems preeminent, and opera is unfettered by inherent pressures toward realism, emotional or otherwise. The role of the artist again changes, and the creative involvement of artists increases dramatically. Artists are no longer mere artisans. Artists make positive contributions. Emotional creativity from artists is not merely allowed but is expected. Artists are no longer mere slaves to their emotions or to the emotions of ordinary life. Artists are now free to choose the emotional content of artworks, unconstrained by life. Artists are now even more completely free than under the unrestricted representation theory. Neither the outer world nor the given inner world dictates the contents of artworks. The major limiting factor is the emotional imagination of artists. The only other serious limiting factor is that artworks must have an emotional content, real or imaginary.

The unrestricted expression theory deals best of all with objections that are problems for previous versions of the theory. First, the unrestricted expression theory no longer implies that direct tear-jerker music, crude horror stories that frighten us witless, or flashy plays that provoke immediate jollity automatically constitute excellent artworks. Effortlessly evoking some common emotion is no longer the point. Deviations from and transformations of emotions felt directly in life and merely imagined emotions can produce more aesthetic value than facile evocations of common emotions. The unrestricted expression theory obviously is better in accommodating this point.

Second, problems remain in applying the theory to major kinds of complex extended artwork. What and whose emo-

tions does Musil's *The Man without Qualities* express? We can say that *Romeo and Juliet* is about young love, but does it express young love? Again, characters in these works express emotions, but the attribution of the expression of emotion to the artwork itself remains problematic. But arguably with the loosening of the notion of expression here the objection is less acute than for previous versions of the theory.

Third, the theory no longer threatens to trivialize art. Here art is a source of emotional experiences unobtainable independently of art. In addition, art intimates how others feel even more fully than is possible in the previous versions of the theory by yielding access to the emotional imagination of others as well as to their actual emotions. Here again art reveals how others feel, by means for which there are no equivalent substitutes. Whatever we learn about how people feel from sources other than art, those sources cannot reveal what art reveals about their feelings. Furthermore, art can change how we feel when we confront the world. The theory clearly connects the expression of emotion in art, emotion experienced directly in life, and human good.

The sophisticated expression theory is better than the pure expression theory and the augmented expression theory, but the unrestricted expression theory is obviously the best, for it fits better with our settled pretheoretical judgments about art. Furthermore, it suggests even more firmly that what matters about art is what is in artworks, not how tightly artworks relate to something else. As the versions of the expression theory improve, so the emphasis on the actual content of artworks increases as opposed to what lies outside them, but naturally, no version of the expression theory severs that link entirely.

The Ascent of Freedom

The development from the pure expression theory to the augmented theory to the sophisticated theory and finally to the unrestricted theory is a development from the less adequate to the more adequate theory. Whatever the ultimate fate of the expression theory as a comprehensive theory of art, the unrestricted expression theory is certainly a far better theory than the pure expression theory. It is better for the more adequate way in which it handles the data, of which our pretheoretical patterns of evaluation are an important part, but the progression also reveals an underlying trend worth noting.

The progression from less adequate to more adequate theory again coincides with an increase of freedom in art. With the pure theory, expression in art simply frees us from practical or habitual actions appropriate to the ordinary emotions of life. This freeing persists in subsequent versions of the theory. The augmented theory reinforces this by freeing us from commonplace emotions themselves by such means as intensification, simplification, and purification. The sophisticated theory takes this further by freeing us from our own limited emotional viewpoint and discloses the emotions of others. The unrestricted theory takes this even further by freeing us from the emotions of life entirely. Again, two distinct factors drive this increasing freedom. At the first stage, the mere fact that something is an expressive artwork frees us from dealing with its contents as if they were the emotions of life. But beginning with the augmented expression theory, the content of expressive artworks themselves increases the gap between artworks and the emotions of life. As we ascend to the unrestricted expression theory, the content of expressive artworks increas-

ingly distances these artworks from the emotions of life. Each step in this freeing progression increases the potential for art to furnish new attention-absorbing objects in its own right.

There is a further aspect to this progression. As the freedom from action and the emotions of life increases, so does the positive contribution expected from artists. More is demanded from artists under the augmented theory than under the pure theory, and yet more is demanded under the sophisticated theory. With the unrestricted theory, the input expected from artists is at its peak. In the sequence of expression theories, the greater the emotionally imaginative content of artworks is, the greater is the potential of artworks to free, and the greater the freedom of artists is, the greater is the potential for emotionally imaginative content in artworks. But the more artists infuse artworks with what is not independently available in the emotional experiences of life, the harder it may be for art audiences to absorb immediately. Greater freedom for artists and art audiences cannot guarantee that the fruits of freedom remain easy to pick.

There is now an explanation why expression and expression theories of art have a prominence approaching representation in the history of art. The emotions also constitute a dominating presence in the lives of ordinary human beings, and an urgent task in fostering freedom is to diminish their dominance. Expressive art plays a crucial role here; it actively aids in freeing us from the dominance of our emotions. Expressive art comes second because the emotions are less potent constraints on human freedom than the real world. Expressive art does not signify a continuing enslavement to the emotions; rather, it signifies a progressive freeing from them. Natural-

ly, this does not imply eliminating emotions or attaining the capacity for their total control, but it does entail a loosening of their dominance.

The Concept of Expression

We have been concerned with emotion and its expression, but an important problem remains. When artworks express emotion, those artworks must embody emotion in some manner, and the emotion must be recognizable from a contemplation of the artworks alone. Indeed, any adequate account of expression must meet this identification condition. But given that emotions are subjective conscious states, how can artworks as mere unfeeling, unconscious objects have emotional characteristics or embody emotion in any form whatever? The problem is not equally acute for all the arts. Bodily movement plays a significant role in natural expressions of emotion, and its exploitation for expressive purposes in dance is unremarkable. Language is already a vehicle for the direct expression of emotion, and its use for emotional expression in poetry is also unremarkable. The human voice figures prominently in natural expressions of emotion, and its deployment for expressive purposes in music is hardly surprising. But take painting: How can differently colored physical substances smeared on a physical surface embody emotion? Take purely instrumental music: How can different sequences of physical sounds embody emotion? In short, how can emotions be there in any form, and how can they be recognized as being there? These questions are crucial to what we can expect art to contribute to life. Next, I consider pivotal accounts of emotional expression in art and how they interact with the problems before us. The focus is on basic conceptual connections.

EXPRESSION AND REPRESENTATION Human beings naturally express their emotions in many ways: they laugh, cry, chortle, groan, frown, smile, leap, slump, caress lovers, bang tables, blush, tear out their hair, and so on. Artworks often are expressive of emotion simply by being representations of natural expressions of emotion evinced when people experience emotions. Viewing such representations can be as feeling-neutral as observing scenes in which no emotions are expressed. But typically to witness emotions being expressed is to be charged or to feel a tendency to be charged with an energy that is normally absent. Even if we lack sympathy for the specific emotions expressed, the experience is still more charged. Representations in art of natural expressions of emotion have the potential to carry some of this additional charge.

When Vasari praises artists for their special capacity to express emotion in their artworks, he invariably has the representation of natural expressions of emotion in mind.[11] Here there is little difference between the representation theory and the expression theory. The potential benefits of contemplating artworks embodying emotions in this way depend largely on whether representation is construed in the pure representation theory, augmented representation theory, sophisticated representation theory, or unrestricted representation theory. In the most advanced version of the representation theory, significant benefits flow from contemplating representations of natural expressions of emotion that cannot flow directly from immersion in life.

But representation cannot constitute a complete account of expression in art. It could account for expression only in art that has human or other animate subjects, for music that con-

tains human voices, and so on.[12] It cannot account for expressive visual art with inanimate subjects and purely instrumental music. If representations of natural expressions of emotion are the only way in which expression can enter art, then abstract expressionism is immediately excluded. Although such exclusion is precipitate, the challenge to explain how artworks can be expressive of emotion even when they lack animate subjects remains.

EXPRESSION AND CAUSATION One account of expression is that an artwork expresses an emotion if and only if that emotion is a cause of the artwork. Here artworks may have either animate or inanimate subject matter. A point in favor of this proposal is that causation appears essential in our normal understanding of the natural expression of emotion. Thus tears are an expression of grief if the grief causes the tears. If I am grieving, but peeling onions causes my tears, then my tears are not an expression of my grief. My thumping of the table is an expression of my anger if my anger causes the thumping. If I am angry, but my desire to kill a fly causes my thumping of the table, then my thumping the table is not an expression of my anger.

Such cases suggest that a causal link between the emotion and its expression is necessary. However, the proposal that a causal link is sufficient faces serious difficulties. My anger may cause me to have a stroke, but the stroke is not an expression of my anger; it is a consequence, perhaps, but not an expression. My anger may cause my dog to tremble, but the dog's trembling is not an expression of my anger; rather, it is an expression of the dog's fear. The proposed causal link is insufficient for the expression of emotion. A causal link between

an artist's emotions and the artwork does not guarantee that the artwork is an expression of those emotions.

The identification condition requires that the emotion be recognizable from the artwork itself. However the satisfaction of the proposed causal condition fails to guarantee this. If I feel profound grief that induces me to seek expression in music, I might produce something entirely nondescript and not identifiable as expressing any specific emotion. Certainly the grief is a cause of the work, but I myself might allow that the work fails to capture what I felt. To generalize, incompetent artists, writers, composers, or choreographers may have strong emotions and be intent on expressing them, and those emotions may be causal factors in the production of their artworks, but it may be impossible to identify their emotions from their artworks. Provisionally we can insist that not only must the emotion be a cause of the artwork, but it must also leave an identifiable trace in the artwork.

Taking the emotion as the cause of the artwork is by itself unpromising as an account of expression in the arts. An alternative suggestion focuses on the causal relationship at the other end. Thus, we have an account of expression in artworks through the artworks causing the appropriate emotion in the art audience. Put simply, an artwork expresses an emotion if and only if the artwork is a cause of the emotion in the art audience.[15] One positive motivation for this approach is that it immediately satisfies the identification condition: The emotion is identifiable in the artwork because the artwork actually causes that emotion.

But this account also faces difficulties. Just because created objects cause emotions, it does not follow that they express those emotions. If we take a pill that causes depression, the pill

does not express depression. Suppose that a man gives his mistress a diamond ring; the diamond ring may cause joy, but it does not express joy. When the man's wife sees the diamond ring on the mistress, it may cause her uncontrollable fury. But the diamond does not express uncontrollable fury, either. Suppose that a rich uncle leaves a philistine nephew the El Greco painting *Toledo* in his will. Suppose that seeing the El Greco causes joy in the nephew because it will enable him to settle his debts when sold. Clearly it does not follow from merely causing joy in the nephew that the painting expresses joy. Indeed, if it expresses anything, it expresses gloomy foreboding, yet extrinsically it may cause joy.

Such cases are persuasive that this simple causal account of the expression of emotion in art is inadequate. A mere combination of this criterion with the first one to yield the proposal that an artwork expresses an emotion if and only if the artwork has that emotion as a cause and in turn causes that emotion in the audience is also unsatisfactory.[14] The fundamental problem is that the emotion in some sense must be apprehended as a feature of the artwork itself, a condition that can remain unsatisfied by the previous causal accounts taken either individually or together. The latter view is essentially a fleshing out of the transmission model of expression and as such helps to highlight its limitations.

These difficulties lead to an important proposal that I call the fusion theory.[15] The underlying idea is that it is insufficient for artworks merely to cause emotions; the felt emotion must be fused in some way with the perceptual characteristics of the artwork. Naturally, the fusion occurs unconsciously, so that what finally emerges in consciousness is the product of such a fusion. Thus, if we consider the diamond ring of my exam-

ple, the diamond ring causes joy in one case, but the emotion is not fused with the perceptual characteristics of the diamond ring, and the joy is not felt to be in the diamond. Again, when the wife experiences uncontrollable fury, the fury does not fuse with the observed characteristics of the diamond ring, and the fury is not felt to be in the diamond ring. Similarly, in my example, El Greco's *Toledo* causes joy in the nephew, but the joy is not fused with the perceptual characteristics of the work; the joy is experienced as external to the work and not inherent in it. Fusion theorists maintain that normally El Greco's *Toledo* causes some emotion such as gloomy foreboding, which is simultaneously subconsciously fused with the observed characteristics of the painting. Merely feeling the emotion is insufficient; the emotion must be felt as intrinsic to the work, not as something independent and merely parallel to it. This suggests a further amendment of the previous proposal: An artwork expresses an emotion if and only if the artwork has that emotion as a cause and in turn causes that emotion in the audience and the emotion is experienced as fused with the perceptual characteristics of the artwork.

There are still problems even with this account. First, it excludes the exercise of emotional imagination by artists and confines them to generating art out of their own actual emotions. To insist that artists actually experience the emotions that their artworks exhibit is unduly restrictive, nor is the account plausible as a reflection of actual artistic practice on this score. But this feature can be readily dropped while retaining the central thrust of the account. Second, we do not always experience the corresponding emotion in recognizing its expression in an artwork. This point is reinforced by noting that the recognition of the expression of emotion in ordinary life does not require

that we concurrently feel the corresponding emotion. Consider natural expressions of emotion such as tears, sighs, wringing of hands, clapping of hands, smiling, frowning, ranting, shouting, screaming, grimacing, sobbing, jumping for joy, snapping with irritation, and so on. Typically we understand what emotion is expressed without experiencing the emotion ourselves, so there is no question here of experiencing a fusion of the emotion and the perceptual characteristics of its natural expression. However, some artworks are expressive because they are representations of natural expressions of emotion. The requirement that the emotion actually be caused in the audience because otherwise the emotion would not be identifiable in the artwork cannot apply in these cases. To be sure, I have argued that typically to witness a situation in which emotions are expressed is to have a more energy-charged experience than usual, but this does not mean that we must experience concurrently the emotions expressed by the participants. Perhaps no univocal account of emotional expression in art is adequate, and we must distinguish artworks that are expressive by virtue of containing representations of the natural expression of emotion from those that do not contain such representations. The latter may well require that the emotion be caused in the art audience as a condition of the audience identifying the emotion that the artwork is held to embody, but even this cannot be taken as firmly established.

Let me summarize. Sometimes artworks count as expressive of emotion simply by being representations of natural expressions of emotion. Here we can recognize the expressive quality without feeling the corresponding emotion ourselves, just as we see from a person's natural expression of emotion that the person is depressed without ourselves being depressed. In

such cases, there is no serious question of the fusion of our emotions with the perceptual characteristics of the artwork because we do not actually feel the corresponding emotion. However, this cannot be the whole story about expression in art, and the amended causal account – designated the fusion theory – seems more plausible where art is expressive but does not consist of the representation of natural expressions of emotion. It cannot categorically be excluded as a suitable account of expression for landscapes, seascapes, cityscapes, still life paintings, abstract paintings, and so on.

The observations about painting also apply to other art forms. Recognizing that Regan and Goneril in *King Lear* are expressing greed, ingratitude, and hard-heartedness does not require that we experience greed, ingratitude, and hard-heartedness and fuse those feelings with the perceptual characteristics of the stage presentation. To be sure, if we ourselves never experienced emotions, we could not recognize natural expressions of emotion as expressions of emotion. But this is very different from the claim that whenever we regard artworks as expressive of emotion, we ourselves must directly feel those emotions. All we may need is an understanding of the emotion. To conclude, expression in art cannot plausibly be analyzed even in elaborate causal terms in all cases. Whether such analyses work in some cases remains open. However, there are other approaches, and the proposal that resemblance rather than cause is central to an understanding of artistic expression merits consideration.

EXPRESSION AND RESEMBLANCE The key idea is that what accounts for the expressive character of artworks is the resemblance between perceived characteristics of artworks

and actual emotions. It merits emphasis that the resemblance is directly between artworks and emotions and not simply between artwork and natural expressions of emotion. The latter possibility yields a distinct proposal that will be considered in turn. The current proposal is that an artwork expresses an emotion if and only if the artwork resembles that emotion.[16] The immediate problem here is one of intelligibility. Can sense be made of a resemblance between an artwork and an emotion? There is a strong case that the proposal is indeed intelligible.

Consider a case relevant primarily to purely instrumental music. Take the following two sounds: ascending and descending chromatic scales played as loud and as fast as is technically feasible on a piccolo and a single, soft, low, long-sustained note on a cello. Which of these sounds resembles the feeling of nervous agitation, and which of these sounds resembles the feeling of calm relaxation? There is little doubt that most people feel that there is a resemblance between the piccolo scales and nervous agitation, and that there is a resemblance between the cello note and calm relaxation. Such examples support the claim that there are genuine resemblances between feelings or emotions and sounds. However, such resemblances cannot in principle be exact and cannot ground the exact transmission of emotion.

Next consider a case relevant primarily to visual art with inanimate subjects. Take the following two visual figures: numerous sharp, black, straight lines, some vertical, others crisscrossing and intersecting at random, forming jagged acute angles at the edges, and a smooth, slightly elongated, blue figure eight drawn with a medium-thick line. Which of these figures resembles the feeling of nervous tension, and which

of these figures resembles the feeling of calm relaxation? There is little doubt that most people feel that there is a resemblance between the sharp, straight lines crisscrossing at random and nervous tension, and that there is a resemblance between the smooth, elongated, horizontal figure eight and calm relaxation.[17] Such examples support the claim that there are genuine resemblances between feelings or emotions and visual characteristics. Again such resemblances in principle cannot be exact and cannot ground the exact transmission of emotion.[18]

To be aware of sounds as resembling nervous agitation and to be aware of visual figures as resembling nervous tension involves experiences that are richer than hearing neutral sounds or perceiving neutral sights. Similarly, to be aware of sounds as resembling calm relaxation and to be aware of visual figures as resembling calm relaxation involves experiences that are richer than hearing neutral sounds or perceiving neutral sights. The visual or auditory presentations seem charged with additional potency and intensity. Arguably this additional potency and intensity in the presentations is integral to their being recognized as resembling emotions. These examples explain how the expressiveness of artworks can arise from resemblances between their perceptual characteristics and emotions. Although the account appears most plausible in the case of expressive art without human or animate subjects, its broader application cannot be excluded.

But there is another proposal that locates the resemblance elsewhere. Here the resemblance obtains between artworks and natural expressions of emotion, not between artworks and actual emotions. This proposal has evident merit. The idea of a resemblance between artworks and natural expressions of

emotion is less problematic than a resemblance between art-works and actual emotions. The natural expression of emotion often is vocal, as in cries, sobs, shrieks, screams, whines, whimpers, moans, groans, sighs, hisses, and snarls. That at least some vocal artworks are emotionally expressive by resembling such natural expressions of emotion is difficult to deny. Naturally, bodily posture and behavior often are also vehicles for the natural expression of emotion. This account appears most plausible in the case of expressive art with human or animate subjects, but its broader application seems feasible, especially to purely instrumental music.

It is worth noting that both kinds of resemblance may operate simultaneously in some cases and that some characteristics of an artwork may resemble actual emotions, whereas other characteristics of that artwork resemble natural expressions of emotion. The possibility of such a double resemblance may explain the special intensity found in exceptionally expressive artworks. In any event, the case for resemblance in one form or another being the appropriate account of the expression of emotion in artworks seems persuasive for at least some cases, but other accounts also merit consideration.

EXPRESSION AND SYMBOLIZATION The key idea here is that what accounts for the expressive character of artworks is that the manifest characteristics of the artwork symbolize actual emotions.[19] The essential point is that symbolization is not to be identified with either causing the emotion or merely resembling the emotion or resembling the natural expression of emotion. The proposal is that an artwork expresses an emotion if and only if the artwork symbolizes that emotion. Here a sharp distinction is drawn between the symbol and

what it symbolizes, and a direct awareness of the symbol does not entail a direct awareness of what it symbolizes. What art conveys to the art contemplator is a symbol of the emotion or a concept of the emotion, not the emotion itself.

The relationship between symbols and things must be clarified. Just as there is a difference between a symbol of a table and an actual table, so there is a difference between a symbol of pain and actual pain or a symbol of joy and actual joy. In asserting, "There is a table in the room," the thought consists of concepts mediated by symbols, and we understand the claim through its symbols and concepts. We grasp "John is sad" through its symbols and the concept of sadness; we need not feel sad ourselves at the time. Although apart from literature the language of art differs from the language of discourse, in this view art uses presentational symbols that convey concepts of feelings and emotions, not feelings and emotions themselves.

Turning to music, how can music express emotions through symbols of emotions? How do such symbols acquire their capacity to denote just what they do denote? The received answer is through pattern or form. The proposal is that emotions have characteristic patterns of growth, rates of development, intensification, and attenuation, and music symbolizes emotions by articulating patterns or forms that are identical to the patterns or forms of emotions. However, just as the blueprint for a house (which in a sense embodies the same pattern or form as the house) is not the actual house but only something that symbolizes it, so a segment of music embodies a pattern or form of an emotion but does not convey the actual emotion. To be sure, in listening to music people are sometimes overcome by real emotions, but in the current proposal, this is not typical, and the

presence of actual emotion adds nothing to the quality of the artwork, nor would its absence detract from it. In short, the structural isomorphism of music and emotion enables music to symbolize emotion without requiring deliberately established conventions of correspondence.[20]

The symbolic account faces challenges that are sharpest in the case of music itself. If there is a structural isomorphism between the musical sound and the emotion, then there must also be a structural isomorphism between the musical score and the emotion, and clearly the musical score is a system of symbols. But there is a great difference between reading a musical score and hearing the actual music. There is a richness, completeness, and energy charged potency in actually hearing the sounds rather than merely reading the score. Precisely this difference matters to music: It makes music what it is; it makes music the powerful experience that it is. In the symbolic theory, it is a genuine puzzle why the musical score, visually scanned, should not be just as expressive as the actually heard sounds because the score must be structurally isomorphic with the emotions as well. Music is an interesting test case for the symbolic account and reveals its problematic character. In an intuitive understanding of symbols, the account is plainly untenable, and although more elaborate conceptions of symbolism may revive it, the outlook is hardly promising as an independent account.[21] The account must explicate what the heard music symbols possess that enables them to express emotion that the written score lacks. Here the natural suggestion is that the heard sounds resemble emotions in a way that the written score does not. But the embrace of this suggestion reduces the symbolic account to a resemblance

account and no longer offers a distinctive alternative in its own right.

EXPRESSION AND CONSONANCE The key idea here is that what accounts for the expressive character of artworks is the felt consonance between the manifest characteristics of artworks and actual emotions. Consonance is definitely not to be understood in terms of cause, resemblance, or symbols. This account is a heroic attempt to explain expression in art in completely commonsense terms, thereby avoiding the difficulties in previous accounts. The proposal is that an artwork expresses an emotion if and only if the artwork is felt to be consonant with that emotion. The challenge is to explain the idea of nonresembling consonance. Suppose that we have worked hard outside on a hot day. A glass of cold water may go perfectly with the way we feel. There is a consonance between drinking the cold water and how we feel in general. However, this felt consonance is not based on resemblance. Something that resembles our feelings more closely, such as a hot cup of coffee, may not be felt as consonant with our feelings here. To take another case, many people find that the taste of lemon goes particularly well with the taste of fish; there is a consonance between the two tastes. Again the consonance is not based on resemblance; indeed, they may fit together so well just because they are so different.

Applied to art, the proposal is that emotional expressiveness is attributed to artworks on the basis of their fit with actual emotions. What makes sad music expressive of sadness is that the music is felt to fit with our feelings particularly well when we are actually sad. The consonance theory deals with a major problem for the symbolic account, namely, why a musi-

cal score is not felt to be as expressive as the actual musical sounds. In the consonance theory, there is a felt consonance between the actual musical sounds held to be expressive of sadness and actually feeling sad, whereas no consonance is felt between the visually scanned musical score and actual feelings of sadness.

Straightforward as this account is, it also faces difficulties. Recall the man who gives his mistress a diamond ring that occasions great joy in the mistress. The woman may feel that there is a perfect consonance between the perceptual characteristics of the diamond ring and her joy, they just fit together so well. However, it does not follow that the diamond ring expresses or can legitimately be felt to express joy. What is missing from the simple causal accounts is again missing here: the emotional characteristics that the object is felt to express must in some sense be integral to the object held to be expressive. Consonance may be necessary for expression, but it appears not to be sufficient.

Although many issues concerning expression remain unresolved, the transmission model of expression required by the pure and the augmented expression theories fares poorly when expression is considered in greater detail. The fusion and the resemblance theories are the more plausible of those outlined, and they certainly fit better with the transformation model of expression than with the transmission model. This in turn implies that the move from the pure expression theory, to the augmented expression theory, to sophisticated expression theory, to unrestricted expression theory is a move to increasingly adequate theories. However, I will now address the issues in broader terms.

General Assessment of the Expression Theory

Again, two questions must be distinguished clearly. First, how good is the expression theory as a comprehensive theory of art? Second, does expression have an ongoing vital role in the arts? There is a solid case that the expression theory – even in its strongest version, which I call the unrestricted expression theory – is inadequate as a comprehensive theory of art. There is an equally powerful case for an ongoing vital role for expression in the arts.

Let me begin with the main limitations of the expression theory; these may not be as obvious as the limitations of the representation theory, but they exist nonetheless. The expression theory has trouble with architecture and photography, where expression at best plays only a peripheral role. This objection could be met by arguing that architecture and photography are not major arts and that the expression theory still covers the major arts. The failure to cover architecture and photography adequately, if that can be established, is less grave than the failure of the representation theory to cover music adequately. If there are fatal limitations in the expression theory, they must be found in its application to the major arts.

The expression theory encounters severe difficulties in accommodating certain kinds of literature; it has difficulties with some visual art and even encounters problems with music. The expression theory does not adequately cover so-called novels of ideas such as Voltaire's *Candide*, Huxley's *Brave New World*, and Orwell's *1984*, where ideas dominate, or indeed novels in which ideas are still important but less dominant such as Tolstoy's *War and Peace*, Dostoyevsky's *The Brothers*

Karamazov, and Musil's *The Man without Qualities.* To be sure, emotions are partly involved in all of them, but equally, purely intellectual conceptions are central to their excellence as literary works, and the expression theory cannot accommodate this point. Perhaps the most damaging aspect of the expression theory is its confinement of art to the realm of emotion and its exclusion from the realm of intellect. The expression theory projects the conception of artists as essentially emotional beings, but artists are also thinking beings whose thinking is legitimately incorporated into their artworks.

Similar problems arise for visual art. Factors other than emotion are highly regarded in visual artworks. In Vasari's *Lives of the Artists,* there is frequent praise of artists for their realism, for the accuracy of their representations, and in context such praise seems entirely appropriate even if it cannot be understood in the straightforward sense in which it was intended. Many Renaissance artists explicitly, and surely legitimately, pursued the goal of realistic representation as they conceived it. If accuracy of representation can be a positive virtue in visual artworks, then to that extent the expression theory is deficient.[22] Put generally, if factors other than emotional content contribute to the excellence of visual artworks, then at the very least the expression theory cannot be the whole story. Even more seriously, emotional content may be deliberately absent from some visual artworks. Some of M. C. Escher's drawings embody ideas rather than emotions; they appeal to the intellect rather than to feelings. The absence of emotional content need not be a defect but may actually be a positive virtue. The absence of emotional content may heighten the work's appeal to the intellect and emphasize the purity and clarity of its ideational content. Arguably similarly points apply to music; Bach's *The*

Art of Fugue surely is more noteworthy for its masterly articulation of patterns and forms than for its expressions of emotion.[25]

At the other extreme from the intellectual is the purely sensuous, and this also poses difficulties for the expression theory. Consider some nonart cases. The taste of chocolate, the feel of silk, the luster of gold, or the song of a bird can furnish purely sensory delights that enchant by themselves without expressing or occasioning emotions. There is no sound reason for art to abandon such purely sensory delights.[24] At times such art is dismissed as purely decorative, but this is surely mere prejudice. Some art appeals to the intellect, some art appeals to the emotions, some art appeals to the senses, and some art combines more than one of these appeals. According to the expression theory, only emotion matters in art, but this is unduly restrictive. To be sure, if art appealed only to the intellect or it appealed only to the senses, then it would be severely impoverished. Similarly, if art appealed only to the emotions, it would also be severely impoverished. If visual delight without emotional expression is possible, there is a case for some artworks to provide it. If auditory delight without emotional expression is possible, there is a case for some music to provide it. Even without going so far, surely genuine art can have an engaging integral sensuous content besides an emotional content, and even this limited claim is difficult for the expression theory to accommodate.

The case against the expression theory as a comprehensive theory of the arts is strong. Nevertheless, the expression theory has a degree of tenacity that begs explanation. One noteworthy explanation for its tenacity also leads to a better appreciation of its limitations. When we become aware of expressions of emotion in others, we normally respond with feelings of our

own. When anyone express joy, or anger, or hate, or love, avoiding feelings about this is hard. If we apprehend emotions expressed in artworks, it is hard to avoid feelings about them. Equally, it is hard to avoid feelings about delightful tastes, obnoxious tastes, or even neutral tastes. The point holds for sight, sound, smell, and touch. It is possible but hard to have a merely sensory impact. If the impact is strongly positive, it engages certain feelings; if it is strongly negative, it engages other feelings; if the impact is in between, it evokes still other feelings.

What holds for sense also holds for intellect. When confronting an idea or theory, it is hard to avoid some emotional reaction, ranging from enthusiasm, excitement, or interest to boredom, depression, repulsion, and so on. Artworks that embody ideas typically also engage emotions in a general way. Even in reading novels of ideas such as *Candide, Brave New World,* and *1984,* it is hard to avoid emotional reactions to, say, the portrayal of the evils of totalitarianism. Similarly if a piece of music is simply an aural delight, it is hard to avoid a general lift in mood, and the same applies to purely visually pleasing artworks. Thus, emotion may feature in the contemplation of artworks generally without the expression theory being true and without it being the function of art to express emotion.

Awareness that we cannot take all emotion involved in the contemplation of art as support for the expression theory is vital to a balanced assessment of it.[25] Once such allowance is made, the warrant for the expression theory as an adequate comprehensive theory of art declines significantly. Given the previous arguments, there is little prospect of the expression theory being resurrected as a comprehensive theory of art. Where does this leave expression? Must expression be abandoned as inappropriate to art? Is expression in art essentially

dated? The stance taken on representation is also appropriate here. Although all art need not express emotion, abandoning the expression of emotion entirely or marginalizing it severely cripples the potential of art to yield the values of which it is capable.

To restate a basic point, art derives its capacity to deliver value to human beings largely from the nature of human beings themselves. One central feature of human beings is that they are emotional. All human beings have emotional reactions to the world and to other people; in particular, they have emotional reactions to the emotional reactions of others, and again there are doubtless good evolutionary grounds for this. One clear benefit ensuing from expression in art is that it engages this prior interest and builds on it. Let me develop this point and begin with a basic observation.

Expressive artworks sever the normal connection between emotion and action. They free us from the normally appropriate actions or concerns. We cannot aid or even genuinely sympathize with the central figure in Munch's *The Scream*. Listening to Liszt's *Liebestraum* does not necessitate buying flowers, whispering endearments, or arranging candlelight dinners. Again, this separation is crucial, for it means that without extraneous concerns, attention can focus exclusively on the expressive artwork itself. This separation both liberates and intensifies emotional awareness. Merely being an expressive artwork already guarantees experiences unobtainable from reality. Furthermore, interest in expressive art depends essentially on our prior interest in people and their emotions, but not in such a way that the world alone could satisfy that interest. Expressive artworks lift the objects of contemplation from the ordinary flux of action, thought, feeling, desire, and

perception to where they simply become objects of awareness and hence yield a fresh and unencumbered approach to emotion even if the approach is less direct.

Although the separation from the normal flux of life that results merely from being an expressive artwork is a significant ground for the possibility of more intense and focused experiences, the expressive artwork can be manipulated to heighten that intensity. For example, the radical isolation and simplification of the central figure in Munch's *The Scream* to little more than an expression of anguish, together with the menacing red sky and the dark, oppressive, amorphous background combine to furnish an experience of exceptional intensity. Many ways of manipulating expressive artworks to furnish experiences unobtainable from immersion in life emerged when examining the augmented expression theory.

A natural question arises here: Why be concerned with expression at all? Why not manipulate the characteristics of artworks directly, independently of any attempt at actual expression? Again there is no valid objection to following this path, but there are also good reasons for persisting with expression. If we return to the example of Munch's *The Scream,* then not only is the experience intensified in the ways suggested earlier, but the experience is enriched by the natural interest that people have in emotions. To abandon expression is to abandon this source of enriching experience. Nor does the capacity for enrichment end there. The very fact that the artist, too, finds emotions of absorbing interest, aspects of which the artist feels are worth drawing special attention to, both reinforces and increases our own interest in emotions and, if the artist is a good one, enriches our conception of them. Here are sev-

eral ways in which expressive art can enrich experience that are simply unavailable to nonexpressive art.

But this still fails to capture fully the contribution that expression makes. If the account of expression embodied in the sophisticated and unrestricted expression theories is correct – as it appears to be – then art yields a new kind of value unobtainable directly from life. The essential point is that expressive art never simply transmits raw feelings. Expressive art conveys how others emotionally react to life, either individually or collectively, and this is not something we can gain by multiplying our own direct emotional reactions to life. Expressive art also produces a hybrid entity with one foot in the subjective and the other foot in the objective. The difference between representational art and expressive art can be put as follows: Whereas representational art subjectivizes the objective, expressive art objectivizes the subjective. Representational art makes of the outer world an inner world, whereas expressive art makes of the inner world an outer world.

Expressive art exploits a double interest: It not only exploits our natural interest in life but also exploits our natural interest in others' emotional reactions to it. Expressive art enriches our conception of life, but it also enriches our conception of others and their inner worlds. That life can be emotionally experienced in ways different from our own enlarges our conception of life. That people emotionally experience life in ways different from our own enlarges our conception of human beings. Here art furnishes unique access to the subjectivity of others. In this way, expressive art, by exploiting a preexisting interest in life and in the feelings of others, enhances our conception of both. Naturally, nonexpressive art forgoes the op-

portunity to enlarge our conceptions in this way. This account of expressive art shows a further way to uphold Nietzsche's conception of art as a stimulus to life, as uniquely enriching our conception of life and increasing enthusiasm for it. As long as life still interests us, and as long as the emotional reactions of others to life still interest us, there will be a secure place for expressive art.

Although these benefits from expressive art are important, they are no more the totality of expressive art than the corresponding benefits are the totality of representational art. It is vital that expressive artworks have a drawing power of their own and that they capture and hold our attention and reward contemplation in their own right. Without this intrinsic drawing power, expressive art would have little capacity to elevate us above the ordinary flux of life, and even its capacity to enrich our conception of life and our conception of human emotions would be significantly impaired. Here we face the same analytical impasse as before. It is hard to contest that Munch's *The Scream* has an intrinsic drawing power, but it is impossible to separate how much of what makes it interesting and rewarding to contemplate rests on our prior interest in life and our prior interest in how others emotionally react to life and how much rests on features intrinsic to the expressive artwork. Aside from whether such factors are either introspectively or analytically separable, the multiplicity of such factors indicates the possibility of a depth, richness, and complexity in our experience of expressive art that simply does not exist in nonexpressive art. To voluntarily renounce the opportunities that this presents is impoverishing and pointless self-denial.

Representational art and expressive art form a complementary pair. Representational art engages our interest in the outer

world; expressive art engages our interest in the inner world. Representational art liberates us from the routine and narrow in our approach to the outer world. Expressive art liberates us from the routine and narrow in our approach to the inner world. Representational and expressive art free us from the commonplace and simultaneously enrich experience beyond it. Neither can be renounced without cost.

Form

Form has been prominent in thought about the arts and has also furnished one of its great theories. Formalism locates the point of art entirely in artworks and not in something external to them, in contrast to the representation and expression theories, and this is typically seen as one of its strong points.[1] But formalism also is no longer viable as a comprehensive theory of art. Nevertheless, it bears a relevance to art that merits continued attention. Whereas the representation and expression theories have natural appeal, to embrace formalism without argument is rare. Nor need we search far for explanations. Often art appears to be representational or emotionally expressive. Neither may be essential to art, but we must explain why representation and expression are so prominent in art if they are merely incidental to it. Formalism needs more justification than the representation and expression theories do, for the appearances are against it. Formalism also

faces a fundamental justification problem. It needs to explain what gains flow from the contemplation of forms in art, when a profusion of forms is already available for contemplation in the world.

According to formalism in its basic version, the essential function of an artwork, whether painting, sculpture, architecture, literature, drama, music, or dance, is to articulate and present forms for aesthetic contemplation. Arguably its most immediately plausible application is to sculpture. The theory embodies a strong negative criterion of aesthetic merit. The merits of artworks do not depend on representational or emotionally expressive characteristics or any other nonformal features. Indeed, the more nonformal features dominate artworks, the less merit they have as artworks. The most pressing issues for formalism concern its rational basis and the elucidation of the concept of form, but it is useful to establish a context before proceeding to these issues.

Although Plato is justifiably seen as an adherent of the representation theory, particularly in *The Republic*, arguably his metaphysics fit better with formalism. To review, according to Plato, ultimate reality consists of spaceless and timeless forms, and artists produce copies of copies of them. Ordinary beds are inferior copies of the form of the bed. Artists make inferior copies of these inferior copies. To contemplate the form of the bed is best, next best is contemplation of a bed, and worst is contemplating a painting of a bed. The only things really worth contemplating are forms. In contemplating a painting, the only important ingredients are the forms that it indirectly reflects. Ultimately only forms count. Here is as good a fit between metaphysics and a formalist theory of art as is

likely to obtain. This point grounds a challenge to Plato's negative assessment of art.

In a painting of a bed, the matter of this lower world is less extensive and less intrusive than in a physical bed. The actual bed is crammed with what is not inherently a part of the form. The artwork, being sparer and less crammed with the material of this world, places us closer to the form. Arguably artworks furnish better access to forms than concrete reality does. Considering poetry enhances the case. Enormous selectivity and exclusion of the ordinary world are necessary in poetry, and the forms reflected in it surely can be discerned more adequately there than in the chaotic complexity of the real world. In short, we are closer to the forms in artworks than in the real world. Embracing formalism would have given Plato a theory of art fitting more neatly with his metaphysics and permitting a more elevated status for the arts.

To pave the way for an appreciation of more recent defenses of formalism, let me consider a line taken by Kant.[2] The case can be outlined as follows. Some judgments are plainly subjective and make no claim to objective rightness or universal acceptability. If I say that caviar is tasty, it is understood that I am expressing a subjective preference with no claim to objective rightness or universal acceptability. Kant thought that sensations or purely subjective feelings cannot ground objective rightness or universal acceptability; sensations are where subjectivity and personal idiosyncrasy reign. However, certain judgments about art are implicitly claims to objective rightness and universal acceptability.

To give a deliberately extreme illustration, if I maintain that Beethoven's *Archduke Trio* is better music than random scrap-

ings of fingernails on blackboards, then I am making a judgment that implicitly claims objective rightness and universal acceptability.[5] Certainly some people may prefer random scrapings of fingernails on blackboards to the *Archduke Trio,* but if they were to convert this preference into the claim that random scrapings of fingernails on blackboards is better music than the *Archduke Trio,* then it is appropriate to maintain that the claim is simply wrong. Preference for random scrapings of fingernails on blackboards fails even to turn them into music, much less good music. Thus, if there are objectivity and universal acceptability in aesthetic claims, as there appear to be in my example, and sensations provide only subjectivity and variability, then something other than mere sensation must ground aesthetic judgments. They are grounded in what mind, in contradistinction to the senses, apprehends in artworks, and that is form. Thus the features of artworks that belong merely to sensation are basically irrelevant to aesthetic merit.

Our pretheoretical intuitions that form is important to what makes the *Archduke Trio* good art and random scrapings of fingernails on blackboards not merit respect and bolster Kant's argument. In any event, this is one way of understanding Kant, and it illustrates that serious defenses of formalism are possible. In short, the argument is that we can sustain the distinction between merely subjective expressions of taste and serious aesthetic judgments only if we accept formalism. I will not assess this argument directly, but I do not accept that formalism is the only solution to the problem posed.[4]

Let me turn to more recent defenses of formalism. Modern formalists such as Clive Bell and Roger Fry are influenced by two interconnected trains of thought, one relating to values and the other to semantics.[5]

The Value Argument

Bell begins with the eminently defensible claim that the value derivable from art cannot be derived from anything else and that value resides in the aesthetic emotion that artworks generate.[6] In other words, art furnishes autonomous values. It does not generate substitute values; it generates new values unobtainable outside art. For example, what genuine music lovers find valuable about music cannot be obtained from anything else. There simply is nothing in the world that furnishes what music furnishes. Naturally, the point applies equally to lovers of literature, painting, dance, and so on. Most art lovers doubtless endorse this claim, so it appears to be a sensible starting point.[7]

Beyond that, the reasoning is as follows. If the representation theory were true, then the contemplation of artworks would merely furnish substitute values better realized by contemplating the actual things represented. But given that we derive something of value from artworks that we cannot derive from a contemplation of the actual objects represented, artworks do not merely furnish substitute values; therefore, the representation theory must be false. Similarly, if the expression theory were true, then the contemplation of artworks would merely furnish substitute values better realized by experiencing emotions directly without the mediation of artworks. But given that we derive something of value from artworks that we cannot derive from direct experiences of emotion, artworks do not furnish substitute values, so the expression theory is false. The essential claim is that neither the representation theory nor the expression theory explains what we find valuable about artworks, so there must be some other factor than represen-

tation or expression that makes artworks valuable. This is the negative argument. Whatever is fundamental to art, it must be something other than representation and expression. This is the first step to formalism – at least for these theorists.

The argument is not entirely without persuasive force and merits attention. At root the argument is that because art supplies its own values, art cannot be essentially representation or expression. Given our previous consideration of the representation and expression theories, this case for formalism clearly is weak. If the only possible representation theory were the pure representation theory, and the only possible expression theory were the pure expression theory, then the argument would have considerable force.[8] However if we take the unrestricted representation theory and the unrestricted expression theory, then it is easy to explain how artworks can be valuable to contemplate independently of contemplating the corresponding realities or feeling emotions directly without artworks being mere substitutes that are always second best. What was shown in both cases was that art offers a great deal that cannot be attained from direct experiences of the world and life, without art ceasing to be representational or emotionally expressive. We can fully accept that an explanation is needed for how art can be valuable beyond direct awareness of the world or direct experience of emotion in life, but these explanations are more than adequately supplied by the unrestricted representation theory and the unrestricted expression theory. The complete abandonment of representation or expression is not needed to explain how art furnishes values not furnished by direct encounters with the world and life. Thus this case for formalism collapses; it is based on conceptions of the representation and expression theories that are simply too crude.

The Semantic Argument

Specifically concerning visual art, Bell proceeds as follows.[9] He inquires into what is common to all visual artworks. He considers examples such as Mexican sculpture, a Persian bowl, Chinese carpets, Giotto's frescoes, and the paintings of Cézanne. He argues that there must be some feature common to all these things in virtue of which they are called art.[10] This common feature cannot be representation because they are not all representational; the common feature cannot be expression because they are not all emotionally expressive. Bell concludes that the only thing that they have in common is form. But as most things have form, if that was all there was to it, then almost anything would count as art. What artworks have in common that nonart lacks is *significant form*.

An interesting consequence of his theory is that Bell reverses the progress thesis that Vasari advances in his *Lives of the Artists*. According to Vasari, from Giotto on, Renaissance artists became better and better at realistic representation, with the development of perspective playing a leading role in the process, and art itself progressed as a result. But according to Bell, the more Renaissance artists focused on perfecting representation, the more they neglected significant form, and as their paintings became more realistic, they became worse as artworks.[11]

The semantic argument incited one of the great debates in the analytical philosophy of art in the twentieth century. The extreme positions are that a definition of the term *art* must be possible if *art* is to be a meaningful term and that a definition of the term *art* is in principle impossible, and is not necessary for the meaningfulness of the term *art*.[12] Bell's semantic argu-

ment clearly rests on the first supposition. The debate is considered in detail in chapter 5, but the following is a fair assessment of the current situation. First, it has not been conclusively established that a definition of the term *art* is either possible or necessary. Second, it has not been conclusively established that a definition of the term *art* is in principle impossible.[13]

The resulting dialectical situation is that theorists such as Bell cannot rely on the assumption that there must be a definition for the term *art* or that all art must share common features. However, it leaves theorists free to propose definitions and common features that can then be tested for adequacy. The debate has destroyed the semantic argument as a forcing argument, but it leaves open the theoretical possibility of definitions and common features and thereby leaves open the possible adequacy of formalism. But I will not rest my consideration of formalism entirely on Bell's specific defense of it, and I now turn to a more general consideration of formalism.

Form is a conspicuously elusive concept.[14] I will rely initially on the commonsense concept of form. Certainly formalists are free to modify our commonsense concept, but unless they preserve its essential core their designation as formalists is vacuous. A key feature of the commonsense concept of form is that it is a contrast concept. Form must be embodied in something that is itself more than just form; it always implies features besides form. There is always an implied distinction between either form and matter, form and substance, form and content, or form and substratum. This is the crucial point here. A more extensive analysis of the concept of form in art will follow, but that is not needed yet and does not affect the immediate case. Naturally, different versions of formalism ensue from the varying roles assigned to form in artworks.

Strong Formalism

Here only form counts as an aesthetic factor. The essential and only function of an artwork, whether it is from painting, sculpture, architecture, literature, drama, music, or dance, is to articulate and present forms for aesthetic contemplation. The corollary is that there are always aspects of artworks that are of no aesthetic importance, namely their nonformal features. The theory embodies a tough negative criterion of aesthetic merit. The less artworks depend on anything other than form for their appeal, the better they are as artworks. Artworks that rely on representational or emotionally expressive features for their appeal are vitiated as artworks by such reliance.

Arguably the superior art forms are sculpture and architecture, sculpture because it fully articulates forms and abstracts them from their usual surroundings and thus permits a more direct, complete, and exclusive focus on forms than is possible in painting, and architecture because it is typically free of any representational and emotionally expressive elements. Ballet is better than opera because it lends itself more readily to the exclusion of representational and emotionally expressive elements, without which opera is hardly imaginable. Abstract painting is better than representational painting because it typically focuses directly on form and thus avoids the inevitable distractions present in representational and emotionally expressive art. Turning to music, the human voice is of no particular importance and may even be a drawback because its emotionally expressive characteristics can divert attention from the form, which is the only thing that matters. Computer art may emerge as better than human art because the exclusion of distracting representational and emotionally expressive

elements present no difficulties to computers, and their capacity to generate and manipulate pure forms is outstanding.

Strong formalism carries substantial implications about the role of the artist. Here only the artist's capacity to generate and articulate forms counts. This may take high levels of skill and high levels of formal inventiveness, but artists must not contribute anything else. No traces of thought, feeling, insight, or experience of the world can be allowed to intrude into artworks. This implies that no experience of life and the world is necessary or even desirable in artists. Immaturity and inexperience are no disqualification for the highest artistic achievement. Indeed, it is hard to see in strong formalism what could prevent computers from becoming the superior artists of the future.[15]

The fundamental justification problem is as follows: Given strong formalism, how can art enrich human experience? What benefits flow from the contemplation of form in art? Given that there is an endless variety of forms in the world, why cannot any benefits flowing from the contemplation of form in art just as readily flow from contemplating forms in the world? Let me cite the benefits that accrue from art even in this austere and uncompromising version of the theory.

PLEASURE IN FORMS Human beings find contemplating forms pleasurable. Furthermore, some forms plainly are more pleasing than others, and some are positively delightful. Through exclusive focus on form, strong formalism promises such pleasures in the most complete, intense, and pure way possible.

INVENTION, SELECTION, AND ELABORATION In some instances, the forms furnished by art are entirely invent-

ed and are simply unavailable outside art. This is most obvious in music and literature: The sound forms embodied in string quartets do not occur in the world outside music; similarly, the forms embodied in poetry do not occur in the world outside literature. Of forms already in the world, artists can select the most pleasing and then present them in art in ways that clarify, isolate, and accentuate them to furnish maximum delight.

In other instances, the explicit concentration on form leads to the elaboration of forms suggested by the world to furnish more pleasure than is furnished by any forms found directly in the world.[16]

SEVERANCE FROM ACTION AND CONCERN Here again artworks sever the ordinary nexus between perception and action that obtains in life. Purely formal artworks free us from practical involvement and release us for unrestricted and concentrated contemplation of the artworks themselves. In strong formalism there is a complete separation of art from any problems or prospects in the world and life outside art. If the problems of the world are too much, or if the pleasures of the world are insufficient, then there are always the independent pleasures of art.

Turning to assessment, strong formalism lacks an effective criterion for distinguishing purely formal aspects of artworks from nonformal aspects.[17] Such a criterion is crucial to the viability of the theory. However, it is highly doubtful whether any such criterion could ever be successfully articulated. The task of furnishing a single criterion that could meaningfully apply across the arts is, if not actually unintelligible, then at least inherently problematic. Even if the task is pared down to finding

separate criteria for each of the major arts, the enterprise still faces a problem that appears insurmountable. Certainly the concept of form in art is an extension of the commonsense concept of form, but both clearly face the same problem. The problem is that the commonsense concept of form lacks criteria for distinguishing formal aspects from nonformal aspects, nor are such criteria automatically present in the concept of form as extended to the arts.[18] The criteria must be invented, and without the commonsense concept of form dictating the boundaries, any proposal must be inherently arbitrary. In short, there is an indeterminacy at the heart of the concept of form that vitiates strong formalism as an acceptable theory of art. When we turn from abstract argument to concrete cases, the theory immediately encounters powerful counterexamples from each of the major arts.[19]

Take Henri Matisse's *The Dance* and imagine a black-and-white photograph of it of the same size. In any intuitive sense of form, the form remains unaltered by such a procedure. But surely the vitality, intensity, and dramatic impact of the work would be significantly reduced. This loss is a loss of something that few art lovers would contest as being important to art, and it is a profound weakness in strong formalism, intuitively understood, that it would not count this as a loss. To be fair to Bell, he includes color as an aspect of form, although his principle of inclusion is unclear, but at least he escapes this particular criticism.[20] However, Bell maintains that representation does not pertain to form and is therefore irrelevant to art. Even this is surely implausible. To see the figures in *The Dance* as human figures, as opposed to mere volumes of color, is just as integral to the vitality, intensity, and dramatic impact of the painting as the color.[21] In the best art, everything counts, and

strong formalism cannot accommodate this, even allowing that there is more to the concept of form in art than there is in the concept of form in ordinary life.

Take Erik Satie's three *Gymnopédies* and imagine them played on a harpsichord rather than a piano. In any intuitive sense of form, the form of the pieces surely remains unaltered by being played on the harpsichord rather than the piano. As pieces for the harpsichord they fall flat, as pieces for the piano they are little gems, and the specific tonal characteristics of the piano play an important role in this. It is not just the form but what the form is embodied in that is vital to aesthetic merit in these cases, and this again is simply not a point that strong formalism can accommodate.

Take Stephen Crane's *The Red Badge of Courage.* In any intuitive sense of form, there is a contrast between form and content, and one cannot exist without the other. The strong formalist must maintain that the novel's being about war pertains to content and thus is irrelevant to its literary merits. Such an observation could have a serious point if the proponent continued that the novel is really about facing a life-defining crisis, the anguish of feeling that one failed the test, and the possibility of redemption. However, the strong formalist must reject this: Here the merits of the novel still turn on certain situations and certain feelings, and these pertain to content. For the strong formalist, whatever the novel is about, whatever feelings it reveals, whatever insight it has are irrelevant to it as an artwork. This is surely implausible. Although form may well be important, content is no less vital. Imaginatively entering the world created by Crane is essential to an appreciation of the novel.

Strong formalism, articulated by using the commonsense

concept of form, is clearly unacceptable. Our pretheoretical aesthetic judgments are too powerfully aligned against it, and as a theory it lacks sufficient independent warrant to override such judgments.[22] Nor is it easy to remedy the situation by refining the notion of form. As long as the crucial distinction between form and content is preserved, counterexamples of this kind are bound to occur. Thus strong formalism is too extreme to be acceptable, but it is by no means the only kind of formalism.

Moderate Formalism

Here form always counts as the main aesthetic factor. The primary and only essential function of an artwork is to articulate and present forms for aesthetic contemplation; other factors beside form may contribute positively to artworks, but such factors are always secondary and vary from artwork to artwork. Moderate formalists can happily admit that factors other than form contribute aesthetically to Matisse's *The Dance,* Satie's *Gymnopédies,* and Crane's *The Red Badge of Courage* but still maintain that form is the most important factor. Here form always counts the most, but other factors may play a significant role.

Given the dominant role of form in this version of the theory, the previous judgments about which are the superior arts remain largely, but not entirely, intact. Arguably sculpture and architecture remain the superior art forms. Ballet is still better than opera because it can better resist domination by representational and emotionally expressive elements. Abstract painting remains better than representational and emotionally expressive painting because it can more readily focus on form. Turning to music, there is now a subtle change regard-

ing the human voice; the qualities of the human voice may now make positive contributions that lack equivalent substitutes. Computer art is no longer the same threat because representational and emotionally expressive elements are now permitted a significant role and may even be necessary for the best art, and these elements may be hard for computers to handle. The implications for the role of the artist also change here. The capacity to generate and articulate forms, though still of central importance, is no longer the only thing that counts. Experience of life and the world is now desirable. Arguably even higher levels of skill are necessary: There is the same need for high levels of formal inventiveness and skill in the manipulation of form, but now skill and imagination are needed to integrate the nonformal elements that now have a positive role.

On moderate formalism, how can art enrich human experience? Compared with strong formalism, there is a loss of benefits that depend on absolute purity, but to balance this, there are substantial gains from increased richness.

PLEASURE IN FORMS Moderate formalism promises to deliver the pleasure that we take in form as its main contribution, but complemented by pleasures derivable from nonformal aspects of artworks.

INVENTION, SELECTION, AND ELABORATION As before, some forms furnished by art are entirely invented and are simply unavailable outside art. Again, this is most obvious in music and literature. Of the forms already found in the world, artists can select the most pleasing and then present them in a way that clarifies, isolates, and accentuates them to furnish maximum delight.

In other instances, the emphasis on form leads to the elab-

oration of forms suggested by the world to furnish more pleasure than is furnished by forms found directly in the world. The key change here is that artists are now free to enrich experience by blending the delights obtainable from the contemplation of these forms with those obtainable from representation, emotional expression, and other nonformal aspects of artworks.

SEVERANCE FROM ACTION AND CONCERN Here artworks still sever the ordinary nexus between perception and action that obtains in life. Formal artworks free us from practical involvement and release us for unrestricted and concentrated contemplation of the artworks themselves, and this remains so even when artworks also contain representational, emotionally expressive, and other nonformal elements. Although there is no longer an invariable separation of art from problems and prospects in the world and life beyond art, the central focus is on artworks themselves. Whatever the world and life offer, there are always the independent pleasures obtainable from a contemplation of forms in art.

Moderate formalism fits our pretheoretical aesthetic judgments better than strong formalism, but major problems remain. The problem of articulating a criterion to distinguish formal aspects of artworks from nonformal aspects remains. The problem is less pressing for moderate formalism than for strong formalism because moderate formalism does not exclude all nonformal aspects from aesthetic relevance. However, the incapacity to furnish a satisfactory criterion remains a theoretical deficiency. Furthermore, moderate formalism has other weaknesses: It does not explain which nonformal characteristics are aesthetically relevant, why they are aesthetically

relevant, or what their positive contribution is. Indeed, the major emphasis on form tends to undermine its capacity to furnish convincing answers here.

Problems also emerge in concrete cases. In some artworks, form is almost certainly not the most important aspect. Take Munch's *The Scream* again. Form may well be an important aspect of the painting, but that form is its most important aspect is implausible; its most important aspect surely is the intense expressive content. Turning to music, take any fugue from Bach's *Well-Tempered Clavier;* its form is both essential and primary to it. But take the *Prelude and Liebestod* from Wagner's *Tristan and Isolde;* although form may be essential to its aesthetic merits, the intense emotional content is far more important than the form.[23] In literature, James Joyce's *Ulysses* surely owes far more to its rich kaleidoscopic content than to any discernible form. Whereas form is aesthetically dominant in some artworks, it plays only a secondary role in others, so even moderate formalism is ultimately untenable. However, even more modest versions of formalism are possible.

Weak Formalism

Here form alone always counts as an aesthetic factor. The only essential, but not always primary, function of an artwork is to articulate and present forms for aesthetic contemplation.[24] Here form always matters, whereas no other factor always matters, even though form may not always be the most important factor. Some artists have self-consciously embraced such flexibility. Kandinsky produced works that he assigned to three different categories: impressions, arising from nature; improvisations, arising from his inner feelings; and compositions,

focusing on form.[25] Representation, expression, and form all are accorded preeminence in different artworks. There can be no real dispute that such variation of emphasis on different aspects in different artworks is perfectly legitimate, and this favors weak formalism over its more restrictive rivals. But the permissive nature of weak formalism precludes any grounded judgments about some art forms being superior to others. Equally, the implications for the role of the artist become nebulous. Although artists must be adept at form, this may be far from their only weapon, and it need not even be their most potent weapon.

Given weak formalism, how can art enrich human experience? Certainly weak formalism deals more easily with this fundamental justification problem, but it does so partly by parasitically relying on justifications furnished by other theories.

PLEASURE IN FORMS Weak formalism still promises to deliver the pleasures that flow from contemplating forms. But its promise to deliver such pleasures is no longer as direct or decisive as for previous versions of the theory.

INVENTION, SELECTION, AND ELABORATION In art, we can invent forms that furnish more pleasure than any forms to be found in the world, but as the role of form in art is diminished, so is the pressure to invent new forms. Although the benefits of selectivity and elaboration of the forms that are already found in the world remain, the importance of such possibilities diminishes with the diminished role of form itself.

SEVERANCE FROM ACTION AND CONCERN Artworks still sever the ordinary nexus between perception and action

that obtains in life. Artworks still free us from practical involve-
ment and release us for unrestricted and concentrated con-
templation of the artworks themselves. However, there is no
longer a complete separation of art from any problems or pros-
pects in the world and life beyond art. The more form domi-
nates artworks, the less the world intrudes into them. How-
ever, there is now a choice. If the problems of the world are
too much, or if the pleasures of the world are insufficient, then
there are always the independent pleasures of artworks in
which form dominates. But we can also seek in art connec-
tions to the world and emotion, if we are so inclined.

The major theoretical weakness of strong formalism and
moderate formalism persists in weak formalism. There is still
no adequate criterion to distinguish formal aspects of artworks
from nonformal aspects. The problem remains one of explain-
ing what nonformal aspects count and why they count. There
is now an added puzzle: If form is not always the most impor-
tant feature of artworks, why could there not be artworks in
which form is entirely unimportant or perhaps even absent?
Certainly weak formalism fits our pretheoretical aesthetic judg-
ments better than either strong formalism or moderate formal-
ism, but this better fit carries a substantial cost. The cost is that
weak formalism is virtually contentless. The transition from the
pure representation theory to the unrestricted representation
theory and from the pure expression theory to the unrestricted
expression theory is not parallel to the transition from strong
formalism to weak formalism. Whereas the one essentially in-
volves a refinement of the concept of representation and the
other a refinement of the concept of expression, the transition
in formalism does not involve a refinement of the concept of
form but merely expands the role of nonformal features in art.

Weak formalism is less prone to decisive counterexamples in concrete cases, but it is by no means free of difficulties. In some artworks, the mode of generation counts as one of its most vital aspects, and sometimes this operates in complete disregard of form. In action painting, one of the most important aspects of the artwork is the unfettered spontaneity of its creation. In such works, if form plays a positive role, it does so only by accident, and it is natural to expect such procedures to generate artworks in which form plays no significant role. Similarly, some music has been written relying on chance alone by selecting successive notes in an entirely random way. Whatever the positive merits of such musical works are, it is hard to believe that form is a significant contributor to such positive merits. Thus even weak formalism ultimately is unacceptable.

The Ascent of Freedom

The transition from strong formalism to moderate formalism to weak formalism is in one important sense a transition from the less adequate to the more adequate theory, for there is an increasingly better fit with pretheoretical aesthetic judgments. Whatever the ultimate fate of formalism as a comprehensive theory of art, weak formalism clearly is less prone to decisive counterexamples than strong formalism. Here again the progression reveals a noteworthy pattern.

The progression from the highly counterexample-prone strong formalism to the minimally counterexample-prone weak formalism coincides with an increase of freedom in art. The exclusive focus on form in strong formalism certainly frees us from concern with either the outer or the inner world,

but it simultaneously robs us of the satisfactions derivable from associations in artworks with the world or the emotions of life. Moderate formalism frees us from this onerous restriction and opens the possibility of greater complexity and richness in our experience of art. Weak formalism takes this even further by broadening the range of enriching experiences derivable from art.

Again there is a further aspect to this freeing progression. As the freedom from domination by form increases, so does the potential for a greater positive contribution by artists. More possibilities are open to artists under moderate formalism than under strong formalism, and even more are open under weak formalism. With weak formalism, the possibilities open to artists are at their peak. This greater freedom for artists implies the possibility of greater rewards for art audiences. The greater the freedom to vary the role of form in art, the greater the possibilities for richness, complexity, and diversity in the experience of art. Although form is certainly of major importance in art, its importance is not such as to adequately ground a whole theory of art.

There is now an explanation why the focus on form and formalist theories of art is less prominent in the early history of art than are representation and expression. An exclusive preoccupation with form already presupposes a significant freeing from the real world and its emotions. Purely formal art requires other art to have prepared the way. Purely formal art may constitute a positive addition to art, but form is unpromising as the totality of art. To appreciate these points better, a more intensive consideration of the concept of form is in order.

The Concept of Form

The concept of form underpinning formalism must be rooted in the commonsense concept of form. Theorists need not preserve every aspect of its ordinary use, but the central core must be retained; if it is not, then it is more honest to drop the term *form* entirely. The commonsense concept of form has aspects that imperil the prospects of formalism as an adequate theory of art, and attempts to modify these aspects improve the situation only slightly.

Let me begin with some basic observations. The clearest application of the concept of form is to individual natural objects: the human body, a tree, a mountain, an animal, a fish, a flower, and so on; mere aggregates typically do not qualify. Essential to the concept are unity, complexity, order, cohesion, and stability. The utterly simple, such as a totally featureless expanse of white, lacks form. The entirely disordered, such as a fortuitous pile of junk may have shape, but to claim that it has form is anomalous. The entirely haphazard, such as the chaotic havoc produced by a tornado, lacks form. The entirely unstable, such as the turbulent flow of liquids, lacks form. The application of the concept to occurrences structured in time rather than space conforms to these criteria. A bird's song has form if it has unity, complexity, order, cohesion, and stability. However, the sound of water rushing over rocks in a rivulet or the sound of waves breaking on shore usually is not ascribed form. The complexity may be there, and the stability may be there, as there is a sameness about the sound that often contributes to its relaxing nature, but there is no unity, discernible cohesion between the sounds, or order in their sequence.

Unity, cohesion, and stability each play a role. We attribute form to individual sheep but are less inclined to attribute form to a flock of sheep even though, at a particular time, they may be clustered in an identifiable shape. Individual sheep constitute a unity in a way that a flock of sheep does not. There is greater cohesion between the parts of an individual sheep than there is between an individual sheep and a flock of sheep, and the shape of an individual sheep is far more stable than the shape of a flock, which is constantly changing. Similarly, we attribute form to an individual tree but are less inclined to attribute form to a forest. This is again explicable by reference to the previous criteria. There is a greater unity, cohesion, order, and stability in an individual tree than in a forest.

As a rule, we attribute form to things that exhibit an easily recognizable, easily differentiated, and memorable pattern that facilitates reidentification over time. The previously identified criteria underpin easy recognizability, easy differentiation, memorability, and easy reidentifiability. A flock of sheep lacks a stable shape easily reidentifiable over time, and a forest, though more stable, lacks an easily recognizable or easily remembered shape.[26] This suggests strongly that the distinction between things to which we attribute form and those to which we do not is related to human interest rather than marking ultimately important divisions in reality.

It is integral to the commonsense concept of form that what has form has other aspects besides form. Common sense may not be entirely comfortable with the designation of these other aspects as matter, substance, content, or substratum, but it is committed to their existence. However, although it is committed to their existence, it is not committed to any clear de-

marcation between what belongs to form and what does not. A vital point is that the commonsense concept of form implies that what has form must have other aspects besides form but that it does not imply any clear criterion of what belongs to form and what does not. The commonsense concept of form is not a part of a philosophic or scientific analysis of the constitution of things.

Pragmatic considerations govern the commonsense concept of form. The point is to simplify cognitive operations. This explains why the commonsense concept implies a distinction between form and what is not form but lacks a clear criterion for the distinction. A clear criterion is not needed to facilitate ease of recognition, ease of differentiation, ease of remembering, and ease of reidentification. Whatever is enough to get the job done will do. The concept's utility requires that details carry little weight; its very strategy is to ignore details, among which is the detail of what is and what is not a detail. To add such a criterion would impede the ease of recognition, ease of differentiation, ease of remembering, and ease of reidentification that ground the attribution of form and its utility.

In addition, form is context dependent. The question "How many forms are exemplified in my study?" has no coherent answer as it stands. Consider another question with a parallel indeterminacy that partly grounds the indeterminacy of the question about form: How many things are in my study? It all depends on what counts as a thing. Consider my books. In some contexts, they all simply count as one thing (my collection of books); in other contexts, each separate volume counts; in other contexts, the number of separate titles counts, and because I have multiple copies of several titles, this number differs from the previous one. In some contexts, the number

of pages counts; in others, the number of paragraphs; in others, the number of sentences; in others, the number of words, and so on. In some contexts, the number of molecules, atoms, or subatomic particles is relevant. The question "How many forms are exemplified in my study?" is unavoidably infected with the indeterminacy concerning the number of things.

There are further dimensions to the context dependence of form. Sometimes mere change in orientation constitutes a change of form, and sometimes it does not. If I stand on my hands, it is odd to say that I have changed my form, as it is odd to say that my dog changes its form every time it rolls over. However, if I contrived to invert one of the great pyramids of Egypt and place it on what is now its apex, it is natural to say that I have altered the form of the structure radically. Similarly, if I inverted Uluru in central Australia, one of the world's largest natural monoliths, I would be taken to have drastically altered its form.[27] The operative principle appears to be that for things that frequently change their orientation, a change in orientation is not regarded as a change in form, whereas for things that rarely, if ever, change their orientation, a change in orientation is regarded as a change in form.[28]

One test of the principle is this: Take a square sheet of white paper, where there are no acceptable generalizations concerning the frequency of change of orientation, and draw a rectangle on it with the vertical sides twice as long as the horizontal. Then rotate the sheet ninety degrees. The vertical sides are now half the length of the horizontal. Are there two different forms here, or is there only one? A case can be made for either view. On one hand, I have not interfered with the figure itself; I have merely rotated the sheet of paper, so the form is the same. On the other hand, my architect may have drawn

the initial figure with the double-length vertical lines repre-
senting the vertical elevation of a building being designed for
me. I might respond that this is not what I want; I rotate the
sheet of paper ninety degrees and insist that this is what I want.
I do not want a tall, thin building; I want a long, low one. Here
the second form is radically different from the first form. Clear-
ly the answer to the question varies with the context. The orig-
inal question has no proper answer as such because no con-
text was supplied. Once specific contexts are supplied, the very
same state of affairs constitutes a change of form in some con-
texts and constitutes no change of form in others. This further
strengthens the claim that form does not mark fundamental
divisions in reality but merely marks divisions geared to vari-
able human interests.

If this analysis of the commonsense concept of form is sound,
then further light is cast on some previous judgments. Argu-
ably under strong formalism, sculpture and architecture are
the highest art forms. If the clearest applications of form are
to things that constitute a natural unity exhibiting complexity,
order, coherence, and stability, and much of traditional sculp-
ture is representational, then, at least partly, form is attribut-
ed to such sculpture because it is a representation of something
to which form is attributed in its most basic sense. Just as some
artworks are emotionally expressive because they are the rep-
resentations of human beings showing natural signs of emo-
tion, so some artworks embody form because they are the rep-
resentations of human beings that are attributed form in its
original sense. Architecture is clearly different in that it is rare-
ly representational, but it typically exhibits the characteristics
of unity, complexity, order, coherence, and stability to a high

degree and thus clearly falls under the commonsense concept of form.

But more complexity remains to be unraveled. Typically a marked transformation takes place in the concept of form in its extension to artworks. Sculpture is a good place to start. Take Donatello's *Saint Mark*, made for the Weavers' Guild around 1412. Recall that for human beings, a mere change in orientation, either of the whole or the parts, is not typically regarded as a change of form. If I sit, stand, bend down, or raise my arm, it is not correct to say that my form has changed; here details about specific orientation are simply irrelevant. But for the sculpture, precise orientation is absolutely crucial. The specific inclination of the head and body, the specific disposition of the arms and legs, even the specific folds in the clothing are important. Change the inclination of the head, move an arm, alter a fold, and the statue has a different form. Form is regarded differently if it is the form of a live being than if it is the form of a sculpture. We might seek to accommodate this point by appealing to the principle that for things that frequently change their orientation, a change of orientation is not regarded as a change of form, whereas for things that rarely if ever change their orientation, a change in orientation is regarded as a change in form. Thus the inert and unchanging sculpture would be attributed a changed form even if the head were inclined only slightly differently, whereas even if a living and moving being inclines its head extensively, this is not regarded as an alteration of its form. There is something in this, but it fails to reach the heart of the matter.

To grasp what is at issue, we need a bird's-eye view of the role of form in practical life and the role of form in art. Not only

are these roles different, but they are in conflict with each other. The ordinary attribution of form supports the enterprise of dealing with the world; here facilitation of action is paramount. Forms radically simplify identification and differentiation; they do this by drastically reducing the full complexity of the objects in question. In successful action, the cognitive tasks of grasping and monitoring the situation are vital, but they are only one aspect of successful action. Overinvestment in cognition always threatens to be counterproductive. It is important to determine whether the approaching animal is a tiger or a sheep. Quick decisions are vital. What is appropriate: fight, flight, capture, or something else? If it is a tiger, determining the precise number, width, color, and arrangement of its stripes is more likely to hinder escape if that is necessary or to frustrate a successful hunt if that is the object. Cognitive operations governing practical action demand a principle of economy. We must grasp enough of the situation for action to succeed; attention to irrelevant detail imperils success. Here the commonsense concept of form plays its part; rather than pursuing detailed and exhaustive description, it reduces objects to just enough features necessary for identification and differentiation. Drastic simplification rules here, operating on the principle of least effort needed to attain the goal.

The situation differs radically in art. Artworks are meant to be exclusive objects of attention when we are contemplating them. Utility for action is no longer an issue; what is presented for contemplation must fully absorb attention in its own right. The pared-down, instantly graspable forms so important for effective action are unlikely to command, sustain, or reward protracted exclusive attention in artworks. The very fact that form in art is there for contemplation rather than action

dictates that form in art offers more than is encompassed in the commonsense concept of form. The commonsense concept of form is essentially synoptic. Only enough is encompassed in the form of the bear to easily identify and differentiate bears from other things. My contention is that this commonsense concept of form is not of central importance in the arts. The concept of form in art transcends the commonsense concept of form in a number of ways.

The concept of form in art is essentially elaborative. The task is to present something that can command, sustain, and reward protracted attention in its own right. Here inner articulation becomes a significant factor.[29] Returning to Donatello's *Saint Mark*, that the sculpture embodies a human form is only the barest beginning; the specific inclination of the head and body, the specific disposition of the arms and legs, even the specific folds in the clothing are highly significant. Inner articulation is now one of the key factors that commands, sustains, and rewards protracted attention. The form that the figure shares with all other human beings and sculptures of human beings is insignificant. What now matters is how this figure differs from all other human beings and sculptures of human beings. Let me call the concept of form involved the specific concept of form.

The inherent dynamic of the commonsense concept of form is to expel as much detail as possible while preserving speed and ease of identification and differentiation. The inherent dynamic of the specific concept of form is to include as much detail as is needed to command, sustain, and reward protracted attention. Here forms are deployed as ends in themselves, and the power to capture and hold interest is the decisive factor. The specific concept of form is the concept of form typi-

cally operative in the arts. Clearly the two concepts are at odds with one another. The more emphatically something commands sustained attention, the more it hinders practical action. Effective action demands limited distraction; effective art demands total absorption. A concept of form crafted for action is at odds with a concept of form crafted for contemplation.

There is another difference between the commonsense concept of form and the concept of form in art. With the ordinary concept of form, form is not typically attributed to mere aggregates. A woman, a man, a mirror, a chandelier, and a dog may all individually have form, but even if they happen to be clustered together, it is odd in ordinary life to attribute form to such aggregates. The reason for this has already been established: No particular arrangement of the aggregate is likely to facilitate identification, differentiation, reidentification, and remembering; an attribution of form to the aggregate is practically useless and is not made in ordinary life. But in Jan van Eyck's *The Marriage of Giovanni Arnolfini and Jeanne Cenami* (1434), the specific arrangement of the woman, the man, the mirror, the chandelier, and the dog is an essential component of the form in the painting.[30] Nor is this point restricted to painting. In the ancient Greek sculpture *Laocoön*, where Laocoön and his two sons are struggling with a large snake, form is involved at several levels. The commonsense concept of form attributes form individually to Laocoön, each son, and the snake, but the commonsense concept would not apply to the aggregate of the four in life, even if they were temporarily interestingly arrayed. But in the sculpture, there is more to the form than the forms of the individual figures already mentioned. The precise orientation and relation between Laocoön, each son, and the snake is now critical to the

form of the sculpture. Here is an extension of the concept of form to aggregates to which the concept would not be applied in life.

Drawing these points together, there are two notable departures from the commonsense concept of form in art. First, for the forms that the commonsense concept recognizes, such as those of woman, man, snake, and dog, the specific arrangement of the internal parts of the form is significant in art in a way in which it is not in ordinary life; the inner articulation of these forms matters in art. Second, how aggregates of the forms that the commonsense concept recognizes are arranged relative to each other is of major significance in art but plays almost no role in ordinary life. In art, there is a definite extension of the commonsense concept of form in the directions of both greater depth and greater breadth.[51] These extensions are natural and are still governed by the criteria of unity, complexity, order, cohesion, and stability. But these extensions have important ramifications. In ordinary life, we are typically interested in common forms. In art, we are typically interested in unique forms. Usually it takes more features to articulate unique forms than it does to articulate common forms, and this in itself betokens a greater potential to command, sustain, and reward contemplation, quite apart from the special interest that uniqueness itself creates.

But the extensions of the concept of form in art fall short of alleviating the key problem facing formalist theories of art. Until formalists furnish satisfactory criteria for distinguishing what belongs specifically to form and what belongs to that which has form but is not itself form, formalism contains a theoretical indeterminacy that clearly enfeebles the theory. The problem is most acute for strong formalism, but it extends to

the less extreme versions. The investigations of form here reveal no real prospects of remedying this situation. The difficulty only increases in literature and music, where the application of the concept of form is even more remote from its application in ordinary life than it is in sculpture and painting.

General Assessment of Formalism

Here, again, two questions must be clearly distinguished. First, how good is formalism as a comprehensive theory of art? Second, does form have an ongoing vital role in the arts? There is a persuasive case that formalism, even in its least counter-example-prone version, is inadequate as a comprehensive theory of art. There is an equally powerful case for an ongoing vital role for form in the arts.

Let me begin with the obvious limitations of formalism. The chief difficulty in all versions of formalism is to articulate a concept of form that distinguishes formal features of artworks from nonformal features. To be sure, the difficulty is the greatest for strong formalism, but the inability to resolve it is a significant weakening factor even in the less extreme versions. Nor can this difficulty be met by noting that many legitimate concepts have a penumbra of uncertainty in their application. The legitimacy of using the concept of form in art is not under challenge; what is under challenge is its capacity to act as the foundation for a comprehensive theory of art. The latter role requires explicitness in the concept, and this demand for explicitness is in no way arbitrary. The inability to draw a clear distinction between formal and nonformal features of artworks significantly undermines claims that form is the only thing, or the most important thing, in art. Fuzziness in the concept casts doubt on the evidence that such claims must rest

on. We cannot persuasively generalize from an inspection of past art that form is paramount if the distinction between formal and nonformal features cannot be clearly drawn, and the capacity to test formalism against current and future art is equally impaired and equally corroding to the theory. As a theory, formalism would be improved if it could articulate a clear criterion to distinguish the formal from the nonformal, but such an improvement might merely highlight its other defects.

Particularly in its extreme versions, formalism is confronted with the pervasive and persistent view that in the best art everything counts.[32] This view can be supported with solid argument. The core of art lies in the production of absorbing objects of interest for conscious awareness. It is essential that the objects command, sustain, and reward protracted exclusive attention. Art that avails itself of the combined resources of the formal and the nonformal has a greater potential to command, sustain, and reward protracted attention. Visual art ought to have available all resources that enhance the capacity of visual artworks to command, sustain, and reward protracted attention. Similarly, literature ought to have available to it all the literary resources that enhance the capacity to command, sustain, and reward protracted attention, and the same applies to the other major arts. It stands to reason that artworks in which everything contributes to commanding, sustaining, and rewarding protracted attention have a competitive advantage over those with idle features that contribute nothing to these ends. Not every artwork must fully use all such resources, but it is hard to conceive how the greatest art could flourish if it was prevented from doing so.

A further challenge for formalism is to explain why form is

so important to art. The defender of the representation theory can argue that prior human interest in the world transfers naturally to representational artworks. The defender of the expression theory can argue that prior human interest in emotions transfers naturally to their expression in artworks. In these theories, representation and expression are important in art because they are solidly grounded in prior human interests. Nor are these interests in any way superficial or frivolous; they are the warp and woof of the fabric of life. Formalism lacks an equally simple and plausible explanation why form is so important to art. To my mind, there is explanation for the importance of form in art, but this explanation tends to oppose rather than favor formalism as a comprehensive theory of art.

Form plays a vital role in turning representational art and expressive art into truly absorbing objects of interest. Once we move beyond the pure representation theory and the pure expression theory, where either the world or actual emotions entirely dictate the content of artworks, the potential emerges to invest artworks with something beyond the manifest world and actual emotions and to add features that enhance the capacity of artworks to command, sustain, and reward protracted attention. Form is crucial here. Art deals with form in a way both deeper and broader than that found in ordinary life. Treating form in greater depth and breadth than is done in ordinary life furnishes artworks with unique drawing powers that directly experienced ordinary objects and directly experienced ordinary emotions lack. Whereas the world and actual emotions furnish the basic elements of form, their elaboration in art yields something new and attention absorbing. In this view, the function of form in art typically is complementary. But how can form be so important if its value is typically complementary?

To traverse familiar ground, artworks sever the normal connection between perception and action. They free us from the normally appropriate actions or concerns; all our attention can be devoted to the awareness of artworks themselves. This separation both liberates and intensifies our perceptual awareness. The very liberation and intensification of attention demand that there be enough in artworks to occupy this liberated and intensified awareness. Here our prior interest in the world and emotions supplies the foundation on which the elaboration of form constructs amplified attention-absorbing features. The special treatment of form in artworks enhances their attention-holding powers in ways that cannot be matched by ordinary objects and emotions. Although the separation from the normal flux of life effected merely by being an artwork is a significant ground for the possibility of more intense and focused experiences, artworks must make their own unique contribution to heighten that intensity, and here form plays a vital role.

But this does not yet fully capture the contribution that form makes. If the account of representation and expression embodied in the sophisticated and unrestricted representation and expression theories is correct, then art furnishes a wholly new kind of value that is unobtainable directly from the world. Artworks never show how things really are in themselves but only how artists transform them; the objects and emotions of ordinary life are cast in a new form. Artworks are impregnated with forms that are absent from the ordinary world. This is clearly evident in music and literature, but it also holds, even if less dramatically, in visual art. One of the key ways in which representational and expressive art enriches our experience is through the forms that it elaborates and articulates. Form

is what turns ordinary subject matter into absorbing objects of interest. The possibility for maximum depth, richness, and complexity in our experience of art depends on form playing a key role in the transformation of the everyday.

A natural question arises here. Why not be concerned with form directly and exclusively? Why not focus entirely on form in artworks independently of representation or expression? Again there is no valid objection to following this path. If the view proposed here is correct, then good representational art and good expressive art articulate attention-absorbing forms, and this would naturally be expected to heighten the taste for form and to create an appetite for works in which form becomes the major focus. Such a development can only be healthy, and arguably the history of art has followed it. However, there is no cogent reason why such art should supplant all other art. To abandon representation and expression is to abandon a significant source for enriching experience, not the least part of which is the captivating experience of its integral forms.

The Limits of Art

Examination of the three major traditional theories of art reveals a strong connection between art and freedom. The analysis of what artworks offer individually given these theories supports the case, and at the theoretical level, the more adequate the version of the theory is, the more freeing potential it allots to art both for artists and art audiences. This trend continues in posttraditional theorizing. Indisputably the traditional theories ultimately fail as comprehensive theories of art. The growing perception of their inadequacy was driven by three basic factors. First and foremost, there were radical and continual transformations across the arts throughout the twentieth century, transformations that the traditional theories found hard to accommodate. Second, around the mid-twentieth century philosophical developments concerning language cast serious doubts on the very possibility of defining terms such as *art* and thus appeared to undermine a ba-

sic presupposition of the traditional theories. Third, accumulating direct critiques of the traditional theories themselves continued to erode their viability. This situation paved the way for a new phase in thinking about the arts that begins with what can aptly be called the "no-theory" theory of art and contains subsequent developments such as the institutional and the historical theories of art as major players. Here the issue of the boundaries of art becomes especially prominent. I propose to consider these developments and their implications for the role of freedom in art.

The "No-Theory" Theory of Art

According to Morris Weitz, the leading proponent of this position, no definition or general theory of art is possible; indeed, no universally valid generalizations about art are possible.[1] This position is no mere reflection of the failure to attain a satisfactory definition, theory, or valid universal generalizations about art in the past. Such perceptions of failure undoubtedly were contributory factors, but his position is not simply a pessimistic projection of past failures. Rather, the key claim is that the very concept of art itself positively precludes the possibility of a definition of art and hence of any general theory that covers all art.

The position relies heavily on Ludwig Wittgenstein's innovative investigations into language.[2] In traditional views, there are two kinds of concepts. First, there are concepts that can be completely defined in terms of other concepts. The concept of triangle is a standard example: It can be defined as a three-sided, enclosed plane figure. The definition gives necessary and sufficient conditions for the application of the term. Second, there are concepts that cannot be defined in terms of other

concepts but can be defined only by what has been called ostensive definition; that is, they can be defined only by presenting an example of the feature that they refer to. "Red" is a standard example. In traditional views, both kinds of concept share a fundamental feature. For conceptually definable concepts, all instances to which the concept applies must have each of the definitional features. For ostensibly definable concepts, all instances to which the concept applies must have the same ostensibly identified feature. In this view of concepts, the concept of art would have to be conceptually definable, and there would be some set of features that all art would have, or the concept of art would be ostensibly definable, and there would be some single manifest feature that all art has.

Wittgenstein argued that there is a third kind of concept different from either of the two traditionally identified kinds. Taking games as an example, he maintained that if we focus on games themselves, we find a remarkable diversity. There are board games, card games, ball games, Olympic games, and many more. He argued that the most careful inspection fails to reveal any set of features or any single feature common and peculiar to all games.[5] There are overlapping strands of similarity, and what ultimately binds games into an identifiable grouping is resemblances. He called such concepts *family resemblance* concepts on the grounds that families exhibit just such crisscrossing strands of similarity such that different members of the family resemble each other in different respects. Some family members may have similar noses, some similar eyes, some similar ears, and so on, but those who have similar noses may not have similar eyes, and those who have similar eyes may not have similar ears. No single feature is shared by all members of the family. Family resemblance concepts form

a distinctive category of concepts, and no single or set of necessary and sufficient conditions can be given for them; in short, they are indefinable.

Weitz distinguishes two kinds of concept: closed concepts, which are definable, and open concepts, which are not. Closed concepts are the traditionally recognized concepts identified earlier, which he claims bar modification in the face of new cases; open concepts are family resemblance concepts that permit modification in the face of new case. Also, he distinguishes a descriptive and evaluative use of the term *art* and focuses specifically on its descriptive use. There is both a negative and positive prong to Weitz's case. Negatively, he argues that art could not be a closed concept because these preclude innovative creativity and genuine novelty. Consider a typical contemporary case: when Christo draped enormous sheets over whole coastlines, whole buildings, or whole bridges, was this art? The argument is that no closed concept of art could have anticipated or allowed for such developments. Nevertheless, such things are counted as art, and it is in the nature of the art enterprise that the possibility for such innovative creativity and genuine novelty be left permanently open. Positively, Weitz argues that a direct consideration of the concept of art reveals that it is an open concept – indeed, that it is a family resemblance concept of the kind identified by Wittgenstein. The failure of all previous definitions to withstand counterexamples is construed as solid evidence for this. If art is indeed such a concept, then the possibility of defining art or articulating a comprehensive theory of art is simply excluded. The fact that we do not usually rely on a definition of art to distinguish art from nonart sometimes is advanced as additional ground for the claim that art is a family resemblance concept.

But the latter point is quite weak, for almost anyone can distinguish circles from noncircles, but many would find framing a definition difficult.

The theory faces a number of formidable objections. First, the claim that definitions or closed concepts rule out creativity or novelty is unsustainable. We need to distinguish between intrinsic properties such as "red" and relational properties such as "to the left of." To be sure, if definitions are framed in terms of intrinsic properties, then they rule out anything that lacks those properties and in an important sense exclude creativity and novelty. But this does not hold for definitions framed in relational terms. For instance, let me define the concept of an "equator crosser" as follows: Anything is an equator crosser if and only if it is crosses the equator at least once. Anything can be an equator crosser: ships, aircraft, boxes, bottles, books, radios, clothes, food, fish, animals, humans, artworks, clouds, tornadoes, and so on. Be as creative as you like, create any novelty that you like, it can fall within the definition of equator crosser. Definition of itself does not preclude either novelty or creativity. Thus one of the key claims used to defend the theory collapses.

Second, there are strong arguments that resemblance alone cannot sustain any determinate grouping and that consequently the idea of family resemblance is incoherent.[4] Whatever initial grouping one makes on the basis of resemblance alone, there will always be things outside that grouping that resemble things in the group, forcing an expansion of the grouping, which in turn yields further things outside the grouping that resemble the new things in the grouping, and so on, until eventually resemblance drags in absolutely everything. The point can best be appreciated by considering families themselves.

Families do not group people together simply on the basis of resemblance. People are grouped into families on the basis of genetic and legal ties. The resemblances one detects between family members is subsequent to such a grouping and are not the basis for it. Imagine that resemblance were the sole grouping factor. For any family that I know, there are always people not in the family who resemble people in the family as much as some family members resemble each other. If resemblance were the sole operative factor, these would have to be included in the grouping. But for this expanded grouping there would be some people outside it who resemble people inside it just as much as people inside it resemble each other, these outsiders would also have to be included, and again resemblances would exist between those in this new expanded grouping and those outside it, forcing a further expansion. Ultimately all human beings would have to be included, and it is difficult to see what would prevent the spread to primates, and then all other animals and beyond. One needs to be careful about the upshot of this argument. It does not demonstrate that art can be defined. The possibility remains open that art contains a grouping of objects of such a kind that no necessary and sufficient conditions exist for membership of the group. But the argument destroys the viability of resemblance as the definition-defying principle of grouping.

Let me interpose a general observation here that will be of continuing relevance to the subsequent discussion. Any adequate account of the concept of art, irrespective of whether it is a definitional account or a nondefinitional account, must effect a separation between art and nonart. One way an account of the concept of art can fail is by drawing nonart within its compass. So some mechanism is needed to prevent the

spread of the proposed characterizing conditions beyond art into nonart. Let me call such a condition a *spread inhibitor*. Thus one of the key weaknesses of the resemblance account of the concept of art is that it lacks an effective spread inhibitor. This point has been argued in general here, but it can be seen in specific cases, as the next point shows.

Third, there is a powerful specific objection to the positive aspect of the doctrine that the relevant grouping factor for art is resemblance. If Duchamp's urinal, baptized *Fountain,* is an artwork, then surely every urinal in that style by that maker must also be an artwork if resemblance is the operative grouping factor.[5] The willingness to accept *Fountain* as an artwork without accepting every other urinal of the same style and make as artworks indicates that resemblance cannot be the crucial grouping factor. For those who are unwilling to accept *Fountain* as an artwork, other equally telling cases are available. Resemblance is a symmetrical relationship in which if A resembles B, then B resembles A. Undoubtedly Rodin's plaster statue *Naked Balzac* (c. 1893) is an artwork and resembles other artworks, but it also resembles Balzac himself and vice versa. If resemblance were the operative principle of grouping, Balzac himself would have to be just as much an artwork as Rodin's *Naked Balzac,* and this is surely an unacceptable outcome.[6] Similarly, forgeries of artworks or mere copies of artworks typically are not regarded as artworks in their own right, yet they would have to be regarded as artworks in their own right if resemblance were the operative grouping factor. In short, the resemblance account lacks an effective spread inhibitor.

Fourth, George Dickie argues that Weitz's account of the concept of art as grounded on resemblance would not permit met-

aphorical uses of the term *artwork* because any resemblance warranting a metaphorical application of the term would equally warrant its literal application. To the extent that our actual concept of art permits such metaphorical attributions, the resemblance-based account of the concept cannot be correct.[7]

Fifth, Dickie argues that the account makes genuine disagreement about whether something is an artwork impossible because anyone who claims that something is an artwork is bound to be able to find a preexisting artwork that it resembles in some measure.[8] Suppose that a person performing house repairs for me accidentally spills a can of black paint that flows out to cover uniformly a rectangular board. As soon as I point out the indisputable similarity between this board and the well-known all-black painting by Malevich, the status of my board as an artwork is established beyond dispute in the resemblance account. Yet given our actual concept of art, it makes perfectly good sense to question whether my board is an artwork irrespective of how that question is resolved in the long run.

Sixth, in perhaps the most telling argument, Dickie argues that the account involves a vicious infinite regress.[9] To be deemed as artworks, current candidates must resemble some previous artworks, these previous artworks have their status as artworks only by virtue of resembling even earlier artworks, these earlier artworks have their status as artworks only by virtue of resembling still earlier artworks, and so on. Given that an actual infinite regress is impossible in this case, the clear implication is that at least one artwork must have the status of being an artwork independently of its resemblance to other artworks. So resemblance cannot be essential to what it is to be an artwork. Furthermore, if at least one artwork must have the status of being an artwork independently of resemblance, why

could not two, or three, or billions have the very same status without resemblances to prior artworks? The essential point, considered in terms of recursive procedures, is this: Even if resemblance is adequate as the recursive rule to generate art out of previous art, resemblance remains incapable of accounting for the base of the recursion, the initial input to the rule that sets the whole process in train.

Finally, there is a serious issue whether the position is in some degree self-refuting. The strong claim that creativity and novelty are essential to our understanding of art suggests a property that may be possessed by every artwork. Every artwork has the property of being an element in an enterprise to which creativity and novelty are essential. To be sure, this is well short of a definition, and the property is quite complex, but I can see no obvious grounds for denying that every artwork possesses it, even under Weitz's own assumptions. Drawing this and the previous points together, I conclude that the positive part of the doctrine that resemblance constitutes the grouping factor underpinning the concept of art has been shown to be untenable, but here the verdict is still not in on whether the concept of art is indefinable.

Although nearly every aspect of Weitz's case has come under intense critical scrutiny in the subsequent debate, one key claim has remained basically unchallenged: The art enterprise is inherently open to creativity and novelty. Indeed, even those who argue against Weitz and maintain that a definition of art is possible accept that a defensible definition must accommodate this point. There is a remarkable and significant unanimity here. But openness to creativity and novelty is the freedom to follow new and unanticipated directions, to tread untrodden paths, to produce and present what is startlingly unlike

anything that has gone before. In this debate both sides either explicitly or implicitly accept that freedom is an essential aspect of the art enterprise. To be sure, the emphasis here is on the freedom that artists and art practitioners have in their productive activities rather than on the freeing potential of artworks themselves. But these aspects are essentially connected: An enlargement of freedom for artists increases the freeing potential of art for art audiences. In short, the debate over the "no-theory" theory strongly supports my claim concerning the centrality of freedom in the art enterprise.

The Initial Institutional Theory

The critical assault on the "no-theory" theory paved the way for fresh attempts to define art. According to Dickie, a leading participant in that assault, art can be defined in institutional terms. His widely influential initial account proceeds as follows: A work of art in the classificatory sense is (1) an artifact and (2) a set of aspects that has had conferred upon it the status of candidate for appreciation by some person or persons acting on behalf of a certain social institution (the art world).[10] Artists, presenters or exhibitors of artworks, and the art audience constitute the minimum core of the art world. But the art world also extends to art critics, art historians, philosophers of art, and the like. Indeed, at this stage Dickie held that every person who sees himself or herself as a member of the art world is thereby a member.[11] One principal merit of the definition is its apparent ready accommodation of the extraordinary developments in art over the last hundred years. It appears to handle Duchamp's *Fountain* case with ease. Another principal merit that Dickie took care to emphasize is that this definition imposes no limits on creativity, novelty, and origi-

nality in the arts and thereby demonstrates that Weitz was wrong on this point.

Although Dickie has significantly modified his account, it is instructive to consider some of the problems that the initial definition encounters and how they are dealt with in the modified definition. First, the account allows that a "rogue" member of the art world, perhaps having been inspired by Duchamp, could go around and systematically confer the status of candidate for appreciation on sets of aspects of every artifact ever made. The "rogue" member could even have impressive credentials in the art world, even though the account does not require this, as indeed Duchamp did. But surely we would be unwilling to accept that the corpus of artworks had been genuinely expanded to embrace every artifact ever made by such a procedure. Here again the account lacks an effective spread inhibitor. Although this objection is undoubtedly formally sound, it leaves unexplained the grounds for our intuitions here. But if, as I maintain, the very point of art is to free us from the mundane and the commonplace and to present us with something beyond it, then our intuitions here are grounded in an implicit recognition of what is essential to the art enterprise itself. A wholesale incorporation of the mundane and commonplace into art would defeat the very point of art, which is to supply what the mundane and commonplace typically cannot. Very limited amounts of the already existing mundane and commonplace might be incorporated into art without threatening its essential point, but wholesale incorporation is incompatible with it.

Second, let me set the stage for this critical point by outlining a story about Giotto from Vasari.[12] Pope Benedict IX sent emissaries to Giotto with the message that the pope was con-

sidering commissioning some artworks but was undecided as to whom to commission. If only Giotto would give the pope some of his artworks, the pope could judge his artistic abilities and probably would award him the commission. Giotto was suspicious that this was simply a ruse by the pope to obtain some free artworks. Giotto took a piece of paper, dipped his brush in red paint, and with a stroke drew a circle that was to all intents and purposes perfect. He gave the paper to the pope's emissaries, asking them to take it to the pope, who could assess his merits from it. The point is that Giotto was not willing to part with an actual artwork but wanted his skills to be known. He conferred the status of candidate for appreciation on a set of aspects of an artifact, but the whole point of the exercise was that he was not sending the pope an artwork. Thus, conferring the status of candidate for appreciation by even key members of the art world is insufficient for something to count as art.

Third, the concept of art appears to involve a degree of gradation even in its classificatory sense. There is a paradigmatic core of artworks comprising works such as Tolstoy's *War and Peace,* Rodin's *The Thinker,* Botticelli's *Primavera,* Beethoven's *Fifth Piano Concerto,* and Tchaikovsky's *Swan Lake.* A basic mastery of the concept of art involves identifying these as art. Anyone who seriously challenges these as art has simply failed to grasp the concept of art. Then there is a wide band of work on which there is substantial but not necessarily universal agreement that they constitute artworks. Rousseau's *Confessions* falls into this category. But anyone challenging the status of the *Confessions* as an artwork does not automatically disqualify himself or herself as lacking mastery of the concept of art. Indeed, a respectable (though not necessarily successful)

case might be mounted that autobiographies and memoirs fail to qualify as artworks. Then we reach a band about which there is far less agreement. Is Damon Runyon's *Guys and Dolls* art? Many would say that it is, but then many would say that it is not. We then reach cases in which a small minority vigorously defends the art status of certain works that the majority would either be unwilling to countenance as artworks or be willing to countenance as artworks only reluctantly. Louis L'Amour's westerns seem to fall into this category. "Wonderful escapist entertainment but not art" is a judgment that many would endorse, but some would certainly be vigorous defenders of their art status. At this end of the spectrum, one does not automatically reveal failure to master the concept of art in disputing that a living human being suspended from a gallery ceiling by hooks piercing various parts of the body constitutes art. Chopin's *Etudes* are artworks, but are Cramer's *Studies* artworks or mere technical exercises?

For our concept of art, the art status of some works is far more secure than the art status of others. The art status of *War and Peace* is more secure than the art status of *Guys and Dolls* or a Louis L'Amour western. The art status of *The Thinker* is more secure than the art status of a living body suspended by hooks from a gallery ceiling. The art status of Beethoven's *Fifth Piano Concerto* is more secure than the art status of *4'33"*. The issue here is basically one of classification rather than value. For instance, it could be that Louis L'Amour's westerns are absolutely fabulous as westerns but are either not art or only borderline cases of art. But in this initial institutional definition of art, it is impossible for the art status of one work to be more secure than the art status of another. All artifacts that have had that status of candidates for appreciation conferred on them by

a person acting on behalf of the art world are absolutely equal from the standpoint of art status. From the standpoint of the institutional definition, it would be just as absurd seriously to question the art status of *Fountain* or *4'33"*, as it would be seriously to question the art status of *The Thinker* or *War and Peace*. But this is surely not the way the concept of art works. Challenging the art status of *The Thinker* and *War and Peace* puts one's mastery of the concept of art in doubt in the way that questioning the art status of *Fountain* or *4'33"* does not. If this is sound, then this initial institutional definition of art fails to capture an important feature of our concept of art.

Fourth, an adequate definition of an artwork also requires a coordinated account of the artist that fits with our pretheoretical intuitions. For Dickie here, the artist is the person who confers the status of candidate for appreciation on behalf of the art world. In normal cases this seems unproblematic. If a novelist writes a novel and presents it for publication, surely that is tantamount to conferring on it the status of candidate for appreciation. The account seems to square well with our intuitions in the case of *Fountain,* where Duchamp turns out as the artist rather than the manufacturer of the urinal. But difficulties emerge in other cases. Let me construct a fictional case using a nonfictional identity. Let us suppose that I illegally entered Picasso's studio and stole a canvas that was well advanced toward completion. But let us suppose that Picasso was a perfectionist who would not have dreamed of presenting that canvas to the public until he was totally satisfied that it could no longer be improved in any way. In short, Picasso was not yet willing to confer the status of candidate for appreciation on it. I may regard such perfectionism as absurd, and I confer the status of candidate for appreciation on it and take it to a dealer

for sale. In the initial institutional theory, this would make me the artist. But this conflicts strongly with our intuitions here: Surely it is Picasso, who painted the canvas, rather than I, who conferred on it the status of candidate for appreciation, who is the real artist. There is a dilemma here for the institutional theorist: Either the actual maker of the artifact is the artist, or the conferrer of the status of candidate for appreciation is the artist. Picking the former gives the wrong answer in the case of *Fountain*. Picking the latter gives the wrong answer in my fictional stolen painting case. In short, the initial institutional theory lacks a coherent account of the artist.

Fifth, because the status of being an artwork requires an act of conferral by someone acting on behalf of the art world, the definition implies that there cannot be any art at all before there is an art world. This is surely an unacceptable implication. In short, this account makes it impossible for the art enterprise to get started.

Sixth, the account faces problems of circularity. These have been thought to arise both directly and indirectly. The definition appeals directly to the idea of an art world, and the objection is that this could not be explicated without a circular appeal to the notion of artworks. Roughly, the art world is the grouping of people in which artworks constitute a major focus of interest. Less direct claims of circularity arise from the definition using the notion of "candidate for appreciation." The claim is that this cannot mean just any kind of appreciation, and the point can be highlighted by amending the phrase to what it is claimed must have been intended, namely, "candidate for art-relevant appreciation." It is then argued that the notion of art-relevant appreciation can be explicated only in relation to the kind of appreciation that is appropriate to art-

works. Thus again, the very notion to be defined is being appealed to in the definition itself. At this stage in the development of his account, Dickie was prepared to accept the first of these circularities but denied that the second constituted any additional circularity and argued that the notion of art-relevant appreciation itself had to be explicated in terms of the conventions and practices of the art world.[13]

Seventh, a lack of parallelism between the art world and its practices and other institutions and their practices has been urged as an objection to the account. The claim is that the art world does not qualify as an institution. To my mind, this objection lacks the force of some of the previous objections. For one, there is an extraordinary diversity of institutions and institutional practices with highly variable levels of formality in roles and structures.[14] Thus the purely negative point that the art world is not an institution is difficult to sustain. But in any event, to my mind, the important point is not whether one actually calls the art world an institution. The key point is whether *art world* designates an actual grouping of people bound by common activities and interests in its own right and whether what it is to be an artwork must be understood in relation to such a grouping.

Eighth, although being an artifact is a necessary condition in the definition, Dickie maintained at the time that artifactuality itself was a conferred status. This is an implausible position. But this claim about the conferred status of artifactuality can be dropped without affecting the substance of the account, so the objection lacks the force of some of those mentioned earlier.

Finally, there is an objection based on the claim that a status that can be conferred can also be withdrawn. Married people can be divorced, people deemed guilty in one court may be

deemed innocent in a retrial, being an Olympic gold medalist can be withdrawn if the performance was shown to have been drug assisted, and so on. But matters appear otherwise in the case of art; it appears that once an object attains the status of an artwork, it retains that status forever. The argument then is, if art status were conferred, we could withdraw it; but we cannot withdraw art status, so art status is not conferred. But an asymmetry between conferral of status and withdrawal of status is not unusual. Even in the case of marriage, it is easier to marry than to divorce, and there are cases in which a conferred status can no longer be withdrawn. Suppose that a person is deemed guilty in an initial trial; suppose that this person works his way through every appellate court and exhausts without success every avenue of appeal, including an appeal for a presidential pardon. Once every avenue of appeal has been exhausted, the person has the conferred status of being guilty, but that status can no longer be withdrawn. Thus it is simply untrue that a conferred status can be withdrawn at any time, and thus the objection loses much of its force. In summary, although some of the objections may not be decisive, overall the initial institutional account is unacceptable as it stands.

The Intentional Historical Theory

The critical assault on the initial version of the institutional theory paved the way for further attempts to define art. According to Jerrold Levinson, a leading participant in that assault, art can be defined in relation to its history.[15] It is useful to highlight the principal difference between the initial institutional account and Levinson's intentional historical account. In the former, the key to what makes something an artwork is its relationship to a contemporary art world and its practices. In

the latter, the key to what makes something an artwork is its relationship to past art and the ways taken as appropriate ways of regarding art in its past. Levinson's account proceeds as follows: Anything is an artwork if and only if it is an object that a person or people having the appropriate proprietary right over nonpassingly intend for regard as a work of art, that is, regard in any way (or ways) in which prior artworks are or were correctly (or standardly) regarded.[16]

Does this account, unlike the "no-theory" theory and the initial institutional theory, contain effective spread inhibitors that prevent the account from extending unacceptably to contain a great deal of what we would be unwilling to recognize as art? Appearances suggest that it does. For one, the requirement that the artist have "appropriate proprietary rights" over the candidate object clearly imposes limits on what objects could be counted as artworks. It certainly precludes any single person from turning every artifact into an artwork. For another, the requirement that the artist firmly intends that the candidate object be regarded in ways in which past artworks have been correctly regarded again seems to impose firm limits on what could count as art. Correct ways of regarding art in the past act as spread inhibitors, preventing an uncontrolled expansion to embrace what we would be unwilling to call art.

However, Levinson's definition cannot be fully understood from its abstract formulation alone, and attention must be paid to how he sees it applying in specific cases. Some of the revolutionary developments in the twentieth century, such as Duchamp's ready-mades, yield critical cases. In a natural reading of Levinson's definition, *Fountain, Snow Shovel,* and *Bottle Rack* were not presented with the intention of being regarded in the way in which artworks have been correctly regarded in the past,

and this seems to rule them out as art in Levinson's definition. But he is unwilling to accept this implication, and claims that the artist's intentions need not be strictly confined to how art was correctly regarded in the past but that the artist's intentions must appropriately relate to how art has been correctly regarded in the past, and this may contain modifications to and even some element of opposition to how art has been correctly regarded in the past.[17] He regards this qualification as necessary to secure the art status of revolutionary art such as *Fountain*, *Snow Shovel*, and *Bottle Rack*. He holds that any adequate account must accommodate the possibility of revolutionary art, and this loosening is intended to meet this contingency. Let us probe the merits of this account.

First, the concession just noted opens the account to serious objections. Suppose that a multibillionaire buys all the Wal-Mart stores, turns each one into a museum, and nonpassingly intends that each item previously for sale in each store be regarded in the way prior artworks were correctly regarded. He may even add, "I intend for them to be regarded in the way in which it is correct to regard *Fountain*, *Snow Shovel*, and *Bottle Rack*," but this is not necessary, and he may simply intend to have them regarded in ways in which is has been appropriate to regard less controversial cases of art in the past. All the previous sale items in all those stores would have to count as artworks under Levinson's definition supplemented by his clarification as to how it is to be applied. The appropriate proprietary rights condition and the intentional condition are both satisfied. But this cannot be correct. Surely we would be unwilling to accept that such a procedure could so massively and indiscriminately increase the corpus of artworks. Once Levinson concedes that the artist's intentions need not be nar-

rowly restricted to simply duplicating correct ways of regarding art in the past but may include modifications and even oppositions to correct ways art has been regarded in the past, then a deviation amplification mechanism is introduced into the account that spreads uncontrolled beyond its intended application.

Second, in focusing exclusively on past ways of regarding art and on the intentions of the artist, the account is reception-insensitive. In other words, whether something is to count as an artwork is entirely independent of how it is received by current and future art audiences. This feature is damaging to the plausibility of the account. Consider the following case: Suppose that an "artist" produces cross-species hybrid plants and animals with the nonpassing intention that they be regarded in ways in which it has been appropriate to regard art in the past, and let us suppose that he or she meets the proprietary rights condition. Let me call these productions bio-mix works. Now suppose that current and future art audiences uniformly and without exception refuse to regard these bio-mix works in the ways it has been appropriate to regard artworks in the past and arrive at the consensus over time that this is mere biological experimentalism to which it is inappropriate to accord the kind of regard that it has been appropriate to accord to past art. There need not be any moral objection in this refusal, nor need these works be regarded as offensive; it may simply be that current and future art audiences are uniformly unwilling to regard them in the ways in which it has been appropriate to regard art in the past. I submit that our concept of art would rule these works out as artworks. In short, a reception-insensitive account of art cannot be adequate to our concept of art.

An acceptable account of the concept of an artwork cannot be entirely backward looking.

Third, in focusing exclusively on ways of regarding art in the past and on the intentions of the artist, the account is content-insensitive. In other words, whether something is to count as an artwork is entirely independent of its content. This feature is also damaging to the plausibility of the account. Let me consider several examples; I apologize in advance for the horrific nature of the first example, but the point depends essentially on its horrific nature. Suppose that an "artist" who owns a live healthy horse tethers it to a platform, soaks it in petrol, sets it alight, and nonpassingly intends that this be regarded in the way in which it has been appropriate to regard art in the past.[18] Perhaps the intended appropriate way to regard it is the way in which it is appropriate to regard the descent into hell of Don Giovanni at the end of Mozart's *Don Giovanni*. The "artist" may even give the "work" a title: *Real Animal Tragedy*. I submit that we would not be willing to call this an artwork, but this is not simply repeating the previous point about the concept of art being reception-sensitive. What rules *Real Animal Tragedy* out as an artwork is its horrific content.[19] To my mind, the case must be understood in terms of values rather than in terms of reception. The problem with *Real Animal Tragedy* is that the manifest substantive disvalue it produces simply overwhelms the positive values that its contemplation might deliver. Things cannot count as artworks where they manifestly destroy far more value than they have any prospect of creating. The art enterprise is essentially concerned with creating and increasing value. A totally content-insensitive account of art that permits enormous net losses of value aris-

ing from the contents of artworks cannot be adequate to our concept of art. Let me introduce a variant of the *Real Animal Tragedy* case. Suppose that someone constructs a life-size robotic horse, soaks it in petrol, and sets it alight, and its movements and sounds resemble those of a live horse being burned, and the "artist" nonpassingly intends that this be regarded in the way in which it has been appropriate to regard art in the past. The "artist" might give the work the title *Artificial Animal Tragedy*. *Artificial Animal Tragedy* might well count as an artwork because it lacks the potent value diminishing content that *Real Animal Tragedy* possesses. In summary, there are telling objections to the intentional historical account; it fails to draw the boundaries of art where they lie.

The Historical Narrative Approach

The historical narrative approach taken by Noël Carroll does not purport to furnish a definition of art; indeed, it casts doubt both on the possibility of a definition of art and on the need for one. Carroll views art as a cultural practice understood by its participants rather than as an institution.[20] His approach offers an account of how we identify works as artworks and, in particular, how we resolve disputes in contested cases. The core of the account is that we now identify something as art by virtue of either an implicit or explicit historical narrative that appropriately connects the candidate artwork to the past evolving tradition of art, which includes past art practices and also the artist's intentions. History, rather than theories of art, is the key to establishing whether new objects are to be identified as artworks.[21] Carroll has undoubtedly shed light on how we come to recognize something as an artwork. According to Carroll, the appropriate status establishing historical narra-

tive must have a special structure, and he supplies the following formula: X is an identifying narrative only if X is (1) an accurate and (2) time-ordered report of a sequence of events and states of affairs concerning (3) a unified subject (generally the production of a disputed work) that (4) has a beginning, a complication, and an end, where (5) the end is explained as an outcome of the beginning and the complication, where (6) the beginning involves the description of an initiating, acknowledged art historical context, and where (7) the complication involves tracing the adoption of a series of actions and alternatives as appropriate means to an end on the part of a person who has arrived at an intelligible assessment of the art historical context in such a way that she or he is resolved to change (or reenact) it in accordance with recognizable and live purposes of the practice.[22]

Let us consider this position. First, the account is strongly, although not exclusively, oriented to resolving disputed cases of art. Therefore, it must be able to resolve the issue of art status both in the affirmative and in the negative. That is, it must be able to establish not only that some candidate is an artwork but also that some other candidate is not an artwork. But the formula is entirely silent on how a historical narrative could establish that in a disputed case, some work is not an artwork. There is simply no clear mechanism to establish the negative case. One solution here is to claim that only a mechanism to establish the positive case is needed, for the negative case can then be defined in terms of the positive case. Thus the disputed case is resolved in the negative if there is no appropriate historical narrative to establish the positive case. Conceptually appealing as this may be, there is a fundamental difficulty. The procedure is simple in the positive case: Just supply

an appropriate narrative. But how can one prove that no appropriate narrative exists to be constructed? How hard do we have to try to construct one? Carroll gives an example of a case in which he believes that an appropriate art status conferring narrative could not be constructed: He argues that this is so for van Gogh cutting off his ear.[23] But because van Gogh's cutting his ear off is not a disputed case of an artwork, the example is of little help in seeing how disputed cases are to be resolved in the negative. As a dispute resolving proposal, the historical narrative approach faces serious doubts about whether it contains a coherent account of how we can decide the issue in the negative, that is, that a disputed candidate is not an artwork.

Second, suppose that there is a narrative of the kind required by the formula – call it the *Fountain* narrative – connecting *Fountain* in a positive way with past art. Further suppose that there is also a rival historical account that rejects *Fountain* as a genuine continuation of the past traditions of art and dismisses the *Fountain* narrative as merely dealing with superficial and peripheral strands of connectedness in that tradition.[24] The difficulty is real because one clause in Carroll's account requires it to establish of a person in the narrative that he or she has an intelligible assessment of the art historical context. But whether a person has achieved an intelligible assessment of his or her art historical context is an issue on which fully informed art historians can legitimately disagree. What criteria are to be used to resolve which of these rival narratives is to prevail? There is limited theoretical advance in the historical narrative approach if it is just as difficult to specify under what conditions a narrative can successfully establish the art status of a candidate artwork as it is difficult to establish di-

rectly under what conditions a candidate artwork qualifies as an artwork. Indeed, given the legendary disputes of historians including legitimate differences in their interpretations, it will surely be at least as difficult to identify under what conditions a narrative suffices to establish the art status of candidate as it is to identify a candidate as an artwork in the first place. The issue of identification shifts from how we identify an artwork to how we identify an art status establishing narrative. But the second identification problem is arguably no easier than the first and may even be more difficult. Presenting some persuasive examples of such narratives is of no more assistance in solving the second problem than presenting some persuasive examples of artworks assists in solving the initial problem.

Third, it is not entirely clear whether the account is meant to be universal by proposing that every disputed case can be settled decisively by an appropriate historical narrative or whether the account is merely being proposed as a way of settling some disputed cases.[25] Under the first interpretation, this seems to imply that a neat classification of things into art and nonart is possible and that there are no genuine borderline cases unable to be resolved by the method of historical narrative – that every case in principle can be definitively settled. But this is highly contestable, and arguably some disputed cases are inherently irresolvable. My own case is Louis L'Amour's westerns. To my mind, the case for and against art status is about equally strong, and I cannot imagine an accurate historical narrative that could decisively tip the balance one way or the other. In short, in this interpretation the account fails to allow for genuine borderline cases that I take to be a feature of the concept of art. Under the second interpretation, if the account is merely proposing a settling pro-

cedure for only some disputed cases, then this is tantamount to an admission that historical connections are not overridingly important in identifying something as art.

Fourth, as in Levinson's case, as a temporally backward-oriented account it is reception-insensitive; whether something is to count as an artwork is independent of how it is received by current and future art audiences.[26] But this is surely implausible. The account allows for the possibility that an appropriate historical narrative might exist that according to the account establishes the art status of a candidate artwork, but current and future art audiences uniformly and without exception refuse to accept it as an artwork. Such a possibility seems real in the case of the bio-mix works mentioned previously. I can see no reason why an appropriate historical narrative ought not to be accompanied by total rejection by current and future art audiences.[27] This possibility is heightened by the fact that Carroll merely requires that the artist make an intelligible assessment of the art historical context and not necessarily an accurate assessment. To my mind, such rejection carries substantial weight and has the power to override historical narratives, which means that at best the historical narrative account is incomplete. If it is claimed that the envisioned situation could never arise, then we need an explanation for how this could be so because having a historical narrative attached to a candidate and how the candidate is currently received are logically independent. If it is made analytic that a historical narrative would count as establishing the art status of a candidate only if it does not leave open the possibility of total rejection by art audiences, then this would be tantamount to requiring the account to be reception-sensitive. This would be a retreat from the central

thrust of the account because the central thrust is that look-ing to the past is sufficient to establish art status. The envi-sioned concession would require looking to the future as well as the past, and this seems to fit better with an institutional account.

Fifth, unlike Levinson's account, the historical narrative account is not overtly content-insensitive; it leaves the issue to art's history. But I think that the account still faces a difficulty here. Insofar as I have a grasp of the idea of a historical nar-rative sufficient to establish the art status of a candidate work based on the examples in the literature, I cannot see any rea-son why an appropriate narrative could not establish the art status of *Artificial Animal Tragedy* if anyone bothered to cre-ate it. However, if *Artificial Animal Tragedy* were created and accepted as an artwork on the basis of an appropriate narra-tive, with this precedent, I find it difficult to see why an appro-priate narrative could subsequently not also be given for *Real Animal Tragedy*. But for reasons already given, this seems to me unacceptable.

No doubt the proponent of the historical narrative account can argue that whatever makes *Real Animal Tragedy* unac-ceptable as art, if it is indeed unacceptable, is grounded in past art and its traditions that would preclude the construction of an art status conferring historical narrative in this case. There is clear merit in the reply, although my intermediary case is intended to cast doubt on its ultimate adequacy. To my mind, the basic problem here is this: Until we antecedently establish what is really fundamental and important about art, we are in no position to assess whether a historical narrative estab-lishes or fails to establish the art status of any given contested case. We need an account of the underlying point of the whole

art enterprise to be in a position to distinguish genuine art status–establishing narratives from those that fail to do so. Indeed, the more hotly the art status of a candidate is contested, the more we need such an account. In summary, the historical narrative account constitutes a valuable perspective on the nature of art, but it faces the same problem of response-insensitivity as the intentional historical account and is arguably incomplete in other respects.

The Modified Institutional Theory

Dickie freely acknowledges that his initial account faces serious difficulties.[28] Most of the difficulties arise from the condition that being an artwork is at least in part a conferred status, and this is something that he explicitly rejects in his modified account. In his modified account, the concept of a work of art is not selected and highlighted as the principal object of focus; rather, Dickie presents a set of interrelated definitions among which the definition of a work of art, as central as it may be, is only one definition but one that must be understood in relation to each of the others. Jointly these definitions characterize art's essential framework for Dickie. These are the definitions: (1) An artist is a person who participates with understanding in the making of a work of art; (2) a work of art is an artifact of a kind created to be presented to an art world public; (3) a public is a set of people who are prepared in some degree to understand an object that is presented to them; (4) the art world is the totality of all art world systems; and (5) an art world system is a framework for the presentation of a work of art by an artist to an art world public. I propose to raise four points in relation to these definitions.[29]

First, the circularities in the definitions are evident and are both acknowledged and defended by Dickie. Do they vitiate his account? Let me present an argument that they do not. Take the case of modal terms such as *necessary, possible, impossible,* and *contingent.* These notions can be defined in terms of each other, but there is no way to break out of the circle of definitions and define any of these notions in nonmodal terms. There is an elaborate semantic theory that seeks to make systematic sense of these modal terms, but the notion of a "possible world" is at the very heart of the theory.[30] A great deal can be said in the theory about possible worlds and their structure, and there is no doubt that the grasp of modal terms is enhanced in the process. But the theory does not break out of the circle of modal terms: Possibility itself is explained in terms of "possible world." This is surely closely parallel to explicating artworks in terms of "art world." The point can be put rhetorically: If ineradicable circularity can be part of an informative account of modality, why cannot ineradicable circularity be part of an informative account of art?

Second, Carroll argues that this revised account is insufficiently specific and articulates a structure that is not unique to the art enterprise but is one that is shared by a number of enterprises, including philosophy.[31] He argues that if one replaced *art* with *philosophy, artwork* with *work of philosophy, art world* with *philosophy world,* and so on, then the structural relations articulated by Dickie also hold just as much for the philosophy enterprise as they do for the art enterprise.[32] The point is persuasive, but its precise import must be noted carefully. If the point is sound, then it means that Dickie's set of definitions fails to articulate a set of sufficient conditions for the art enterprise. But that in no way shows that it does not articu-

late a set of necessary conditions for the art enterprise. To successfully articulate a set of necessary conditions is an attainment in its own right.

Third, the account deals more adequately with some of the difficulties raised for previous accounts. For example, the account is explicitly reception-sensitive, which I have argued is necessary for any satisfactory account of art. The situation in regard to content-sensitivity and containing an effective spread inhibitor is less clear-cut. Certainly the account cannot be accused of being overtly content-insensitive or of overtly lacking an effective spread inhibitor. In this account, the degree of content-sensitivity and the degree of permissible spread are matters for the art world itself to determine. So the account does contain implicit mechanisms to regulate content and to regulate spread. But in my view, certain kinds of extreme contents and excessive amounts of spread are incompatible with the art enterprise, and an account of art that made this explicit would be preferable to one that did not. However, as I will shortly argue, the modified institutional theory could easily be supplemented to accommodate this point.

Finally, an intriguing challenge to the institutional theory of art arises from the claim that we can coherently conceive of a single person in complete isolation from other people and their institutions who could both create and enjoy art.[33] Consider the case of a baby surviving a plane crash on a humanly uninhabited island and managing somehow to survive into adulthood. Such a person might one day notice a rough similarity between the shape of a rock and a local animal such as a tiger but also notice a number of clear dissimilarities. Suppose that this person had already had experience in modifying stones to create primitive tools. This person might sense that by chipping away

at the stone where it deviated in appearance from the tiger he or she might get the stone to look even more like a tiger. Suppose the person did just that and succeeded in modifying the stone to the point at which it appeared pleasingly similar to a tiger. Suppose that this person placed the object in his or her cave and enjoyed looking at it from time to time, deriving pleasure both from simply looking at it and from its resemblance to actual tigers. Surely this tiger figure constitutes art for such a person – so the argument goes. In discussing an analogous case, Dickie argues that merely being a representation is not sufficient to make something art.[34] Passport, driver's license, and credit card photographs illustrate the point quite neatly. What about the point that the person simply enjoys looking at the tiger figure? That also is insufficient for it to count as art, for presumably the person also enjoys looking at other things that are in no way candidates for art status, such as some plants, animals, and natural scenes. Nor is the combination of these two points sufficient. Some people enjoy looking at their passport photographs, but that does not make them art. Perhaps if we add the fact that the person exerted some effort to produce it. But this is not sufficient to make the difference, for the tiger figure, even if enjoyable to look at, may have been produced to throw at tigers in an attempt to ward them off, with its representational character being regarded as especially likely to contribute to its efficacy in this regard. For the entirely isolated person, an object's being a representation, being enjoyable to contemplate, and being his or her own artifact are neither individually nor jointly sufficient to turn that object into art.

One difficulty here is this: Art is a general concept; the mere existence of the individual tiger figure and the enjoyment in its contemplation cannot of itself generate a concept of art. The

tiger figure furnishes no rule whatever as to how future items are to be classified. Is it to be classified with all stones? Is it to be classified only with stones that have been intentionally modified? Is it to be classified with all things that have been intentionally modified? Is it to be classified with all things that are enjoyable to look at? Suppose that the person enjoys simply looking at the flickering flames of fires and the flickering shadows on the cave wall, some of which occasionally resemble animal shapes; will these be classified with the tiger figure? Is it only to be classified with representations or what seem like representations, and does that include reflections in water? Suppose that the person enjoys looking at clouds and occasionally notices that they take shapes similar to animal shapes, including tigers, on occasion; are such clouds to be classified with the stone tiger figure?

For the tiger figure to count as art, there must be a rule that distinguishes it from nonart. Even if the isolated person is unable to self-consciously articulate such a rule, the rule must at least be implicitly used by the isolated person. It is incoherent to suppose that the isolated person both draws no fundamental difference in kind between the tiger figure and any other object, and yet the tiger figure constitutes art whereas the other things do not. But as my list of possible rules and classifications suggests, it is implausible that the isolated person is operating with a determinate rule at all and even more implausible that the isolated person is implicitly operating with a classificatory rule that is even close to the one we use in differentiating art from nonart. For something to be art for a person, it has to be at least implicitly recognized as art by that person; otherwise, the object in question is just another object among all the other objects that that person encounters

and whose presence he or she may enjoy. But the conditions for recognizing something as art, even if only implicitly, are absent in the isolated person case. Obviously such a person no more needs a definition of art to recognize something as art than we do, but even implicit recognition implies relevant concept possession and specific rule-governed classification that it is simply implausible to ascribe in the envisioned situation.

But these arguments notwithstanding, intuitions that the isolated person has produced genuine art are sufficiently strong that it has driven one supporter of the institutional theory to contemplate the desperate expedient of claiming that our isolated person forms an institution without the involvement of any other people and solely performs a variety of institutional roles within it.[35] But such a maneuver surely stretches the concept of institution beyond breaking point and, in any event, empties the institutional theory of art of any substantive content. To my mind, the isolated artist does not represent a genuine possibility and thus does not constitute an insurmountable difficulty for the institutional theory.

The Art Enterprise and Value

The positive insights of posttraditional theories of art notwithstanding, some characteristic but not necessarily universal deficiencies have emerged. Three related factors are especially significant. First, an adequate account of art must contain an effective spread inhibitor that prevents the account from flowing well beyond the bounds of what most people would consider art. Second, an adequate account must be reception-sensitive. The account must not deem something to be art that no one is willing to accept as art. Failure on this point does not

have to lead to the uncontrolled spread of the account to anything and everything, so this factor is related to but independent of the first. Third, an adequate account must be content-sensitive at least in the minimal sense that nothing can count as an artwork if its content is manifestly destructive of value that clearly and substantially outweighs any prospects of positive value that the work might offer.

My contention is that these are not arbitrary demands or merely formal conditions of adequacy, but rather that they flow from the fundamental nature of the art enterprise itself, which is to create and deliver values that are not independently available in the preexisting nonart world. The demand that the values art generates reach beyond those that are already available independently of art grounds the requirement that any adequate account of art contain an effective spread inhibitor that prevents a wholesale incorporation of preexisting nonart objects into art. Such a wholesale incorporation is incompatible with the creation and delivery of values that are not already available independently of art. This requirement does not rule out the incorporation of some preexisting objects into art such as *Fountain*, where the context furnished by such incorporation may create and deliver values that are unavailable outside an art context, but such incorporations could only be strictly limited. The idea that a sweeping incorporation of preexisting objects into art could create and deliver values that those objects are not antecedently capable of delivering is incredible.

Similarly, the requirement that an adequate account of art must be reception-sensitive also follows from this fundamental value augmenting nature of art. A universal unwillingness by art audiences to regard an object as a possible source of the

kind of value they seek in art completely undermines the capacity of such an object to deliver such values. The point of art is to deliver value, and this is not essentially a point about good art or bad art; the point of all art is to deliver value. Bad art may not deliver much or indeed any positive value, but whether it succeeds or not, that is its point. Objects that art audiences universally reject even as candidates for creating and delivering the kind of value that they seek are simply pointless. They have no positive role in the art enterprise; they are not art. Accounts of art must be reception-sensitive. For art to create and deliver value, someone must be prepared to receive that value.

The requirement that an adequate account of art must be content-sensitive also follows from this fundamental value augmenting nature of art. Nothing can count as an artwork if its content is manifestly destructive of value that substantially outweighs any prospects of positive value that it might offer. The point of art is to create and deliver value that is not already independently available; a work that in net terms is destructive of value is simply incompatible with this fundamental point and cannot count as art.

My claim is that characteristic weaknesses in posttraditional theories of art could be significantly ameliorated if there were an explicit recognition that the essential point of art is to create and deliver values that are not independently available in the preexisting nonart world. In the earlier chapters I explored some of the ways in which art could create and deliver such values and argued that a positive freeing from the preexisting nonart world was an essential condition for the creation and delivery of such values. That freedom has the central role I claim it has in creating and delivering such values may well

be open to challenge, although the posttraditional theories manifestly also accept either implicitly or explicitly that freedom is essential to the art enterprise. But it is surely beyond any reasonable challenge that the essential point of art is to create and deliver values that are not independently available in the preexisting nonart world.

Art and Progress

The possibility of progress in art is frequently denied. The issue is crucial to the nature of value and the role of freedom in art. Thinking here often is vitiated by unreflective reliance on an inappropriate model of progress for the arts, namely the scientific model. Art is compared unfavorably with science, which is seen as progressive whereas art is not. Taking physics, Galileo improves on Aristotle, Newton improves on Galileo, Einstein improves on Newton. The physics of Einstein is clearly superior to the physics of Aristotle. For obvious reasons, this can be called the supersession model of progress. But taking music, Mozart is not an improvement on Bach, Beethoven is not an improvement on Mozart, Wagner is not an improvement on Beethoven, and Bartók is not an improvement on Wagner. The music of Bartók is not clearly superior to the music of Bach.[1] To many, nothing could be plainer than that there is progress in science and no progress in art.

The critical assumption here is that a model of progress appropriate to science is also appropriate to art. It might be an appropriate model for art if there were no other models of progress or if the aims of art were essentially the same as those of science. Neither situation obtains: There are other models of progress, and the aims of art are not those of science. Let me turn to alternative models of progress. Progress in mathematics over the centuries has been enormous, but it only rarely consists of better theories replacing worse theories; the general rule is that complementary theories are added to those already there. Number theory, differential and integral calculus, geometry, group theory, set theory, and so on, all make their cumulative contribution. Typically progress in mathematics consists in adding to what is already there rather than superseding it. For obvious reasons, this can be called the accumulation model of progress.

The accumulation model is a more suitable general model for progress in the arts.[2] This is evident partly from the way in which valuation works in the arts. It makes good sense to seek to improve quantum mechanics, and even small modifications could be real advances. However to seek to improve Tolstoy's *War and Peace* or Beethoven's *Ninth Symphony* after their creators are fully satisfied that they themselves cannot improve them any further is pointless. Even if it is true that had *War and Peace* or the *Ninth Symphony* not existed, a more perfect *War and Peace* or *Ninth Symphony* could have been created, once they actually exist and establish their presence in aesthetic space, tampering with them violates their integrity. It is certainly appropriate to seek to write a grander novel dealing with the same issues, but the more it resembles *War and Peace* the less of an aesthetic achievement it is, and the

less it resembles *War and Peace* while still succeeding as a novel dealing with the same issues, the more it deserves a place beside *War and Peace* and not in place of it.

One objection to the accumulation model as applied to art is that it makes no allowance for quality and simply reduces progress to increasing quantity. This ignores the inevitable involvement of quality. To enter the corpus of living artworks, artworks must make genuine contributions that have not already been made. The increase is not merely a quantitative one; it is the quantitative increase of the qualitatively well endowed. A virtue of the accumulation model is that it can be refined to accommodate more complex situations. Suppose that in one period there are a large number of fine additions to the corpus of living art, and in the next period of comparable length there are few additions of fine artworks. Here we can legitimately speak of a relative decline in art, even while there is some progress overall. Thus by taking the rate of accumulation into account we can identify relatively barren and relatively fecund periods in art. This does not end the complications. There might be periods in which there are very few additions to the corpus of living art, but they are all of the highest quality, and other periods in which there are many additions to the art corpus, but most are not of the first rank. In these cases it is largely arbitrary which period we call the more progressive.

Furthermore, fuller notions of progress in art are possible that have the accumulation model at their base. As the corpus of living artworks expands over time, it increasingly reveals the nature of human beings to themselves.[5] This is an additional dimension of progress beyond the sheer numerical increase in high-quality artworks. In revealing the nature of

human beings to themselves, art not only increases understanding of human nature but also increases respect for it. The staggering creativity of human beings and their indomitable urge to communicate their creations shows itself in the evolving corpus of living artworks.

It merits emphasis that the numerical increase in high-quality artworks is not the only issue here. Works devoted to art criticism, art history, sociology of art, psychology of art, art theory, aesthetics, and the philosophy of art also steadily increase.[4] Collectively these add new dimensions of meaning to art that would be lacking if we had only the growing corpus of artworks. The growth of meaning applies both to individual artworks and to the corpus as a whole. Just as multiple perspectives on the world enlarge and enrich our conception of it, commentary on artworks from different points of view and different subject areas enlarges and enriches our conception of them and eventually of art itself. In addition, for performance-dependent arts such as music, theater, and dance, the varying interpretations of directors, actors, dancers, and musicians reveal hidden aspects of artworks and generate enlarged and enriched conceptions of them. These interpretations in turn generate further commentary with further potential for meaning expansion. Progress in art consists of more than a numerical increase in high-quality artworks; it also consists of a collateral increase of meaning-expanding commentary and performance.

A further dimension of the accumulation model merits consideration. The addition of artworks to the existing corpus of living artworks is not the addition of entirely independent and inert elements that exert no influence beyond themselves. The addition of any artwork to the corpus has transformational effects on the corpus as a whole, however slight they might be.[5]

If the music of Mozart were the only music in existence, its meaning would differ markedly from its meaning in a musical context that also contains the music of Bach, Haydn, Beethoven, Wagner, Bartók, and so on.[6] If the visual art of Picasso were the only visual art in existence, its meaning would differ markedly from its meaning in its actual historical position. The addition of new works brings into sharper relief works that are already there and brings previously unnoticed aspects to light. Nor should this be interpreted in narrowly perceptual terms; the very meanings of artworks change against an evolving and increasing background of other artworks and art commentary. Sometimes this occurs indirectly, but at other times artworks are directly affected by becoming the objects of other artworks such as the *Mona Lisa* in the hands of Marcel Duchamp and Andy Warhol.[7] Clearly the process of addition is double-edged, for while it enriches our conception of some works and increases our admiration for them, it undermines the status of others to the point of elimination or major displacement in the corpus of artworks. This implies an important point about aesthetic value in general.

Aesthetic value is partly intrinsic and partly relational.[8] There must be something in artworks by virtue of which they are good artworks, but at least part of their value depends on their relationship to the world and to other artworks. That aesthetic value depends partly on what is intrinsic to artworks is hard to deny, but there may be doubt about the dependence of aesthetic value on relationships to the world and to other artworks. Let me bolster the arguments already advanced with a number of extreme hypothetical cases. Imagine two worlds in each of which there are only the two colors green and yellow. In one world, 99 percent of the visible surfaces are green, and only 1 percent

are yellow. In the other world, the situation is reversed: 99 percent of the visible surfaces are yellow, and 1 percent are green. A predominantly green artwork simply cannot be seen in the same way in the two different worlds. The very significance of the color green is different in the two different worlds. The capacity of such an artwork to command, sustain, and reward contemplation must surely differ in the two different worlds. If we return to this world, a predominantly white visual artwork cannot have the same meaning for those whose environment is permanently snowbound and those whose environment is permanently lush jungle. Put abstractly, the very meaning of a color, the very way in which a color is perceived in artworks, depends partly on the frequency of occurrence of that color in the world outside art.[9]

We can repeat the argument for shape. Imagine two worlds in each of which there are only objects with two shapes, the sphere and the cube. In one world, 99 percent of the objects are spheres, and only 1 percent are cubes. In the other world, the situation is reversed: 99 percent of the objects are cubes, and 1 percent are spheres. An artwork that contains only a sphere cannot be seen in the same way in the two different worlds. The very significance of a sphere is different in the two different worlds. Again, the capacity of such an artwork to command, sustain, and reward contemplation must surely differ in the two different worlds. Put abstractly, the very meaning of a shape in artworks depends partly on the frequency of occurrence of that shape in the world outside art.[10] To generalize from these two central cases, the significance of anything that features in artworks depends partly on its place in the world outside art, and this applies just as much to other art forms as it does to visual art. If an incident of eating dogs occurs in a novel, it cannot have

the same significance for a person from a society in which such behavior is considered perfectly natural and a person from a society in which such behavior is abhorrent.

Turning to a real example, Steiner argues that the vast bulk of English poetry from its inception to the present is well on its way to disappearing from the corpus of living artworks because of the high level of classical Greek, Roman, and biblical allusions it contains.[11] The cultural background in which such poetry could be read with easy comprehension and unforced enjoyment is simply gone. Its meaning is now recoverable only with the aid of extensive annotation and commentary that destroys whatever vitality, spontaneity, and immediacy of impact it originally had. The capacity of these artworks to command, sustain, and reward contemplation has been seriously if not fatally diminished by changes in the background culture. It is unreasonable to maintain that the value of these works is unaffected when almost no one now experiences the unforced delight that they once occasioned.

Let me turn to the dependence of aesthetic value on the relationships between artworks. Suppose that I write a play that is literally indistinguishable from *King Lear* except for the last two lines. Whereas *King Lear* ends with "we that are young shall never see so much nor live so long," my new play ends with "we that remain will not see much or live long." If we think of aesthetic value as entirely intrinsic, then my tragedy is almost as good as *King Lear*, and the art world should be grateful for something of nearly the same quality as *King Lear*. But this is nonsense. That *King Lear* is already there means that anything new must be measured against it, and the very same intrinsic qualities that make *King Lear* great make my play aesthetically otiose. If only intrinsic qualities mattered,

then my play should take its place solidly next to or only the merest shade below Shakespeare's *King Lear*. That it clearly cannot means that intrinsic qualities are not the only ones that matter. The repetition of the intrinsic qualities in one artwork of the intrinsic qualities in another artwork is relevant to an assessment of its aesthetic merit.

Let me defend the point with another example. Imagine a rectangular visual artwork of specific size, divided in half with a horizontal line, each half colored uniformly by a different color, green on top and orange below. It is conceivable for such a work when first produced to be characterized as fresh, bold, innovative, stimulating, and absorbing. But suppose that the artist continues producing just such visual artworks, the only variation being differing colors in the two halves. After a few hundred of such productions, the latest probably would justly invite characterization as stale, staid, unimaginative, uninspiring, and boring. Nevertheless, had the latest production been the first in the series, it might well deservedly have been characterized as fresh, bold, innovative, stimulating, and absorbing. In short, the value of an artwork does not depend only on its intrinsic characteristics but also on how it relates to other artworks.

A further issue germane to the accumulation model arises here. The increasing corpus of artworks and art commentary seemingly creates an increasingly tough aesthetic environment for artworks to survive in. Every important addition appears to raise the entry level for those to come. The task confronting artists is to do something different and at least as good as what is already there. One contention is that the aesthetic space occupied by the current corpus of living artworks is so dominated and crowded by the creative giants of the past that no

more large-scale areas remain to be filled. Taking music, there is no large enough area left in the aesthetic space of music to take another Bach, Haydn, Mozart, Beethoven, or Wagner. In this view, there may still be interstices to be filled here and there, but major contributions are no longer possible. A similar case could be advanced for literature and visual art. Several assumptions in this pessimistic view warrant examination.

One assumption is that aesthetic space is fixed and finite and that each new addition to the corpus of living artworks diminishes the possibility for further worthwhile additions. This is highly questionable. There simply would have been no place in aesthetic space for Bartók's string quartets in the late eighteenth century; they just would not have counted as music. Even Beethoven's late string quartets struggled for a place some time later. But the aesthetic space of music expanded to accommodate both Beethoven and Bartók and will doubtless expand even further. The point is that the addition of anything genuinely new to the corpus of living artworks partly transforms artworks already in that corpus. It is more plausible to argue that each genuinely new creation expands the possibility for further new creations rather than diminishing them. To put the argument in a psychologically crude way, change the aesthetic inputs to artists and you change their aesthetic outputs. Every genuinely new artistic production creates a new aesthetic environment in which it is improbable that only the very same aesthetic responses are possible as were possible in the previous aesthetic environment.

The Sources of New Art

Although typically existing art and art commentary profoundly affect the art that continues to be produced, art rarely forms a

closed causal loop. The conditions of contemporary life inevitably influence its art. The conditions of life undergo relentless change, and these feed into the production of art, whether they are explicitly acknowledged or not. Typically the best art transcends its age, but equally typically, the best art also says something special to its own age that it says to no other. Those who seek to produce an art that speaks to their age will inevitably, where successful, produce new art. This implies that the task of art can never be completed, for as the conditions of life unavoidably change, so will the art most suited to those conditions.

Earlier I argued that art frees us from habitual ways of perceiving, thinking, feeling, and acting and develops an inner world of experience that, though different from the experience of everyday contemporary life, arises only in relation to it. For art to loosen the bonds of habitual ways of perceiving, thinking, feeling, and acting, it must allude to current life, however indirectly. The starting point for increased freedom and an increased inner life must always be life as it is currently lived. This implies that the task of art in relation to life remains essentially incomplete unless human life ceases to change entirely. Even if we ignore all the past evidence of the propensity of human life to change, the underlying biological fact that, apart from identical twins, all human beings are genetically unique forcefully suggests that changes in human life are inevitable as each crop of genetically unique individuals is added to the human mix.

How much new art is influenced by life and how much new art is influenced by previous art obviously changes with time. The first art must have arisen from life directly because there was no art to influence it. But as the corpus of living art grows

in quality and quantity, the scope for the influence of previous art in the production of new art constantly increases, to the point where some art is produced almost entirely in reaction to previous art. However, art produced under the pressure of life has a capacity to speak to its age that art produced entirely in response to art does not. Either way, the two major sources of art now, art and life, each has its own inner dynamic driving ceaseless change and generating new possibilities for artistic creation that are further enhanced by the interaction of the two streams. Both individually and together, art and life change in ways that undermine the art pessimists.

The expanding corpus of artworks contains more and more of what has the potential to free, to command, sustain, and reward contemplation, and to enlarge the inner self. The very growth of such a corpus involves an expanding art world principally concerned with producing, promoting, presenting, evaluating, and preserving the growing corpus. This creates new possibilities for ways of life that are almost exclusively preoccupied with art itself. The art world in time generates routine and habitual ways of perceiving, thinking, feeling, and acting in relation to art. But if the inherent dynamic of art is to free us from routine and habitual ways of perceiving, thinking, feeling, and acting, then we can expect that dynamic to be in evidence when the routine and habitual become aspects of the art world itself. If I am right, then the so-called anti-art movements of the twentieth century can be understood at least partly as manifestations of the underlying dynamics of art.

Such developments merit attention. Art that frees us from the routine and habitual ways of perceiving, thinking, feeling, and acting that are specifically features of the art world are likely to be less rewarding for those who are not full par-

ticipants in that world. Art preoccupied with art has limited appeal for those who are principally preoccupied with life; for them, art preoccupied with life is likely to have more appeal. My position makes sense of Duchamp seeking to enter a urinal in an art exhibition, the notorious *Fountain*.[12] It was intended to disturb habitual and routine ways of perceiving, thinking, feeling, and acting in the art world and thereby promotes freedom in it.[13] The inclusion of such an object in an art exhibition was bound to be shocking. However, the effectiveness of the gesture depends heavily on context, on precisely the routines and habits that it meant to disturb, and on the mildly taboo aura of objects directly associated with excretion. Accepting that it is a freeing act, the critical question becomes, "Freeing for whom and for what?" It is hardly freeing for those who are not bound by the conventions that it sought to disturb, and unless the freeing actually enlarges the class of objects that it is rewarding to contemplate, the freeing is pointless. To give a simple analogy, freedom to eat is pointless where there is no food. It is doubtful whether even for the professionals fully enmeshed in the art world, *Fountain* both frees and expands the class of objects that reward contemplation. When we turn to ordinary art contemplators, the situation is even less promising. The intrinsic capacity of *Fountain* to command, sustain, and reward contemplation is minimal, and such capacity as it has is largely available outside art. Here I return to the fundamental contention that unless art furnishes rewards unavailable outside art, it is essentially pointless.

As another example, take Cage's *4'33"*.[14] This is a work in three movements in which no sound is made by any musical instrument for the nominated period of time. Although it

is written for any instrument or instruments, it was first performed at the piano without, in conformity with the score, a key being struck. Here again is an assault on habitual and routine ways of perceiving, thinking, feeling, and acting in the art world of music. As such it exhibits the freeing aspect of the inherent dynamics of art, but again we can legitimately ask, "Freeing for whom and for what?" In freeing, does it expand the class of objects that reward contemplation? The intrinsic capacity of $4'33"$ to command, sustain, and reward contemplation is extremely low, and in any event, whatever we can obtain from contemplating it, we can largely obtain from the world outside art. Here the desert island thought experiment is worth conducting. Suppose that we are allowed to take only one musical CD with only one track on it to a desert island with no prospects for more CDs. How many music lovers would choose $4'33"$ for their CD? It would occasion surprise if there were even one among those with unimpaired mental faculties. Art is about freedom, but it is not merely freedom from; it is also freedom to garner rewards not otherwise attainable. Artworks that free without furnishing rewards beyond the freeing itself must surely be judged as artistic failures.

An avant-garde always faces at least two challenges. The first is to secure freedom from artistic routines and habits that no longer furnish artworks that command, sustain, and reward contemplation. The second is to furnish new objects that do exactly that. The danger is that the first challenge will be so exhilarating that the second will disappear from view, and the first one will be taken to constitute the whole of the art enterprise. However, there is no point in pursuing the first one unless the second one can also be met.

The Future of Art

There is a pessimistic thesis that the arts are creatively exhausted and therefore, even if progress occurred in the past, progress is no longer possible.[15] To take visual art, the argument is as follows: There is nothing left for representation to do, there is nothing left for expression to do, and there is nothing left to do in presenting forms. My consideration of the representation, expression, and formalist theories shows that if we take these theories in their simplest versions, then the pessimistic thesis appears surprisingly solid. But once we turn to the unrestricted versions of the representation and expression theories and probe more deeply into the notion of form, we find unbounded flexibility that precludes ever being exhausted. To be sure, there is no guarantee of continuing resolve to mine these resources, but that is very different from claiming that no ore remains to be mined.

Let me focus on representation in visual art where it encounters fierce assault. That the world around us is constantly changing is beyond dispute. The idea that there are no new subjects for representational art is simply unsustainable. Warhol had a special flair for spotting new subjects in a transformed world. The world around us and ways of life changed rapidly and radically during the twentieth century and are continuing to change at an unabated rate. Globalization, climate change, genetic engineering, and fast-spreading computerization and electronic device use are only the most obvious elements in these changes. This must precipitate new objects, structures, and environments, new ways of living and feeling, new problems and prospects – in short, new subjects to interest representational artists. Only jaded palates can condemn

this feast as a famine. The issue transcends subject matter. Representation has unbounded flexibility, and even if there were nothing new in the world to represent, myriad possibilities for fresh and revealing representations would remain. Analogous points hold for expression and form. The ceaseless transformations of the world and life must create new feelings and interest in new forms. Neither representational art, expressive art, nor formal art can become creatively exhausted in a world undergoing constant fundamental change. Nor can it be ruled out that a new realm of nonrepresentational, nonexpressive, and nonformal conceptions could generate further novel artworks that command, sustain, and reward contemplation.

To the uncreative, there will constantly be the illusion that creativity has been exhausted.[16] The possibility of the visual art of Picasso or Klee would have been inconceivable in any century before the twentieth. If someone considered what creative possibilities remained in visual art for the twentieth century from the standpoint of the mid-nineteenth century, they could not have even imagined Picasso or Klee.[17] The very point of creative genius is that it is imaginable only after the fact. This is one reason why I rely so heavily on general arguments to support the claim that the basic conditions for creativity in the arts remain unimpaired.

The Threat from Science

One argument that art must eventually end proceeds as follows. A time will come when scientific understanding of the universe is complete, including a complete understanding of ourselves and our place in the universe and also a complete understanding of the nature of art. This complete scientific

understanding undoubtedly will evoke many reactions, and some of these may be transmuted into further art. Both the reactions and their transmutation into art will be entirely explicable in terms of our scientific understanding of the universe and ourselves. The very fact that art would be entirely explicable in scientific terms entails that art would have nothing new of significance to contribute in its own right. In short, complete knowledge renders art redundant. I have already argued that knowledge is not the main point of art and that its freeing role is fundamental. However, I will meet the challenge on its own terms. I will argue that the complete knowledge envisaged by the argument is in principle impossible and that the recognition of its impossibility secures a place for art from which it can never be displaced.

To begin, human beings are simple entities in a highly complex world. We are staggeringly simple compared with the complexity of the universe as a whole. The complexity of the universe as a whole cannot be represented in a simple part of it, which is what human beings are, either individually or collectively. Even if our knowledge of the universe resides in human beings collectively, human beings collectively are still only a very simple part of an immensely complex universe. In principle the best that we can attain is simple models of the universe. This is not a limitation that can be removed by time, money, or effort. Our knowledge of the universe is essentially, and not merely accidentally, incomplete.

Furthermore, a knower cannot fully know his or her own nature, for to fully understand oneself one must be of an order of complexity higher than that which one is seeking to understand. The point applies equally to individuals or to groups. An individual can be fully understood only by a more complex

individual, and a group can be fully understood only by a more complex group. The best in principle that we can attain either individually or collectively is a simpler model of ourselves than we really are. Here again, our knowledge of ourselves is essentially, and not merely accidentally, incomplete.

The case is strengthened by the argument that not merely is complete knowledge impossible but that no pure knowledge is possible. Let me explain. In coming to know, there is an interaction between the knower and the known. We cannot extract from the interaction a warranted view of how the world is in its own right or of how our own nature is in its own right. To arrive at a sound view of how the world is, we must discount for the contribution our own mind makes in knowledge-seeking interactions. However, we cannot fully know our own minds until we know how the world as it really is influences our representations of it in knowledge-seeking interactions. We have a neat circle here. If we could independently fully know the nature of our own minds, then we could discount for that in assessing the products of our knowledge-seeking interactions. On the other hand, if we knew exactly how the world was independently of our minds, then we could come to understand our minds better in seeing how they reacted in knowledge-seeking interactions. If only we could pin one side down, then we could uncover the other. But there is no way we can ever pin one side down. We can have only the product of the interaction between the knower and the known. This clearly implies that neither the knower nor the known can be fully understood as they are in themselves.

These arguments can be reinforced. We have both limited senses and limited devices for processing inputs from them. This strongly suggests that we must begin with a finite, limit-

ed stock of concepts that are the products of our initial encoun-
ters and our initial nature. It is eminently arguable that a lim-
ited beginning for a limited device means a limited output. We
can generate only a limited class of models of the universe,
given our limited initial and limited continuing access to the
world. Implications drawn from the theory of evolution sug-
gest that ours is only one of a large number of ways of inter-
nally representing the universe. Perceptual and cognitive ap-
paratus are species-specific and geared to survival. There is
little reason to believe that the class of models that we gener-
ate has any unique status.

In addition, there are further fundamental limits to what we
can know about mentality in the universe. To the best of our
knowledge, evolution can begin in the universe only when the
universe is both very old and very large. Time is needed for
nuclear reactions to form the more complex atoms needed for
life, and the universe continues to expand while this is hap-
pening. The distances involved make it theoretically impos-
sible for us to know whether life and mentality has evolved in
some parts of the universe and practically impossible for us
to do so in others. We cannot seriously investigate parts of the
universe that light signals take a billion years to reach. Extra-
terrestrial biology and psychology cannot help but be flimsy
in the extreme, and this reflects negatively on both our knowl-
edge of the universe in general and our knowledge of our-
selves in particular. I fail to see how we could reasonably claim
to fully understand our own consciousness if we did not un-
derstand consciousness in extraterrestrial life forms if they
had it.

There are other developments pointing to the inherent limi-
tations of our knowledge. Quantum mechanics precludes gath-

ering complete information about physical systems. This applies to both prediction and measurement. Again, what appears to be involved is an essential incompleteness in our knowledge and not merely an accidental incompleteness. There are other considerations arising out of thermodynamics, catastrophe theory, chaos theory, and the like on one hand and incompleteness and unprovability results for formal systems and computing devices on the other that further bolster the claim that our knowledge of the universe must be essentially incomplete.

Finally, a general limitation to knowledge turns on the underdetermination of theory by evidence. Theories always go beyond the evidence marshaled in their favor. A theory is never the deductive consequence of the evidence on which it rests. The possibility can never be ruled out that there is another theory as adequate as our original theory and as compatible with the totality of evidence in its favor. Again, this is not a matter of chance or luck or accident; it inheres in the logic of the situation. For any theory we accept, there must be in principle an alternative theory that fits equally well with the available evidence. This is one of the most profound and far-reaching results in contemporary philosophy of science, and it puts enormous pressure on the idea that theories really uncover the ultimate nature of things as they are in themselves.

These arguments are individually strong and cumulatively overwhelming that every human picture of the universe must be essentially incomplete. Science can never furnish a complete understanding of the universe, ourselves, and our place in the universe.[18] The interpretations that art furnishes of either the outer world or the inner world can never be rendered redundant by a completed science because a completed science is in principle impossible. Here I partly reverse an

argument by Hegel. Hegel argued that to obtain a complete understanding of the universe we must move beyond art to religion and then philosophy.[19] But if a complete scientific understanding of the universe and ourselves is impossible, then the search for such a complete understanding cannot constitute a genuine ground for abandoning art, nor can such a complete understanding be reached to render art redundant. The forward openness of life and the necessary incompleteness of our knowledge of the universe and ourselves jointly create a space for art that can never disappear. Nor can the role of art in freeing us from routine and habitual modes of seeing, thinking, feeling, and acting be completed and come to an end, for where one routine or habit is disrupted another soon takes its place.

Summing Up

The specificity of the traditional theories of art enables us to draw specific conclusions about the kind of values that art could be expected to create and deliver under their aegis, and I have discussed these in the early chapters. The abstractness of posttraditional theories of art precludes the same kind of specific conclusions to be drawn about what art could be expected to create and deliver under their aegis. But although the posttraditional theories of art contribute valuable insights into art, I contend that they must be specific that the fundamental point of the art enterprise is to create and deliver values that are not independently available in the preexisting nonart world. I have argued that major difficulties in posttraditional theories could be remedied by such an explicit recognition. Furthermore, I have argued that the manner in

which the art enterprise involves the creation and delivery of values that go beyond the preexisting nonart world depends essentially on a positive freeing from that world and goes well beyond mere effortless addition. This too needs explicit recognition and grounds the continuing possibility of fresh value creation in the arts.

CHAPTER 1: THE ART ENTERPRISE

1. This broader inquiry into value in the arts is energetically defended and pursued by Gordon Graham in *Philosophy of the Arts.*

2. Peter Kivy argues that liberation from the world is a crucial factor in what makes absolute music valuable to us but denies its importance for the other arts. I propose to argue that liberation is a crucial factor in all the major arts. See his *Philosophies of Arts,* 202–17.

3. Although this holds for painting, sculpture, music, literature, dance, and so on, it does not apply to architecture. Architecture presents special problems of its own, which I will not deal with here, although I will make reference to it in relation to various theories of art as they come up.

4. Aristotle, *Ethics,* bk. 2, ch. 1.

5. Kant, *Critique of Practical Reason,* ch. 3.

6. To be sure, not all approaches to morality are rule based, but this has been by far the dominant trend and is reflected in Kantian, utilitarian, and even contractarian accounts. Although virtue accounts differ on this point, limiting the sphere of acceptable actions is still central to them.

7. This separation of art from the ordinary is noted by Georg Simmel in his illuminating discussion of the idea of adventure: "For the essence of a work of art is, after all, that it cuts out a piece of the endless continuous sequences of perceived experience, detaching it from all connections with one side or the other, giving it a self-sufficient form as though defined and held together by an inner core." *Essays on Sociology, Philosophy and Aesthetics,* "The Adventure," 245.

8. Peter Conrad gives one illustration that this is a positive achievement: "In 1895 when the Lumière brothers projected one of their first films, *L'Arrivé d'un train en gare de La Ciotat,* spectators fled from the auditorium, convinced that the locomotive was about to run them down." See his *Modern Times, Modern Places,* 73.

9. There are echoes here of Nietzsche's distinction between the Dionysian and the Apollonian; the Dionysian frees, the Apollonian creates new forms. See *The Birth of Tragedy,* especially the early sections.

10. Institutional and historical theories have been articulated by George Dickie, Jerrold Levinson, and Noël Carroll and are discussed directly in chapter 5.

11. The reference to visual artworks as material objects is merely part of securing an adequate extensional identification; it is not meant to prejudge issues about the ultimate ontological status of visual artworks.

12. For example, in Goya's *The Third of May, 1808,* in some way or other, sympathy for the insurgents about to be shot is quite natural, but the artwork does not literally contain real human beings, and real sympathy directed at the people depicted in the painting is out of the question.

13. The reference to musical artworks as sound complexes is merely part of securing an adequate extensional identification; it is not meant to prejudge issues about the ultimate ontological status of musical artworks.

14. In the initial formulation I choose the noncommittal phrase "emotion-like states" because I do not want to beg the question whether music generates actual emotions. Although I revert to the plain term "emotion" in what follows, it must be understood that the qualification is still in force.

15. Schopenhauer, *The World as Will and Representation,* vol. I, bk. III, §52, 255–67.

16. This point and what follows applies with equal force to theatrical representations.

17. Aristotle, *Poetics*, VI.

18. Nietzsche, *The Will to Power*, #851. This is one of those rare occasions on which Nietzsche agrees more with Plato than with Aristotle.

19. In my view, although the intensification of experience is a positive factor, occasioning such behavior is a sign of weakness in the artwork precisely because it fails to free the reader from the mundane connection between such emotions and such actions. It would have been more impressive if, without sacrifice of felt intensity, it had freed readers from such actions.

20. How this is achieved will be considered in subsequent chapters.

CHAPTER 2: REPRESENTATION

1. What I call the representation theory of art has also variously been known as the imitation theory, the copy theory, realism, and naturalism. Because I do not want to repeat this list every time I refer to the theory, I use the designation *representation theory* as convenient shorthand. To be sure, not all imitations or copies are representations, and certainly not all representations are imitations or copies, but in the sense intended by the imitation or copy theory of art, these imitations or copies are also representations, and the use of the term *representation* as an umbrella classificatory term is appropriate in this context.

2. It has even found distinguished advocates in the twentieth century such as Bernard Berenson; see his *Seeing and Knowing*.

3. This point of view is by no means confined to the ignorant, the uninterested, and the uninformed. It is a point of view that Tolstoy himself shares: "The opera they were rehearsing was of the most ordinary kind, for those who are accustomed to them, but made up of the greatest absurdities one could imagine: an Indian king wants to get married, a bride is brought to him, he disguises himself as a minstrel, the bride falls in love with the sham minstrel and is in despair, but then learns that the minstrel is the king himself, and every one is very pleased. That there never were and never could be any such Indians, and that what was portrayed bore no resemblance not only to Indians but to anything else in the world, except other operas – of that there can be no doubt. That no one speaks in recitative, or expresses

their feelings in a quartet, standing at a set distance and waving their arms, that no where except in the theatre does anyone walk that way, with tinfoil halberds, in slippers, by pairs, that no one gets angry that way, laughs that way, cries that way, that no one in the world can be touched by such a performance – of that there can also be no doubt." *What Is Art?*, 7.

4. For example, Swanston, *In Defence of Opera*.

5. The untutored are not entirely alone in such condemnation. It is difficult to resist quoting the spirited broadside delivered by Berenson: "The term 'abstract art,' like such contradictions in terms as wet dryness, an icy heat, or a soft hardness, may be conceivable to the mind but scarcely to the senses. For many thousands of years visual art has been based on ideated sensations, on a compromise between what one knows and what one sees and between what one sees and what one can reproduce for others. It therefore would seem to correspond to a continuous need or desire or demand of human nature, of man who is matter and spirit, body as well as mind. It is not likely that he will be henceforth satisfied with the store of geometrical squares, lozenges, diagonals, circles, globes, trapezoids, parallelepipedons when he asks for the bread of art. No perfection in smearing canvas or wood or paper with faint colours, guaranteed to represent nothing, no skill in buttering surfaces with pigments, as a good and faithful nursemaid or Werther's Charlotte buttered bread, will replace pictures; no segments of globes in wood or stone, no matter how caressingly polished and put together so as to suggest broad-bottomed, deep-breasted females will replace multimillennial sculpture." *Seeing and Knowing*, 64–65.

6. Tom Wolfe in *The Painted Word* seems not too distant from such a view.

7. Although that, too, involves the activity of the mind and not just the senses.

8. In the tenth book of the *Republic*.

9. He did have other views in other places besides the *Republic*, such as in *Ion*.

10. To be sure, Aristotle recognizes a major ontological division in reality between matter and form, but his division is drawn within the one world and is not a division of reality into two separate worlds.

11. This question obviously is anachronistic in relation to Aristotle, but it is pertinent to the substance of the issue from our viewpoint.

12. Of course, there are limits to what one person can learn from direct experience, and there is no reason why one should not avail oneself of what others have learned directly. It makes sense not to keep trying to discover what has already been discovered.

13. Aristotle, *Poetics*, IV.

14. Ibid., IX.

15. Schopenhauer, *The World as Will and Representation*, vol. I, bk. III, §51, 252–53.

16. Ibid., vol. I, bks. I and II.

17. Ibid., vol. I, bk. III, §52, 255–67. Here Schopenhauer repeatedly refers to music as a representation, copy, or imitation. To be sure, these terms must be understood in light of the qualifications he attaches to them, but these do not undermine their core sense.

18. Schopenhauer, *Essays and Aphorisms*, "On Aesthetics," §10.

19. On the face of it, Schopenhauer's arguments concerning tragedy and music are substantially at odds with each other. On one hand, it is urged as a merit of tragedy that it distances us from an inherently nasty reality, and on the other hand, it is urged as a merit of music that it puts us in closer touch with it.

20. Naturally, extrinsic criteria of aesthetic merit can be grafted onto the theory. For example, it could be made a requirement that what is represented be itself beautiful and that what is then required is an exact representation of that beauty. Exact representation would then become a necessary but not sufficient condition for good art.

21. Vasari, *Lives of the Artists*, 80. Although commitment to the pure representation theory seems to dominate many of Vasari's judgments, there are other judgments such as some of those about Michelangelo's works that make sense only in light of more relaxed versions of the representation theory, which will be dealt with in due course.

22. The artist is Bramantino [Bartolomeo Suardi], "and outside the Vercellina gate, near the castle, he decorated some stables, which have now been demolished, with pictures of horses being groomed; one of these was so well done and so lifelike that one of the horses thought it was real and kicked it repeatedly with its hoofs." Vasari, *Lives of the Artists*, 193.

23. Aretino, *Selected Letters*, 69.

24. "When you wish to see whether the general effect of your picture corresponds with that of the object presented by nature, take a

mirror and set it so that it reflects the actual thing, and then compare the reflection with your picture and consider carefully whether the subject of the two images is in conformity with both, studying especially the mirror." Goldwater and Treves, *Artists on Art,* 54.

25. Vasari, *Lives of the Artists,* 275–76.

26. Whether the conventional conception of what a camera does is sound will be considered in due course.

27. We will see shortly that there is good reason to think that this is not so, but it is useful to pursue the case assuming that the idea is conceptually adequate, and in any event we need to cover the possibility that it may be.

28. The point is noted by Alberti, *On Painting,* 60.

29. Alberti notes this point as well. Ibid., 60.

30. There are significant differences between these cases. Because the *Birth of Venus* is a *mythical* event, no human being could have actually witnessed it and represented it. *The Last Supper* was a *historical* event witnessed by human beings, but Leonardo was not one of them, and it would have been impossible for him to follow his own prescription of holding up a mirror to the real world to test whether it matched the content of the artwork. *The Last Judgment* is a *prophetic* event; nobody has as yet witnessed it, and no one can guarantee that it will or will not occur, so it cannot literally be reported on and represented. Thus, in each of the cases, there is a different reason why the paintings cannot be regarded as actual copies or imitations or representations of the real world.

31. Alberti, *On Painting,* 90–91.

32. The series is titled *The Sculptor's Studio,* produced largely in 1933 and finished in 1934. The series is part of a more extensive series of etchings commissioned by Ambroise Vollard.

33. In drawing, Henri Matisse is the peerless master of such simplification.

34. Suetonius records that Nero had a statue of himself on exhibit, 120 feet high. See *The Twelve Caesars,* 224.

35. In their exploration of possible neurological mechanisms implicated in aesthetic experience, V. S. Ramachandran and William Hirstein identify a phenomenon called the "peak shift effect" in which certain brain mechanisms are more strongly activated by a stimulus that diverges from the original stimulus. Their example is of a rat that has

been trained to discriminate rectangles from squares and that responds even more strongly to rectangles that deviate even further from the square than does the original rectangle that the rat was trained on. Such a mechanism may play a role in each of the devices I have listed. See their "The Science of Art: A Neurological Theory of Aesthetic Experience," 15–51, and the critical discussion that immediately follows it.

36. They include Rudolf Arnheim, Bernard Berenson, Ernst Gombrich, and Nelson Goodman. To be sure, there are significant differences between them, but what concerns me here is what they are broadly agreed on rather than what differentiates them. See Arnheim, *Art and Visual Perception;* Berenson, *Seeing and Knowing;* Gombrich, *Art and Illusion;* Goodman, *Languages of Art.*

37. Gombrich, *Art and Illusion,* 73.

38. Arnheim, *Art and Visual Perception,* 112–16.

39. To acknowledge the presence of such personal factors is itself significant, but some theorists go further and take them to be of primary importance in art. André Malraux argues, "For we now know that an artist's supreme work is not the one in best accord with any tradition – nor even his most complete and 'finished' work – but his most personal work, the one from which he has stripped all that is not his very own, and in which his style reaches its climax." *The Voices of Silence,* 19.

40. There is an excellent discussion of the issue in Blocker, *Philosophy of Art,* 70–85.

41. This position is maintained by Douglas Crimp in "The End of Painting," reprinted in his *On the Museum's Ruins,* and also constitutes an element in Arthur C. Danto's case in "The End of Art," reprinted in his *The Philosophical Disenfranchisement of Art.* But the position is hardly new. In 1926 Osip Brik wrote, "Photography pushes painting aside. Painting resists and is determined not to capitulate. This is how the battle must be interpreted which started a hundred years ago when the camera was invented and which will only end when photography has finally pushed painting out of the place it held in daily life." "Photography versus Painting," reprinted in Harrison and Wood, *Art in Theory 1900–1990,* 454.

42. The gaps left in their respective national cultures would be even more glaring.

43. Kivy challenges the claim that literature is representational. He distinguishes between "phenomenological representation" and "semantic representation" and argues that literature is not phenomenologically representational and therefore is importantly different from visual art. The distinction is useful, and I accept the substance of the point. But this still leaves literature as semantically representational, and this is sufficient for my purposes. Kivy acknowledges that there is something in common between these senses of representation but is more intent on revealing their differences. I am more concerned to explore the consequences of what they have in common. See *Philosophies of Art*, 55–83.

44. It may well turn out that science without metaphor is also impossible, but even if this were so, it would not automatically impugn the ideal of restricting metaphor to a minimum in science.

45. Kivy, *Philosophies of Art*, 120–39.

46. The centrality of the individual and the individual point of view in the novel is defended by Martha Nussbaum: "We must grant that in fact the whole commitment of the novel as a genre, and not least of its emotional elements, is indeed to the individual, seen both qualitatively distinct and separate. In this sense, the vision of the community embodied in the novel is, as Lionel Trilling long ago argued, a liberal vision, in which individuals are seen as valuable in their own right, and as having distinctive stories of their own to tell. While the genre emphasizes the mutual interdependence of persons, showing the world as one in which we are all implicated on one another's good and ill, it also insists on respecting the separate life of each person, and on seeing the person as a separate center of experience." *Poetic Justice*, 70.

47. To my mind, the failure to distinguish these questions has disastrous consequences in thinking about the arts. It leads to an entirely unwarranted transition from a rejection of the representation theory as a comprehensive theory of art to a rejection of the legitimacy and value of representation in art in general.

48. Nietzsche, *Twilight of the Idols*, #24.

CHAPTER 3: EXPRESSION

1. As an example, consider the following observations of the young Paul Klee: "Thoughts about the art of portraiture. Some will not rec-

ognise the truthfulness of my mirror. Let them remember that I am not here to reflect the surfaces (this can be done by the photographic plate), but must penetrate inside. My mirror probes down to the heart. I write words on the forehead and around the corners of the mouth. My human faces are truer than the real ones." Felix Klee, *The Diaries of Paul Klee 1898–1918*, #136, 47.

2. The then major stream in this process of reassessing the function of visual art is illuminatingly dealt with by Charles Edward Gauss in *The Aesthetic Theories of French Artists.*

3. Nussbaum maintains, "Literature is in league with the emotions. Readers of novels, spectators of dramas, find themselves led by these works to fear, to grief, to pity, to anger, to joy and delight, even to passionate love. Emotions are not just likely responses to the contents of many literary works; they are built into their very structure as ways in which literary form solicits attention." *Poetic Justice,* 53.

4. "Art is that human activity which consists in one man's consciously conveying to others, by certain external signs, the feelings he has experienced, and in others being infected by those feelings and also experiencing them." Tolstoy, *What Is Art?* 40.

5. This may be what is implicitly behind Schopenhauer's contention that music has a more direct connection with reality than the other arts. Perhaps what is at issue is that it has a greater capacity than any other art form to reflect our feelings.

6. When Vasari comments on the expressiveness of various artists whom he admires in his *Lives of the Artists,* it is almost invariably in terms of what he takes to be the realistic representation of the natural expression of emotion in human beings.

7. Note Poe's claim that a literary work must be read in one sitting if a unity of effect is to be preserved. See "The Poetic Principle" in W. H. Auden, *Edgar Allan Poe: Selected Prose, Poetry, and Eureka.*

8. A defender of the expression theory is not entirely without defenses here and could argue that complex extended artworks of the kind cited express an extended complex of emotions, but the essential problem of distinguishing between the emotions expressed by characters in these works and the emotions expressed by the work itself remains and requires clarification.

9. The most impressive defender of this version of the theory is R. G. Collingwood in *The Principles of Art.*

10. There is little doubt that this conception is superior to the previous conception. Whether it is ultimately acceptable in its own right is another matter, and the issue of expression is addressed directly later in this chapter.

11. The following observation about a painting of Giotto's is typical: "The outstanding feature is the remarkably lovely young woman who is swearing on a book to refute an accusation of adultery. Her attitudes and gestures are stupendous: she stands there staring straight into the eyes of her husband, who is compelling her to declare her innocence on oath because of the distrust aroused in him by the dark-skinned boy to whom she has given birth, and whom he cannot accept as his own. While her husband shows suspicion and contempt in his expression, the purity of her face and her eyes proclaim to those who are watching her so intently her innocence and her simplicity and the wickedness of the wrong that is being done in having her make her protestation and be falsely accused as a whore." Vasari, *Lives of the Artists,* 70.

12. It would not even account fully for some expressive artworks that have human subjects. To take Edvard Munch's *The Scream* as an example, it is obvious that the representation of the natural expression of emotion by the central figure constitutes only a part of the expressiveness of the picture and that a good deal of the expressive content of the work depends on something other than the representation of the natural expression of emotion.

13. There may be good ground for combining this condition and requiring both that the artwork be caused by the emotion and that the artwork itself cause the emotion in the art audience, but it is useful to consider the second proposal independently.

14. The creations of a depressed biochemist whose depression is causally efficacious in creating a pill that in turn causes depression would have to be regarded as expressive artworks in this account, which they manifestly need not be.

15. The proposal has also been known as the theory of *Einfühlung,* or the empathy theory. For a more extended, historically oriented discussion, see Earl Listowel, *Modern Aesthetics: An Historical Introduction,* 49–87.

16. It is worth noting explicitly that causality does not play a significant role in this account.

17. These examples are inspired by Blocker's discussion of expression in *Philosophy of Art.*

18. Because emotions are neither visible nor audible, they could not in principle exactly resemble what is presented to sight or what is presented to hearing.

19. The main proponent here is Susanne K. Langer. See her *Philosophy in a New Key,* ch. 8, and *Feeling and Form,* ch. 3.

20. For an early but incisive critique of the underlying conception, see Ernest Nagel, "A Theory of Symbolic Form," in his *Logic without Metaphysics.*

21. The prospects of a renovated symbolic account look particularly unpromising in the case of music. In part this is because of the formidable case that Kivy mounts against extramusical reference in music, emotional or otherwise. See *Philosophies of Arts,* 162–217.

22. That the accuracy of representation may not be an absolute but may depend essentially on a chosen method of representation does not undermine the key point.

23. Eduard Hanslick in his *On the Musically Beautiful* argues that it is never the primary function of music to express emotion. He would see my point here as applying to music in general. But the specific example suffices for my purposes and is undoubtedly more resistant to challenge than Hanslick's general thesis.

24. Arguably some of the works of Bridget Riley and Victor Vasarely fall into this category.

25. Hanslick insists on this point in his polemic against the expression theory in music. *On the Musically Beautiful,* 1–7.

CHAPTER 4: FORM

1. The formalist theory of art is commonly called formalism, and that is how I refer to it in what follows.

2. "In painting, sculpture, and in fact all the formative arts, in architecture and horticulture, so far as fine arts, the design is what is essential. Here it is not what gratifies in sensation but merely what pleases by its form, that is the fundamental prerequisite for taste. The colours which give brilliancy to the sketch are a part of the charm. They may no doubt, in their own way, enliven the object for sensation, but make it really worth looking at and beautiful they cannot. Indeed, more often than not the requirements of the beautiful form

restrict them to a very narrow compass, and, even where charm is admitted, it is only this form that gives them a place of honour." Immanuel Kant, *Critique of Aesthetic Judgement*, bk. 1, §14, 67.

3. Consider the following corroborative observation: "In all advanced civilisations musical sounds rank higher than noises (*Geräusche*) in the hierarchy of musical values." In H. H. Stuckenschmidt, *Twentieth Century Music*, 48.

4. David Hume considers essentially the same problem in his essay "Of the Standard of Taste" and arrives at a quite different solution. See Hume, *Selected Essays*, 133–54.

5. See Bell, *Art,* and Fry, *Vision and Design.*

6. Bell, *Art,* 6–7.

7. This does not imply that it is beyond challenge.

8. But it could not have the force that its proponents seem to attribute to it. At best, the argument could establish only that representation and expression are not individually sufficient for art; it cannot establish that representation and expression are not disjunctively necessary for certain kinds of art.

9. Bell, *Art,* 7–8.

10. This line of reasoning is vigorously attacked by Morris Weitz in "The Role of Theory in Aesthetics" and will be explored directly in chapter 5.

11. What Ortega y Gasset laments in *The Dehumanization of Art* as a regrettable loss of the human subject in twentieth-century art would be welcomed as clear signs of the progress and purification of art by formalists.

12. The most comprehensive treatment of the issue is in Stephen Davies, *Definitions of Art.* The issue will be dealt with directly in chapter 5.

13. Indeed, there are definitions such as the ones proposed by George Dickie and Jerrold Levinson that certainly merit serious attention, which they receive in chapter 5.

14. Herbert Read's *The Origins of Form in Art* is a solid introduction to its consideration.

15. Nonformalists may be able to mount effective arguments here, but formalists are in trouble unless they simply want to concede the point, particularly given that a computer has beaten the world chess

champion – an activity once thought to involve an inimitable human creativity.

16. More substance will be lent to this point when I consider the concept of form in art directly.

17. Bell's inclusion of color and three-dimensionality as formal aspects but exclusion of representational and expressive elements as nonformal is grounded in Bell's intuitions, not in any clearly formulated criterion.

18. I will defend this more extensively when I come to focus directly on the concept of form.

19. A. C. Bradley argues, particularly effectively in relation to poetry, that this extreme kind of formalism is untenable and takes the case to be equally applicable to all the arts. At the same time, his case that form is always an important aspect of an artwork merits respect. See "Poetry for Poetry's Sake," in his *Oxford Lectures in Poetry,* 3–34.

20. The price of the escape is an increase in the opacity of the concept of form.

21. Imagining the figures as inert, lifeless, rusted, intertwined, static, metallic objects can noticeably diminish the impact of the work.

22. Concrete poetry aside, the one piece of literature that seems to fit comfortably with strong formalism is Lewis Carroll's *Jabberwocky.*

23. Indeed, some go so far as to claim that emotion and form are inherently antagonistic. H. H. Stuckenschmidt writes, "Art that seeks to express emotion is in principle hostile to form." In *Twentieth Century Music,* 30. But this is too extreme. There can be no doubt that at least sometimes form and emotional expression are mutually reinforcing. A conspicuous example is Diego Rivera's *Mother's Helper* (1950), Anton Schutz Collection, New York. Here the mother is kneeling, and her standing daughter is facing her. The two constitute a unified spatial form whose unity is reinforced by the link between the mother's extended arm and the daughter's outstretched hands, receiving flowers. The strong emotional bond between mother and daughter is reinforced by the unity of the spatial form. By the same token, the unity of the spatial form is reinforced by the spiritual connection between mother and daughter, particularly by way of their eye contact. Here the form heightens the expressive content, and the expressive content heightens the form.

24. The difference between the three versions of formalism can be characterized in terms of necessary and sufficient conditions. Strong formalism: Form is necessary and sufficient for art. Moderate formalism: Form is necessary but not sufficient for art, and form is always the most important condition. Weak formalism: Form is necessary but not sufficient for art, form is the only generally necessary condition, but form is not always the most important condition.

25. This began in 1909. O'Neil, *The Life and Works of Kandinsky*, 6.

26. This is quite different from saying that it has no shape.

27. Until recent times Uluru was known as Ayers Rock.

28. From the examples one may be tempted to conjecture that size is also a factor, but we are no more inclined to say that a whale that has turned over has changed its form than to say that a toy poodle that has rolled over has changed its form.

29. This point has not passed without notice. In "The Beauty of Form and Decorative Art," August Endell writes, "If we wish to understand and appreciate formal beauty we must learn to see it in a detailed way. We must concentrate on the details, on the form of the root of a tree, on the way in which the leaf is connected to its stalk, on the structure of the bark, on the lines made by the turbid spray on the shores of a lake. Also we must not just glance carelessly at the form. Our eye must trace minutely, every curve, every twist, every thickening, every contraction, in short we must experience every nuance in the form." Reprinted in Harrison and Wood, *Art in Theory 1900–1990*, 63.

30. Indeed, the induced formal unity is reinforced in the painting itself by the reflection in miniature in the mirror of the initial grouping from the rear and also including the artist with another person.

31. Bell's notion of "significant form" embodies an intuitive grasp of this point, and the idea deserves a more sympathetic reception than it usually gets.

32. Henri Matisse puts the point nicely: "Everything that is not useful in the picture, it follows, is harmful. A work of art must be harmonious in its entirety: any superfluous detail would replace some other essential detail in the mind of the spectator." In "Notes of a Painter," reprinted in Harrison and Wood, *Art in Theory 1900–1990*, 73.

CHAPTER 5: THE LIMITS OF ART

1. Weitz, "The Role of Theory in Aesthetics."

2. Wittgenstein, *Philosophical Investigations.*

3. Ibid., pt. 1, §66, 67.

4. Mandelbaum, "Family Resemblances and Generalizations Concerning the Arts."

5. Davies, *Definitions of Art,* 13–14.

6. Even for the few who were prepared to argue that in some sense Balzac was an artwork in his own right, they would surely not claim that he attained that status by resembling Rodin's statue of Balzac.

7. Dickie, *The Art Circle,* 32.

8. Ibid., 32.

9. Ibid., 32–33.

10. Dickie, *Art and the Aesthetic,* 34.

11. Ibid., 36.

12. Vasari, *Lives of the Artists,* 64–65.

13. Dickie, *The Art Circle,* 91–95.

14. The Roman Catholic Church and the Quakers illustrate some of this remarkable diversity, even within only one kind of institution, namely, religious institutions.

15. Levinson develops his position in three papers: "Defining Art Historically" and "Refining Art Historically," which are reprinted in his *Music, Art, and Metaphysics,* and "Extending Art Historically," which is reprinted in *The Pleasures of Aesthetics.* Subsequent page references are based on these locations.

16. Levinson, "Defining Art Historically," 8–9. Levinson successively refines this definition, but the major features are the most important and are the ones of primary concern here.

17. Ibid., 15–17.

18. Noël Carroll uses a case of killing chickens in developing a point against Levinson. But the point he is making is quite different from my point, and my argument proceeds on the basis of assumptions that I do not believe that Carroll would accept. See his "Identifying Art," 34–35.

19. Should this content not be regarded as sufficiently horrific by some, substitute one hundred live and healthy horses, or a thousand live and healthy horses, or ten thousand. The exact stopping point is not as important as the recognition that there is a point beyond which the scale of value destruction disqualifies a work from the status of art.

20. Carroll develops his position in a number of papers: "Art, Practice and Narrative," "Historical Narratives and the Philosophy of Art," and "Identifying Art"; the latter is in Robert J. Yanal, *Institutions of Art.*

21. Carroll, "Art, Practice and Narrative," 149.

22. Carroll, "Historical Narratives and the Philosophy of Art," 322, and "Identifying Art," 27.

23. Carroll, "Historical Narratives and the Philosophy of Art," 324.

24. This does not simply introduce an idle speculation. Monroe Beardsley rejects the claim that *Fountain* warrants acceptance as art, and an appeal to the traditions of art is a part of his case. See his "An Aesthetic Definition of Art," in Hugo Curtler, *What Is Art?*, 25.

25. There is much support for the universalistic interpretation: "I propose that a compelling alternative view is that we identify works as artworks – when the question of whether or not they are art arises – by means of historical narratives which connect contested candidates to art history in a way that discloses that the mutations in question are part of the evolving species of art," "identifying narratives replace real definitions," and Carroll refers to them as "reliable methods" in "Historical Narratives and the Philosophy of Art," 315.

26. Carroll allows that an appropriate narrative could be furnished before any presentation of an artwork to the public. "However, nowadays, especially, it is often customary for the identifying narrative to be advanced prior to skeptical challenge. That is, the identifying narrative takes, so to speak, the form of a preemptive strike," ibid., 317; also see "Identifying Art," 17.

27. Carroll maintains that art is a cultural practice that requires both makers and receiver, in "Art, Practice and Narrative," 143–44, but he does not claim that the art status of new objects is in any way determined by how they are received.

28. Dickie, *The Art Circle*, 7.

29. Ibid., 78–82.

30. See Hughes and Cresswell, *An Introduction to Modal Logic.*

31. Carroll, "Identifying Art," 12.

32. It is an interesting point to ponder whether Carroll's structural account of art identifying historical narratives could be immediately transformed into a structural account of philosophy identifying historical narratives by a uniform substitution of philosophy and philosophy-related terms for art and art-related terms in his account.

33. Davies, *Definitions of Art*, 100–106, and Dickie, *The Art Circle*, 56–58.

34. Dickie, *The Art Circle*, 55.

35. Davies, *Definitions of Art*, 102–4.

CHAPTER 6: ART AND PROGRESS

1. Comparable examples could have been selected from painting, sculpture, literature, and so on.

2. In the account of art proposed by Levinson, the appropriateness of the accumulation model would not be a merely extrinsic fact about art but could be seen to flow from the fundamental nature of art itself. The model fits equally comfortably with Carroll's approach to art.

3. This conception is at the heart of Hegel's view of art, but he thought that the process must inevitably come to an end, a view that I oppose in what follows.

4. In the interests of brevity I will refer to all such works as art commentary unless there is a special reason for not doing so.

5. It is eminently arguable that a distinction must be drawn between the ontology of an artwork and the value of an artwork, and a case can be made that ontologically an artwork is not changed by developments in art subsequent to its creation. Indeed, Levinson forcefully defends the thesis in "Artworks and the Future" reprinted in *Music, Art, and Metaphysics*, 179–214. But whether or not the concept of an unchanging aesthetic object ultimately is theoretically useful, to my mind there is an overwhelming case that the value, meaning, or significance of an artwork is constantly being transformed by the artistic activity that follows its production, and it is this value, meaning, or significance that I am principally concerned with.

6. The general point applies all the way down. Mozart's instrumental music could not possibly have the meaning that it would have if Mozart had never written any vocal music. The second movement of Beethoven's last, *C minor Opus 111,* piano sonata could not possibly have the meaning that it would have if Beethoven had never written any other piano music.

7. There are some interesting shifts when dramatic plays are used as the basis for operas. Verdi's use of Shakespeare's *Othello* for his opera *Otello* has in no way diminished the former, or interest in it, or the frequency with which it is performed. On the other hand, Verdi's

use of Alexandre Dumas the younger's *La Dame aux Camélias* for his *La Traviata* has significantly diminished interest in the former and the frequency with which it is performed.

8. The point has already been noted and at least partially defended in chapter 1.

9. The frequency of occurrence of a color in other artworks also affects its value in any new artwork.

10. The frequency of occurrence of a shape in other artworks also affects its value in any new artwork.

11. "The bulk of English poetry, from Caxton's Ovid to Sweeney among the Nightingales, is now modulating from active presence to the inertness of scholarly conservation. Based, as it firmly is, on a deep, many-branched anatomy of classical and scriptural reference, expressed in a syntax and vocabulary of heightened tenor, the unbroken arc of English poetry, of reciprocal discourse that relates Chaucer and Spenser to Tennyson and to Eliot, is fading rapidly from the reach of natural reading." George Steiner, *In Bluebeard's Castle,* 78.

12. The hanging committee for the exhibition to which *Fountain* was first submitted refused to show it.

13. Indeed, Duchamp himself acknowledged that this was his aim.

14. For an illuminating discussion of this work, see Davies, "John Cage's *4'33'':* Is It Music?"

15. Visual art has occasioned an especially rich proliferation of such ideas. Such tendencies were already so powerful by the late 1960s as to warrant Hélène Parmelin mounting a spirited counterattack in *Art Anti-Art.* The idea continues to have serious defenders and has even been extended to embrace the end of art theory and the end of art history. Arthur C. Danto, Douglas Crimp, Victor Burgin, and Hans Belting are important contributors here.

16. Danto, one of the main defenders of the "end of art" thesis, is fully aware of the dangers here. See "The End of Art," in *The Philosophical Disenfranchisement of Art.*

17. The point is neatly illustrated in the title of Robert Hughes's lively history of twentieth-century art, *The Shock of the New.*

18. A comparably powerful case can be developed that we can never arrive at a complete understanding of art itself. For not only is art subject to the limitations already noted, but we have only the most fragmentary evidence about the motives, conditions of creation, and

functions of the art of the past. Indeed, much of the art of the past has been lost through war, natural disasters, deliberate destruction, neglect, natural decay, and so on. Thus, not only is our evidence for theories relating to past art slim, but we have only patchy remnants of the very phenomena we are seeking to explain. Complete understanding seems to be out of the question here. This is one reason why I think that it is important to codify and preserve the partial understandings furnished by both traditional and contemporary theories of art and not to reject them in their entirety in the vain hope that some new theory has all the answers.

19. For Hegel's account of the respective roles of art, religion, and philosophy, see *Hegel's Aesthetics: Lectures on Fine Art,* vol. 1, pt. 1, 91–105.

BIBLIOGRAPHY

Alberti, Leon Battista. *On Painting.* Trans. Cecil Grayson. Harmonds-
worth, England: Penguin, 1991.

Aretino, Pietro. *Selected Letters.* Trans. George Bull. Harmondsworth,
England: Penguin, 1976.

Aristotle. *The Ethics of Aristotle.* Trans. J. A. K. Thompson. Harmonds-
worth, England: Penguin, 1955.

———. *The Poetics of Aristotle.* Trans. S. H. Butcher. London: Macmillan,
1895.

Arnheim, Rudolf. *Art and Visual Perception. The New Version.* Berke-
ley: University of California Press, 1974.

Auden, W. H., ed. *Edgar Allan Poe: Selected Prose, Poetry, and Eure-
ka.* New York: Holt, Rinehart and Winston, 1950.

Beardsley, Monroe C. "An Aesthetic Definition of Art." In H. Curtler,
ed., *What Is Art?* New York: Haven, 1983. 15–29.

Bell, Clive. *Art.* London: Chatto and Windus, 1949.

Berenson, Bernard. *Seeing and Knowing.* London: Evelyn, Adams and
Mackay, 1968.

Blocker, H. Gene. *Philosophy of Art.* New York: Charles Scribner's
Sons, 1979.

Bradley, A. C. *Oxford Lectures on Poetry*. London: Macmillan, 1920.

Burgin, Victor. *The End of Art Theory*. London: Macmillan, 1986.

Carroll, Lewis. *Jabberwocky and Other Poems*. London: Faber, 1968.

Carroll, Noël. "Art, Practice and Narrative." *The Monist* 71 (1988): 140–56.

———. "Historical Narratives and the Philosophy of Art." *Journal of Aesthetics and Art Criticism* 51 (1993): 313–36.

———. "Identifying Art." In R. J. Yanal, ed., *Institutions of Art*. University Park: Pennsylvania State University Press, 1994. 3–38.

Collingwood, R. G. *The Principles of Art*. London: Oxford University Press, 1938.

Conrad, Peter. *Modern Times, Modern Places*. London: Thames and Hudson, 1998.

Crane, Stephen. *The Red Badge of Courage*. New York: Penguin, 1983.

Crimp, Douglas. *On the Museum's Ruins*. Cambridge, Mass.: MIT Press, 1993.

Curtler, Hugh, ed. *What Is Art?* New York: Haven, 1983.

Danto, Arthur C. *After the End of Art*. Princeton, N.J.: Princeton University Press, 1997.

———. *The Philosophical Disenfranchisement of Art*. New York: Columbia University Press, 1986.

———. *The Transfiguration of the Commonplace*. Cambridge, Mass.: Harvard University Press, 1981.

Davies, Stephen. *Definitions of Art*. Ithaca, N.Y.: Cornell University Press, 1991.

———. "John Cage's *4'33"*: Is It Music?" *Australasian Journal of Philosophy* 75 (1997): 448–62.

Dickie, George. *Art and the Aesthetic*. Ithaca, N.Y.: Cornell University Press, 1974.

———. *The Art Circle*. New York: Haven, 1984.

———. *Evaluating Art*. Philadelphia: Temple University Press, 1988.

Dostoyevsky, Fyodor. *The Brothers Karamazov*. Trans. David Magarshack. Harmondsworth, England: Penguin, 1958.

Durrell, Lawrence. *The Alexandria Quartet*. London: Faber and Faber, 1962.

Fry, Roger. *Vision and Design*. Harmondsworth, England: Penguin, 1920.

Gauss, Charles Edward. *The Aesthetic Theories of French Artists*. Baltimore: The Johns Hopkins University Press, 1966.

Goethe, J. W. von. *The Sorrows of Young Werther*. Trans. Michael Hulse. London: Penguin, 1989.

Goldwater, Robert, and Marco Treves, eds. *Artists on Art*. London: John Murray, 1976.

Gombrich, Ernst H. *Art and Illusion*. London: Phaidon, 1960.

Goodman, Nelson. *Languages of Art*. Indianapolis: Hackett, 1976.

Graham, Gordon. *Philosophy of The Arts*. London: Routledge, 1997.

Haapala, Arto, Jerrold Levinson, and Veikko Rantala, eds. *The End of Art and Beyond*. Atlantic Highlands, N.J.: Humanities Press, 1997.

Hanslick, Eduard. *On the Musically Beautiful*. Trans. Geoffrey Payzant. Indianapolis: Hackett Publishing Company, 1986.

Harrison, Charles, and Paul Wood, eds. *Art in Theory 1900–1990*. Oxford, England: Blackwell, 1992.

Harrison, Charles, Paul Wood, and Jason Gaiger, eds. *Art in Theory 1815–1900*. Oxford, England: Blackwell, 1998.

Hegel, G. W. F. *Hegel's Aesthetics: Lectures on Fine Art*. 2 vols., trans. T. M. Knox. Oxford, England: Oxford University Press, 1975.

Hughes, G. E., and M. J. Cresswell. *An Introduction to Modal Logic*. London: Methuen, 1968.

Hughes, Robert. *The Shock of the New*. Updated and enlarged edition. London: Thames and Hudson, 1991.

Hume, David. *Selected Essays*. Ed. Stephen Copley and Andrew Edgar. Oxford, England: Oxford University Press, 1993.

Huxley, Aldous. *Brave New World*. Harmondsworth, England: Penguin, 1955.

Joyce, James. *Ulysses*. London: Bodley Head, 1969.

Kant, Immanuel. *Kant's Critique of Aesthetic Judgement*. Trans. James Creed Meredith. Oxford, England: Clarendon Press, 1911.

——. *Kant's Critique of Practical Reason*. Trans. Thomas Kingsmill Abbott. London: Longmans, Green and Co., 1873.

Kivy, Peter. *Philosophies of Arts*. Cambridge, England: Cambridge University Press, 1997.

Klee, Felix, ed. *The Diaries of Paul Klee 1898–1918*. Berkeley: University of California Press, 1964.

Langer, Susanne K. *Feeling and Form*. London: Routledge and Kegan Paul, 1953.

——. *Philosophy in a New Key*. Cambridge, Mass.: Harvard University Press, 1942.

Levinson, Jerrold. *Music, Art, and Metaphysics*. Ithaca, N.Y.: Cornell University Press, 1990.

——. *The Pleasures of Aesthetics*. Ithaca, N.Y.: Cornell University Press, 1996.

Listowel, Earl. *Modern Aesthetics: An Historical Introduction*. London: Allen and Unwin, 1933.

Malraux, André. *The Voices of Silence*. Trans. Stuart Gilbert. St. Albans, England: Paladin, 1974.

Mandelbaum, Maurice. "Family Resemblances and Generalizations Concerning the Arts." *The American Philosophical Quarterly* 2 (1965): 219–28.

Melville, Herman. *Moby-Dick*. New York: Penguin, 1992.

Musil, Robert. *The Man without Qualities*. Trans. Sophie Wilkins and Burton Pike. New York: Alfred A. Knopf Inc., 1995.

Nagel, Ernest. *Logic without Metaphysics*. Glencoe, N.Y.: The Free Press, 1956.

Nietzsche, Friedrich. *The Birth of Tragedy*. Trans. Shaun Whiteside, ed. Michael Tanner. Harmondsworth, England: Penguin, 1993.

——. *Twilight of the Idols/The Anti-Christ*. Trans. R. J. Hollingdale. Harmondsworth, England: Penguin, 1968.

——. *The Will to Power*. Trans. Walter Kaufmann and R. J. Hollingdale, ed. Walter Kaufmann. New York: Vintage, 1968.

Nussbaum, Martha C. *Poetic Justice*. Boston: Beacon Press, 1995.

O'Neill, Bekah. *The Life and Works of Kandinsky*. Sydney: The Book Company, 1995.

Ortega y Gasset, J. *The Dehumanization of Art*. Trans. Helen Weyl. Princeton, N.J.: Princeton University Press, 1972.

Orwell, George. *Animal Farm*. Harmondsworth, England: Penguin, 1951.

——. *1984*. London: Secker and Warburg, 1949.

Parmelin, Hélène. *Art Anti-Art*. Trans. J. A. Underwood. London: Marion Boyars, 1977.

Plato. *The Republic of Plato*. Trans. Francis MacDonald Cornford. London: Oxford University Press, 1941.

Ramachandran, V. S., and William Hirstein. "The Science of Art: A Neurological Theory of Aesthetic Experience." *Journal of Consciousness Studies* 6(6–7) (1999): 15–51.

Read, Herbert. *The Origins of Form in Art.* London: Thames and Hudson, 1965.

Schopenhauer, Arthur. *Essays and Aphorisms.* Trans. R. J. Hollingdale. Harmondsworth, England: Penguin, 1970.

———. *The World as Will and Representation.* 2 vols., trans. E. F. J. Payne. New York: Dover, 1966.

Shakespeare, William. *The Complete Works.* London: Collins, 1951.

Simmel, Georg, et al. *Essays on Sociology, Philosophy and Aesthetics.* Ed. Kurt H. Wolf. New York: Harper and Row, 1965.

Steiner, George. *In Bluebeard's Castle.* London: Faber and Faber, 1971.

Stuckenschmidt, H. H. *Twentieth Century Music.* Trans. R. Deveson. New York: McGraw-Hill, 1969.

Suetonius. *The Twelve Caesars.* Trans. Robert Graves. Harmondsworth, England: Penguin, 1957.

Swanston, Hamish, F. G. *In Defence of Opera.* Harmondsworth, England: Penguin, 1978.

Tolkien, J. R. R. *The Lord of the Rings.* London: Allen and Unwin, 1966.

Tolstoy, Leo. *War and Peace.* Trans. Constance Garnett. London: Pan Books, 1972.

———. *What Is Art?* Trans. R. Pevear and L. Volokhonsky. Harmondsworth, England: Penguin, 1995.

Vasari, Giorgio. *Lives of the Artists.* Trans. George Bull. Harmondsworth, England: Penguin, 1965.

Voltaire. *Candide.* Trans. John Butt. Harmondsworth, England: Penguin, 1947.

Weitz, Morris. "The Role of Theory in Aesthetics." *Journal of Aesthetics and Art Criticism* 15 (1956): 27–35.

Wittgenstein, Ludwig. *Philosophical Investigations.* Oxford, England: Blackwell, 1958.

Wolfe, Tom. *The Painted Word.* New York: Bantam, 1976.

Yanal, Robert J., ed. *Institutions of Art.* University Park: Pennsylvania State University Press, 1994.

E. E. SLEINIS, a senior lecturer in philosophy at the University of Tasmania, Australia, is the author of *Nietzsche's Revaluation of Values: A Study in Strategies* (1994).

Composed in 9/15 Berthold Walbaum
with Bauer Bodoni and Meta display
by Celia Shapland
for the University of Illinois Press
Designed by Copenhaver Cumpston
Manufactured by Thomson-Shore, Inc.

UNIVERSITY OF ILLINOIS PRESS
1325 South Oak Street Champaign, IL 61820-6903
www.press.uillinois.edu